BEGINNER'S GUIDE TO
SKETCHING

··

ROBOTS, VEHICLES & SCI-FI CONCEPTS

3dtotalPublishing

3dtotalPublishing

Website: www.3dtotal.com
Correspondence: publishing@3dtotal.com

Beginner's Guide to Sketching: Robots, Vehicles & Sci-fi Concepts © 2019, 3dtotal Publishing.

Every effort has been made to ensure the credits and contact information listed are present and correct. In the case of any errors that have occurred, the publisher respectfully directs readers to www.3dtotalpublishing.com for any updated information and/or corrections.

First published in the United Kingdom, 2019, by 3dtotal Publishing.
Address: 3dtotal.com Ltd, 29 Foregate Street, Worcester, WR1 1DS, United Kingdom

Soft cover ISBN: 978-1-909414-77-8
Printing and binding: Gomer Press (UK) | www.gomer.co.uk

Visit www.3dtotalpublishing.com for a complete list of available book titles.

Managing Director: Tom Greenway
Studio Manager: Simon Morse
Assistant Manager: Melanie Robinson
Lead Designer: Imogen Williams
Publishing Manager: Jenny Fox-Proverbs
Designer: Matthew Lewis
Editor: Marisa Lewis

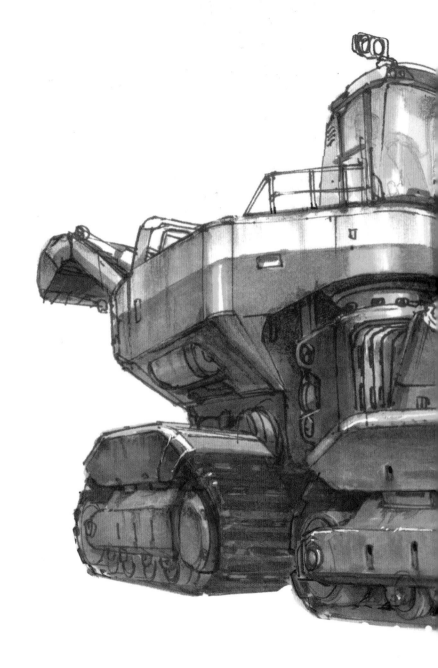

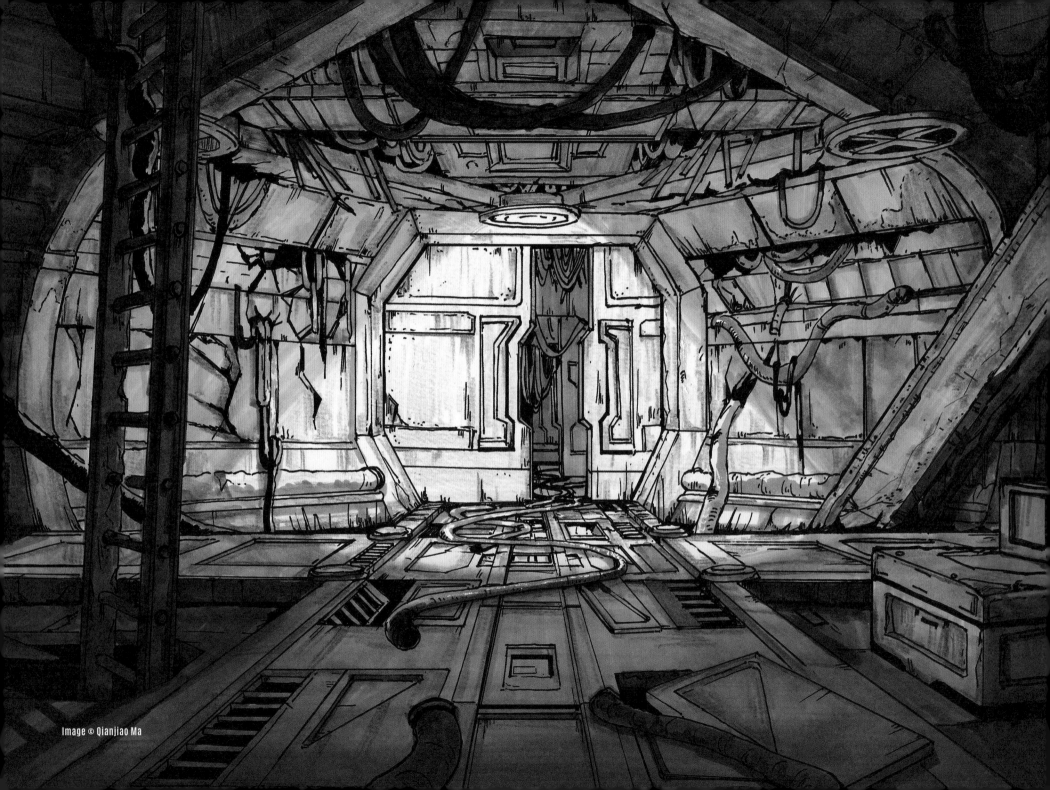

CONTENTS

INTRODUCTION

Science fiction has captivated audiences for decades – centuries, even – from *The War of the Worlds* to *Star Trek* to *Fallout*. It's one of the great staples of fiction and pop culture, and sparks the imaginations of artists of every age and ability. However, making the leap into creating your own worlds full of spaceships, robots, and outlandish vehicles isn't easy. "Hard-surface" concept design, meaning the design of manufactured, industrial, metal subjects, is full of technical challenges than can scare a beginner – and many an experienced artist – away from tackling their first giant mech or flying car. In this book, we shine a light on hard-surface sci-fi and give it our *Beginner's Guide* treatment, breaking concepts down to the nuts and bolts with the help of sixteen talented professional artists. It's an exciting journey and we hope you enjoy it!

Marisa Lewis
Editor, 3dtotal Publishing

HOW TO USE THIS BOOK

Getting Started will introduce you to useful tools, drawing techniques, perspective knowledge, textures and lighting, and a basic understanding of the concept design process. We advise reading this section first, and referring back to it as you progress through the book.

Main Projects will show you how to construct finished sci-fi concepts from scratch. This process includes thumbnail sketching, drawing in perspective, and rendering different surface textures. If you find yourself getting stuck, each artist has kindly provided some downloadable resources to help you follow along, including perspective guides and line drawings to print out and practice on. When you see a tutorial marked with a Downloadable Resources icon (see opposite page), it means you can find useful extras for that project at **3dtotalpublishing.com**. Just click on the Resources page and scroll down to this book.

Quick Studies offers bite-sized insights into further sci-fi subjects, like small vehicles and accessories, that you can use to bring your scenes to life or as a springboard for your own ideas.

Advanced Projects introduces new processes – like extra traditional tools and digital sketching – that you might like to consider to give your future projects a boost. Don't miss the downloads for these too!

Image © Jerel Dye

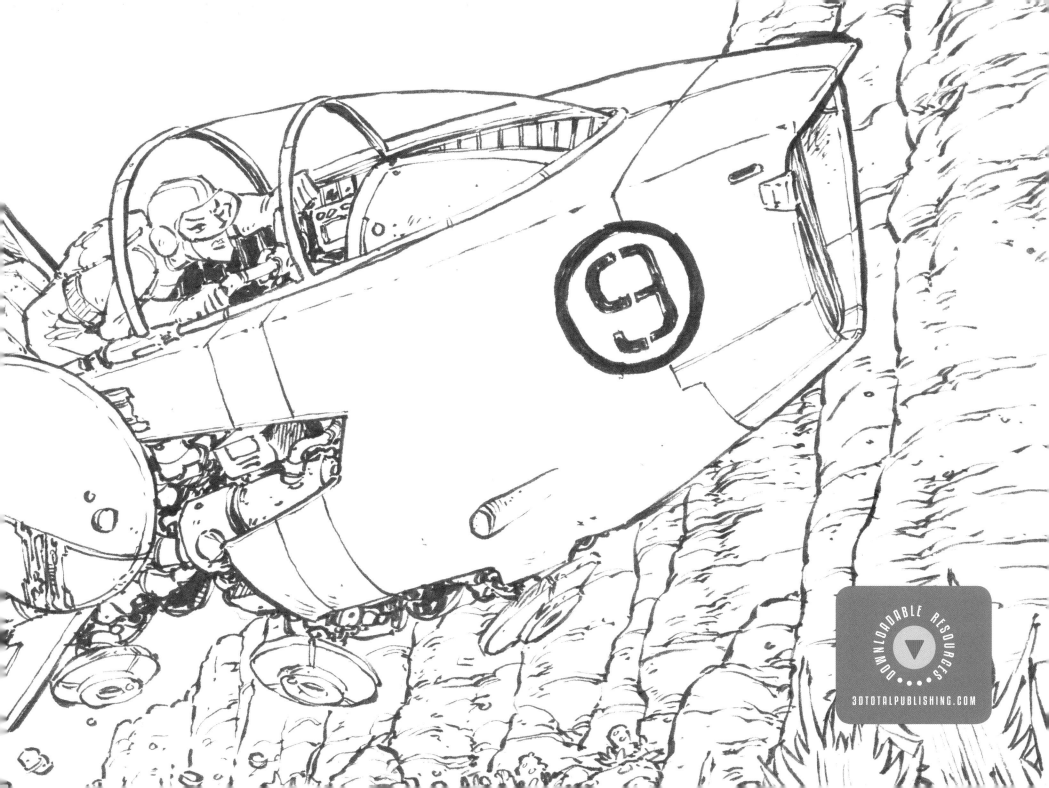

GETTING STARTED

The most common questions asked by beginner artists are, "What tools should I use?" or "What kind of paper do I need?" As with all creative choices we make to produce artwork, there are many options, which professional concept designer John A. Frye will break down for you in this section. This chapter will begin with an introduction to the tools that a sci-fi artist will find the most useful, from pencils and markers to ellipse guides.

Having the tools alone isn't enough if you don't know how to draw your idea, so John will then move on to essential geometry, how to create a concept from basic shapes, and how to analyze the textures and light that will bring your hard-surface designs roaring to life.

Finally, this chapter will walk you through a whole concept development process, so you can see how all these tools and ideas are applied to creating a specific design.

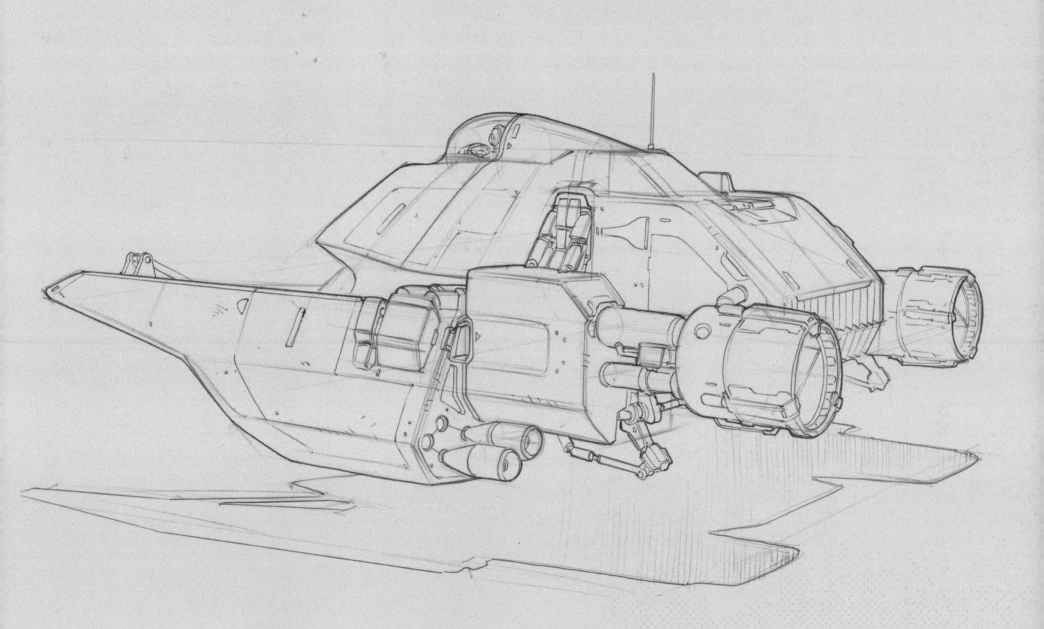

TOOLS & MATERIALS

BY JOHN A. FRYE

fryewerk.com | All images © John A. Frye

Exploring different drawing tools and papers can be a fun process, but without some direction, the breadth of media available in the art store can be overwhelming. I will explain how to logically narrow down the best drawing tools and paper options to suit your style and produce great-looking drawings. This section will delve into the traditional drawing tools that are especially useful and efficient for creating hard-surface sci-fi designs, and some core techniques to learn before tackling the main tutorial projects later on in this book.

DESK OR TABLE

The physical foundation of a great drawing is your desk or table, and the paper on top of it. As drawing is a precise manual labor, having the proper space to move your body and be in a comfortable position bolsters your ability to make smooth, precise lines on paper. I've found that a 24"-wide, 17"-deep drawing surface, at a minimum, gives me enough space to sketch on 8.5" × 11" (US letter size) paper. For a desk, I use a standing workstation that is 42" high. Standing allows me to use my shoulder effectively, and to step back and look at the drawing from a distance to critique my own progress.

STORAGE

I store my markers, pens, pencils, and other tools in artist taborets (portable cabinets) beside my desk. Papers and sketchbooks are stored in a flat file ready for various needs. Make sure you don't leave paper in areas of high heat or moisture, such as inside cars or in direct sunlight. Papers can warp and buckle if not kept well.

⬆ I enjoy the comfort and mobility of working while standing at a 42"-high drafting table with LED desk lamps bouncing light off the wall. Nearby I keep my large-format scanner, pencil sharpener, and artist taborets full of tools.

⬆ I keep a wide assortment of papers in a flat file. Make sure that you have suitable storage for your papers to keep them in good condition.

IS TRADITIONAL DRAWING USEFUL?

Students sometimes question the importance of drawing with traditional media. Very confidently, I can tell you that in any artistic endeavor, the purity of simple analog drawing is a skill that should be mastered above any digital technology. Solid skills in sketching on paper are the foundation of any artistic career. A sketch on a napkin, whiteboard, notepad, or sticky-note is forever powerful as a means of producing ideas and stimulating creative conversations.

PAPER

For line drawings I use A4 office paper normally used for color copiers. It is cheap to buy in bulk, easily portable, and works well with ballpoint pen as the surface is smooth and has a coating that keeps markers from bleeding too much. A ream of good-quality color copier paper, 28 lb or 105 gsm in weight, will last a long time and can be used both for roughs and finished work. It can be too smooth for graphite-shaded sketches, for which you should use heavier sketchbook paper with a slight texture, but is well suited for marker, ballpoint, and gel ink pen drawings. Copier paper made for black and white copiers is not recommended, as it is too absorbent (which will dry out your markers), unevenly textured, and of thin, poor consistency.

PAPER EXAMPLES

For full-color or grayscale marker drawing, marker paper works well. It is designed to work with markers to create even tones and limit the bleeding of marker ink. Gel and ballpoint inks dry more slowly on marker paper, so be careful to let pen ink dry to avoid smearing. Marker paper also helps to extend the life of a marker drawing.

Toned paper and colored paper enable you to add highlights, quickly expressing shape and form with value using minimal tools (such as a light-colored pencil and dark marker). You can learn more about illustrating on toned paper on page 188. For the best results, don't overwork the image, and keep the white tones to a minimum. Papers such as Strathmore's Toned range have a slightly rough surface that works well with the dry texture of pencils.

For design and perspective development, working on layers of tracing paper will help you to develop difficult drawings layer by layer, overlaying iterations of a design without erasing or redrawing the original sketch. Tracing paper is usually not suited for finished marker or pen work, so use it mainly for working with pencil.

A SMOOTH SURFACE
With any paper, always draw with 3-5 more sheets underneath to make a smooth cushion for creating lines, especially when shading with colored pencil.

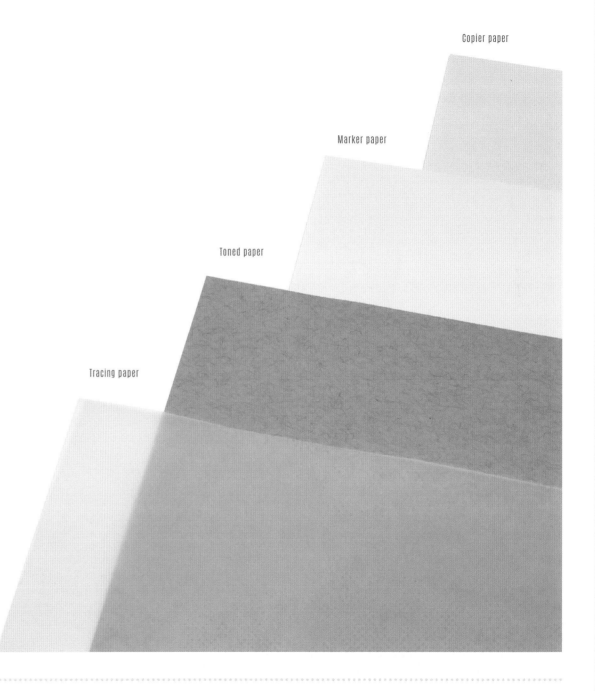

Copier paper

Marker paper

Toned paper

Tracing paper

PENCILS

For many of us, the first adult drawing tool of our youth is a pencil. Young artists find it natural to learn to produce clean line drawings and shading with pencils. Pencil cores, commonly called "leads" (though they're not made of lead) come in different grades, which it is important to understand.

Graphite B leads are soft ("B" indicating "blackness"). The larger the number, like 4B, the softer and darker the shade on paper. These pencils are good for shading objects. H leads are hard ("H" indicating "hardness"). The larger the number, the harder the graphite and the lighter its values. These pencils are good for preliminary sketching and line drawing. HB or 2B are the standard medium grades, and are good all-rounders. A graphite pencil will not be as dark in shaded areas as a colored one (such as a black pencil), so it won't have as much visual impact in a final image, but is ideal for creating tight line drawings or underlays for ink work.

Mechanical pencils have a refillable lead with a fixed diameter, and are excellent for developing precise line drawings as you would with ink, while allowing you to erase and revise. This makes them ideal for perspective drawing. Wood pencils, like the iconic Dixon Ticonderoga, have a larger-diameter lead than mechanical pencils, enabling you to shade large areas smoothly and quickly. These have a core encased in a wooden body, and need to be sharpened, unlike mechanical pencils.

Colored pencils can be categorized as soft, hard, or erasable. As with graphite pencils, their softness or hardness affects the range of values or textures you can achieve. Use hard colored pencils such as Prismacolor Verithin for sharp linework and light sketching, and soft ones such as Prismacolor Premier Soft Core for large, impactful areas. Avoid using erasable colored pencils such as Prismacolor Col-Erase for finished work, as they smear easily, but they are well suited for preliminary development sketches.

COLORED PENCIL TIPS

If you don't know if a colored pencil is hard or soft and are unable to test it, remember that the colored lead usually has a larger diameter in soft pencils, and a thinner diameter in harder, compound pencils. Experiment with using marker pens over soft colored pencil on different papers, as they can give attractive blending effects.

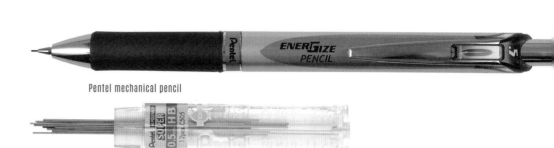

Pentel mechanical pencil

Mechanical pencil refills

Dixon Ticonderoga graphite pencil

Faber-Castell graphite pencil

Prismacolor Verithin colored pencil

Prismacolor Premier colored pencil

Prismacolor Premier colored pencil

Prismacolor Col-Erase colored pencil with eraser

PENCIL EXAMPLES

Mechanical pencils
The very small-diameter lead is designed for tight linework, which is useful for sci-fi designs. In this example, a framework of edge lines is drawn using a straightedge or ruler and varying pressure to achieve clean, precise light or dark lines with 0.5 mm HB graphite lead in a Pentel Energize mechanical pencil.

Erasable colored pencils
Pencils such as Prismacolor Col-Erase can be used with varying pressure to give you value range much like a graphite pencil. While the pencils are erasable, the color doesn't completely erase if you draw with heavy pressure, so use these lightly for preliminary sketches until you are confident in nailing down your final lines.

Graphite wood pencils
These are excellent for creating shading. Apply hard pressure to create dark areas, and try hatching closely-spaced parallel strokes while gradually easing the pressure to vary the value from dark to light. Work on paper with a light tooth, such as tracing paper, which will pick up the graphite easily.

Colored pencils
On the smoother side of green Canson Mi-Teintes paper, with Prismacolor pencil, hatched pressure variation with chartreuse and black hatched lines creates gradations. Start with light colors and work up to dark, using consistency with the direction and slightly overlapping hatching lines to create a smooth appearance.

ERASERS AND BLENDING TOOLS

Erasers can be seen as tools to fix problems, but with experience, they can be creative tools as well. Use them to precisely brighten areas and indicate highlights when working with pencils.

Standard pink erasers are designed specifically for graphite and work perfectly to remove graphite from smooth papers. However, they can be abrasive on the paper's surface, so if you are using a paper with even a small bit of coating (such as color copier paper), heavily erased areas may allow ink to bleed more as the paper has become more rough and absorbent. The pink eraser on a pencil is well matched to the pencil itself, but be vigilant, as the rubber can quickly harden in sunlight and heat. A hardened eraser won't erase well and will smear your graphite.

White drafting erasers are softer and take more effort to remove graphite, but are gentler on paper. This makes them good for coated papers such as marker paper or color copier paper when used with care.

On more delicate papers, vigorous erasing may damage the paper surface; in this case, use a kneaded or putty eraser to gently pick up the marks. A kneaded eraser can be molded into useful shapes and used to dab away both large and fine areas of a drawing, lifting the graphite from the paper without leaving rubbings. A heavily used putty eraser can become dirty and prone to smudging, so may need replacing more often than a pink or plastic eraser.

An eraser shield (shown opposite, far top right) is something of a draftsman's relic, but is useful for controlling the areas where you want to remove graphite. Erasing along the edge of an eraser shield produces a sharp contrast between the shaded and bare paper, which is useful for creating clean edges and highlights in a hard-surface design. To achieve other subtle shading effects, blending stumps (tools made from twisted paper) can be used to smooth out the rough or uneven texture of graphite and colored pencil on paper.

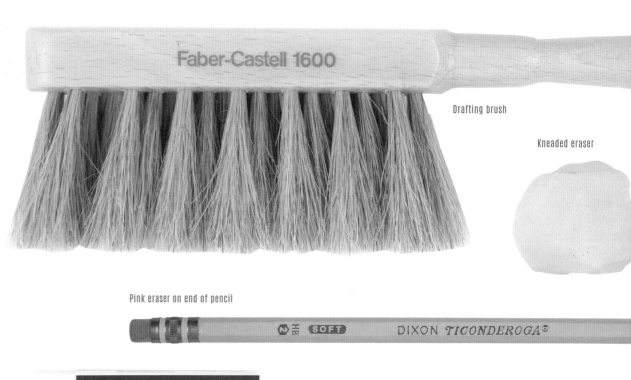

Drafting brush

Kneaded eraser

Pink eraser on end of pencil

White plastic eraser

Tombow Mono Zero retractable eraser

Blending stumps

ERASING AND BLENDING EXAMPLES

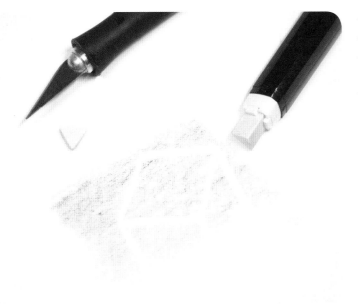

White plastic erasers
This type of eraser works well with graphite. A retractable white eraser such as the Pentel Tri Eraser or Tombow Mono Zero is ideal for detailed cleanup of drawings. Use a razor blade to cut the eraser to a precision point when it gets too dull.

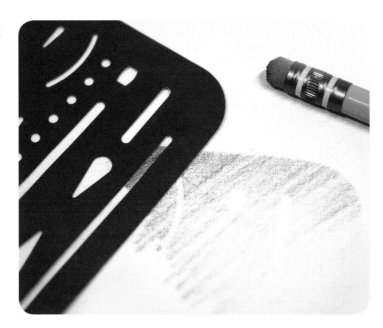

Eraser shields
This tool helps to guide your erasing to a particular profile. When you need to tidy up a drawing, erasing along the edge will give you a clear, sharp line. Dots, squares, and curves on the shield can be used to erase small details.

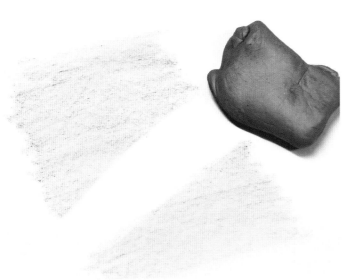

Kneaded erasers
Kneaded or putty erasers work differently than other erasers, as you dab or gently push the eraser to pick up graphite or colored pencil instead of rubbing the paper surface. These are ideal for delicate removal, especially for large areas of shaded graphite, and can create very smooth, gradual highlights.

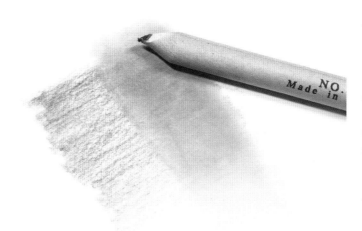

Blending stumps
When working with dry media such as graphite and chalk pastel (see page 23), the texture of the strokes can be smoothed out by rubbing the drawing surface with a blending stump. When blending multiple colors of pencil, a stump makes the color transition seamless.

PENS AND INK

In sci-fi art and hard-surface design in general, clean lines are essential for a precise, manufactured look. This clarity can be achieved with pens such as technical fineliners, which create a consistent dark line. At the same time, variety in lineweight helps to define form and give life to a drawing. Ink pens come in several types, such as fineliner, gel ink, ballpoint, and brush-tipped pens. I select pens according to the key factors below.

Lineweight. Cheaper ballpoint pens can produce a very good variety of line thicknesses, depending on pressure and angle, making them great for sketching. Felt-tip pens, technical pens, gel pens, and high-quality writing ballpoints tend to be designed for a consistent width, making it more difficult to create varying lineweights, but their predictable, sharp line is ideal for finished work.

Reliability. Does this pen play well with others? How do you plan to use it? When you throw a colored marker into the mix, does the ink line bleed? Marker paper is often heavily coated, which will make pens such as gel and ballpoint smear under marker strokes. Many ballpoint pens use alcohol solvents, as do some markers, so when you drag a marker stroke across your tidy lines, the ink may separate and blur.

Accessibility. How easy is it to get replacement pens? Pens that are mass-produced are readily available. Avoid falling in love with an obscure brand that you can't replace when it dries up.

Good art stores will let you test pens. Sketch out strokes on your paper of choice with several pens, taking note of line variety and feel. Use different brands of light-colored markers over the pen lines and look for bleeding or smearing. If possible, test all interactions between pencils, pens, markers, and papers before buying them.

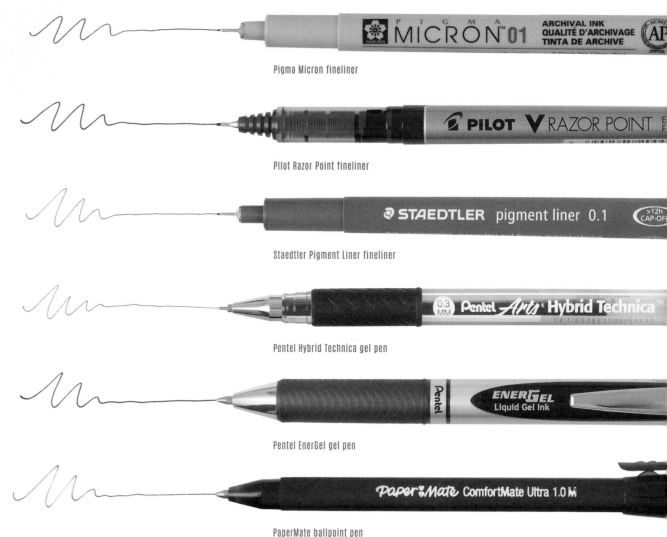

Pigma Micron fineliner

Pilot Razor Point fineliner

Staedtler Pigment Liner fineliner

Pentel Hybrid Technica gel pen

Pentel EnerGel gel pen

PaperMate ballpoint pen

Copic Gasenfude brush pen

PEN EXAMPLES

Ballpoint pens

Here, a PaperMate ballpoint pen is used on Strathmore Toned Gray paper with varying pressure to create light interior lines, heavier outlines, and sketchy lines of varying value. Ballpoint pen is similar to a pencil in that pressure determines value, making it well suited for both light sketching and darker lines.

Parallel hatching

A bend or crease in a surface can be indicated with a gradating band of parallel hatching along the change in direction of a surface. When these lines are used in conjunction with a single light gray marker, the form of the object is clearly expressed. This technique is useful for conveying smooth, curving surfaces that do not have hard angles.

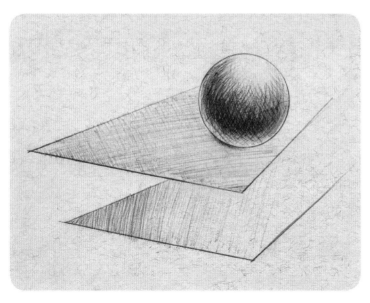

Cross-hatching

Be careful of the flattening effect of uni-directional strokes (shown on the lower plane). Instead, intersect cross-hatching strokes (shown on the upper plane) to give a surface more solidity. Hatching that follows the surface an object can also help to show its shape (shown on the sphere).

Random hatching

With technical pens, the uniformity of value is not well suited for light hatching, so here, random clusters of hatches (what I call "hay-hatching") are used to show slight shading or bends in the surface. This technique is useful for indicating well-worn surfaces, such as dirty metal panels on tanks and trucks.

MARKERS

Markers can be used to fill areas with value and color, defining form and adding excitement to a drawing. They essentially feel like having watercolors in the form of a handy pen. As with ink pens, markers suspend dyes in a solvent which evaporates, leaving the color on the paper.

Markers made with xylene and toluene solvents have a strong odor which make them ill-suited for coffee shop sketching, but the colors are vibrant, and can be used on top of most pen inks without causing them to bleed. These markers tend to flow freely onto the paper, so the color itself may overwhelm the surface and spread farther than you intend unless you work quickly.

Alcohol solvent markers are the most commonly found markers today. Alcohol-based markers are non-toxic and generally light in odor, though the colors on paper are not quite as vibrant as xylene- or toluene-based markers. They make some ink lines bleed easily, so work over an ink line drawing with caution and test the pens for compatibility first.

Markers come in many brands. Copic makes some of the best alcohol solvent markers and are my favorite of this type. They are not only refillable, but come in a delicate array of colors. Super-wide chisel-tip markers such as Copic Wide are great for blocking in large areas and backgrounds. The rich colors of Chartpak AD Markers, another alcohol-based range, are difficult to beat.

Working on marker paper (see page 11) brings the best results for consistent color and value, as the paper doesn't absorb too much, and helps to extend the life of the marker. Marker sets can be expensive, so invest in a set of neutral grays before you spring for a full color set. Try using cheap black markers from an office supply store, instead of high-quality artistic black markers, as they will be used up quickly.

Chartpak AD Marker

Copic clear/blender marker

Copic VARIOUS INK

Copic ink refill

Copic marker

Copic Wide marker

TRY BRUSH PENS

Broaden your creativity by working with a brush pen, such as a refillable Kuretake pen or a disposable Copic Gasenfude pen. Brush pens create lines that vary in width by pressure application, and are useful for creating more organic drawings. However, this makes them more difficult to control, and the ink can require time to dry.

MARKER EXAMPLES

Gray markers

Markers are often sold in numbered sets of grays. For beginner artists, working first with value before color is a good way to learn the importance of value range. Try shading objects like the one shown here, with a range from light to dark, overlapping and shading over previous marker strokes to smooth out the transitions between values.

Blender markers

A clear or blender marker can liquefy and blend colored pencil strokes on paper and give them uniformity, similar to how water-soluble pencils work. This is useful if you want to fully sketch out your colors or shading before committing. When using this technique, work from dark to light areas, and "clean" the pencil color off the marker nib by drawing on a separate paper.

Colored markers

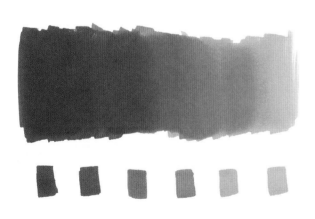

These markers can achieve watercolor-like blending if using similar colors, with the advantage of drying more quickly than paint. Some marker paper holds the ink on the surface so that shading over previous colors blends smoothly, but the strokes may require a light scrubbing afterwards to polish the effect. Keep the stroke direction uniform for smooth gradations.

Marker sketching

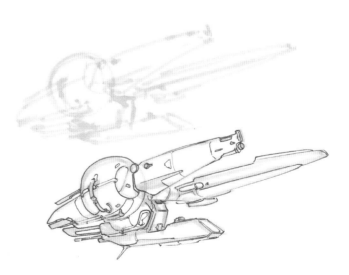

One of the most powerful creation tools we have is seeing a shape or form where there is only chaos or unstructured visual information (a phenomenon known as "pareidolia"). Much like seeing shapes in clouds, sketching quickly and roughly with a broad marker tip can be used as a basis for a distinct form using fine line ink.

WET MEDIA

Drawing is one of the best ways to get ideas down on paper directly and quickly, so for me, avoiding processes that slow down this workflow means minimizing tools like paint that require time to prepare, mix, and clean. However, in efficiently minimal application, paint can be useful as an image-finishing tool, making a drawing come to life or "pop" with an accent of light or color. This section will focus on time-efficient options that are easy to use in conjunction with the tools we've covered previously – for example, gouache paint rather than watercolor.

Gouache is a water-based opaque pigment that can be applied with a brush onto an image. My essential toolbox always contains either a tube of Winsor & Newton gouache in Zinc White and a fine-pointed watercolor brush, or a quality fine-pointed white paint marker (such as those by Molotow). Lower-quality white paint markers do not dry completely opaque, so look for acrylic paint markers to get the best coverage and purest highlights. Colored gouache can be applied with a broad brush to add an impactful splash of background hue that makes a monochrome drawing lively.

Use a good quality pointed brush with gouache to create very clean, thin lines for highlighting edges such as metal panels. Use a flat bristle brush for filling larger areas such as backgrounds.

TEST YOUR PAPER

When using wet media, make sure your paper is up to the task of handling the moisture. Large areas of wet media may buckle and wrinkle thin paper, so you need to anticipate that and work on thicker Bristol or heavy watercolor paper. As with pens and markers, always test your media interactions first.

One 4 All Molotow paint marker

Winsor & Newton Designer Gouache (Blue and White)

Brushes

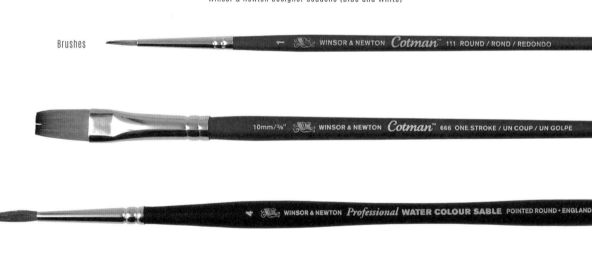

WET MEDIA EXAMPLES

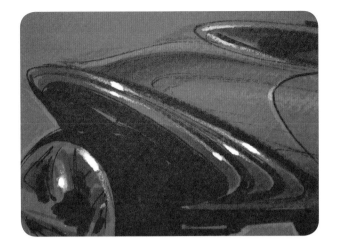

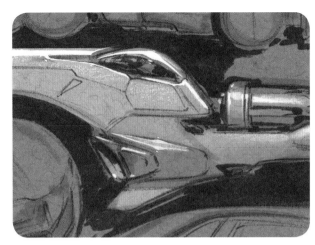

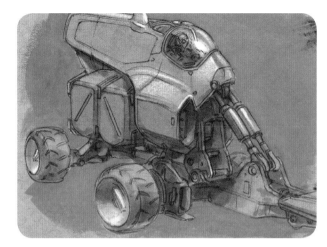

Paint pen on colored paper On toned surfaces such as this red-orange Canson paper, pure white paint from an acrylic paint pen adds the instant appearance of a glossy surface with bright highlights. This technique is useful for a quick finishing pass on loose sketches, as the pen tip and paint application are not overly precise.

Gouache and brush Fine-pointed brushes and white gouache, thinned with a bit of water if needed, can be used for clean and precise highlights. These varied line widths are created by lightly changing pressure. When paint is applied over waxy colored pencil, a small drop of dish soap mixed with the paint will help the gouache to apply smoothly.

Colored gouache A background color can highlight interesting silhouettes and give a drawing impact. Here Cerulean Blue gouache is mixed with Zinc White gouache, and applied with a small flat brush and expressive gusto. The contrasting color helps to make the monochrome drawing pop. It's important to work quickly, with a thin layer of paint, to avoid wrinkling finer papers.

OTHER TOOLS

As you gain drawing and sketching experience, you will start to build a toolbox of essential items, but you'll also find that there's always another tool that could support making a good drawing. When drawing hard-surface subjects like vehicles, mechs, and manufactured objects, it is key to convey a sense of factory-produced precision. Many tools familiar to the drafting and automotive design industries combine well with fine art tools to create a cohesive balance of artistic flair, line, and color with studied, accurate perspective, line, and form.

Straightedges or rulers and triangle sets are necessary items for drawing clean, straight lines, especially for perspective construction. Use a thin, clear plastic straightedge with a length slightly larger than the paper for best results. You will find the transparency will help you to see your reference lines underneath. If the tool has a grid for measurement, that comes in handy too.

Sweeps and ship's curves, originally used for drafting boats and cars, produce long, gradually curving lines by tracing pen or pencil along the edge. French curves are used for tidy tighter bends and arcs. Use these if you have a scratchy, uneven, or shaky natural pen or pencil stroke.

The price tag for a set of ellipse guides may be somewhat daunting, but they are worth the investment: they make the difficult task of sketching precise and correct ellipses easy. Freehand ellipse sketching is sufficient for loose drawings, but finished illustrations look better with well-proportioned, accurately drawn ellipses.

For finishing an image, there are some other materials that can add flair and soul to the illustration. Spray paint can create a stunning background to make your image pop. Chalk pastels, commonly used in automotive illustration, make very clean gradations, perfect for rendering rounded forms. Use a craft knife to scrape the chalk into a fine pile of powder, mixing it with a small amount of baby powder to soften the texture, and rub the powder onto the paper surface using a fine disposable cotton pad. Excess chalk can be cleaned up with kneaded eraser.

Your work studio should be well-equipped for creating expressive, impactful, structured drawings. Once you are familiar with different kinds of sketching, you will be able to construct a "coffee-shop sketch" toolbox that uses a bare minimum of tools, or lay out necessary tools in your home studio efficiently to tackle any sort of drawing job.

▶ Through time and experimentation, you will eventually develop your own unique kit of favorite tools.

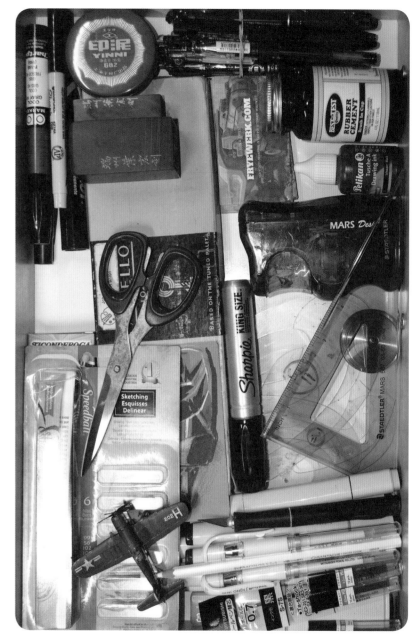

KNOW YOUR INVENTORY

Maintaining your inventory of essential tools is important, as art stores often aren't open as late as other stores. As well as your regular tools, don't forget to keep track of the supplemental tools that you use less frequently. If you're working on a professional project and use up your last white pencil late at night on the eve of the deadline, you may be in trouble!

OTHER TOOL EXAMPLES

Ruler

Sweeps

Ship's curves

Chalk pastels Instead of drawing directly with pastel sticks, you can achieve more subtle effects by using a craft knife to scrape off the amount of pigment you need.

Spray paint Spray paint can create stunning contrast as a background for a clean, precise drawing. Mask your object with paper before spraying over it, as pictured here, or cut the drawing out around the shape of the object and glue it onto a sprayed background. Spray from a distance for a more textured appearance, and try mixing colors for interest.

PERSPECTIVE BASICS

BY JOHN A. FRYE

fryewerk.com | All images © John A. Frye

Drawing in perspective is essential for both visualizing and communicating the three-dimensional reality of a design. For concept designs that need to be engaging, beautiful or exciting from any view, drawing in perspective starts to solidify the form and reveal the complete character of the design. A direct-view drawing, like that of a vehicle seen from the side, only tells a small part of the story of the design; much has not been explained or understood in that limited view. Once you begin to turn the design around in your mind and on the paper, you will understand the design holistically and see the reality of the form. Perspective drawing is the first step towards breaking the limitation of a drawing on a two-dimensional page and adding three-dimensional reality.

While perspective construction may look time consuming and technically overwhelming to new artists, the core logic can become a second-nature process, with practice, that does not require difficult preparation or construction underlay work. Most perspective construction requires only a tidy drawing area, your favorite pen or pencil and paper, and a straightedge or clear ruler. Experience and practice will allow you to eventually create isometric, one-, two-, and three-point perspective quickly freehand, sketching out ideas with a realistic feeling of volume and clarity of shape. Often, an artist will need to rapidly sketch thumbnail drawings to explain part of a design, perspective sketches usually are best for clear communication and understanding.

ISOMETRIC PROJECTION

One of the simplest forms of perspective drawing is isometric projection. It is often used to show a boxy object with realistic proportions, like in a schematic or instruction manual, since the scaling of the object is accurate and consistent. While objects when viewed in reality get smaller as they get farther away, isometric perspective rigidly maintains scale and angle

of view in a fixed position. Some video games are designed and executed completely in isometric view for nostalgic appeal, and also for making development easier. It is often not the most realistic or attractive method of drawing, appearing unnatural and formal, but it is a very simple way to show design detail, proportion, and scale. While other forms of perspective are free to present objects from different views, the explicit presentation of an object drawn in 30-degree isometric is simple using a 30-60-90 triangle and isometric ellipse guide. For isometric sketching, isometric grid paper enables you to work without angle or straightedge tools.

Perspective drawing tools
To lay out perspective accurately, it's important to use a straightedge or ruler. For right angles, a triangle gives you 90 degrees, and a 30-60-90 triangle is also useful for isometric drawing. Ellipse guides will help to draw round forms in perspective. Use low-tack masking tape to secure your paper.

CONSTRUCTING ISOMETRIC PROJECTION

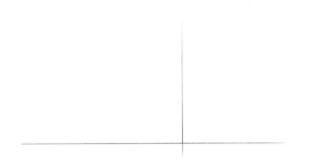

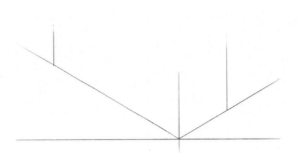

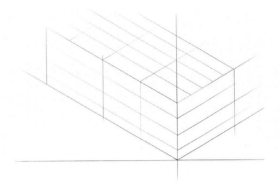

1 Create a horizontal construction line close to and parallel to the bottom of the page. One strong vertical line establishes the near corner of your object; in the next step you'll estimate space on each side of this line for the two sides of the object that face the viewer.

2 Using a pencil and the 30-60-90 triangle, draw 30-degree baselines angling up and away from the bottom of your vertical near corner. These are the bottom foundation lines of the object's two sides. Proceeding back, two more vertical lines, parallel to the first vertical line, will block in the far corners of the object.

3 Any lines on the side of the object that are parallel to the ground in reality are drawn in the same 30-degree angle to the construction line, so we can quickly see a box taking shape. Any subsequent vertical or horizontal lines fall on the vertical or 30-degree angle axes.

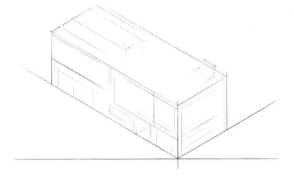

4 Following the perspective of each side, additional lines and boxes are roughly mapped out, indicating where details such as wheels, doors, and windows will fall later.

5 To rough out the wheels, isometric ellipses fit within a square (equal height and 30-degree length) drawn freehand or with an ellipse template, making sure the ellipse touches the center point of each side. Additional detailing that isn't parallel to the ground lines or verticals can start to add some design interest, making the basic shapes look more like a real object.

6 With a blocked-in shape, you can lightly erase the pencil guidelines or make an overlay with tracing paper and begin adding more detail and complexity to the form. Rounding off corners and adding smaller mechanical details makes the design feel more sophisticated while retaining the foundation of perspective.

ONE-POINT PERSPECTIVE

One-point perspective starts to simulate what we see in reality by making objects smaller as they get farther away from us, unlike an isometric view. This is good for simulating depth dramatically, so that long objects like trains can be drawn with large eye-catching detail on the front surfaces before quickly recede toward a single point on the horizon, called a vanishing point.

While one-point perspective starts to approach what we see with our eyes, there is some odd visual distortion as surfaces flat to our view, such as the front of the train, are still drawn as if in direct front view. The farther off to the side that we place the object relative to the vanishing point, the more distorted the forward-facing surfaces will appear (as the object only recedes away from the viewer in one direction).

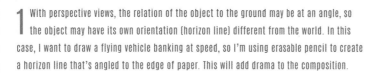

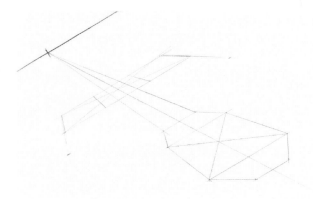

TIP UP VIEWS

Another good use for this perspective is to draw long vehicles or objects from a side view, but slightly above the object, creating a "tip up" view; the one-point perspective adds a feeling of depth and volume to what would otherwise be a very static, flat profile view.

1 With perspective views, the relation of the object to the ground may be at an angle, so the object may have its own orientation (horizon line) different from the world. In this case, I want to draw a flying vehicle banking at speed, so I'm using erasable pencil to create a horizon line that's angled to the edge of paper. This will add drama to the composition.

2 Lightly draw foundations for the object using rectangles. Lines going away from you should all converge toward the single vanishing point on the horizon. Centers of rectangles can be located by intersecting two lines from the corners to make an "X" - this is useful for creating symmetry. Horizontal lines parallel to your view should be parallel to the horizon line.

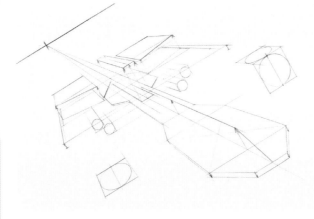

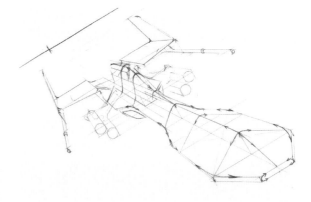

3 Use vertical lines as a framework to add height from the foundation, making the flat outline three-dimensional. Make sure the fronts of the boxes stay perfectly horizontal or vertical. Circles are drawn as ellipses if they are at an angle to the view or facing upward, while circles drawn facing you should be perfectly round.

4 Begin to add crown (a curve such as the bend in a car's hood) and curvature to the framework with a darker line. Drawing a vertical plane in perspective along the centerline can help to establish height, as you can see inside the spacecraft's nose, before sketching in cross-sections through the object to properly scale the parts that are obscured.

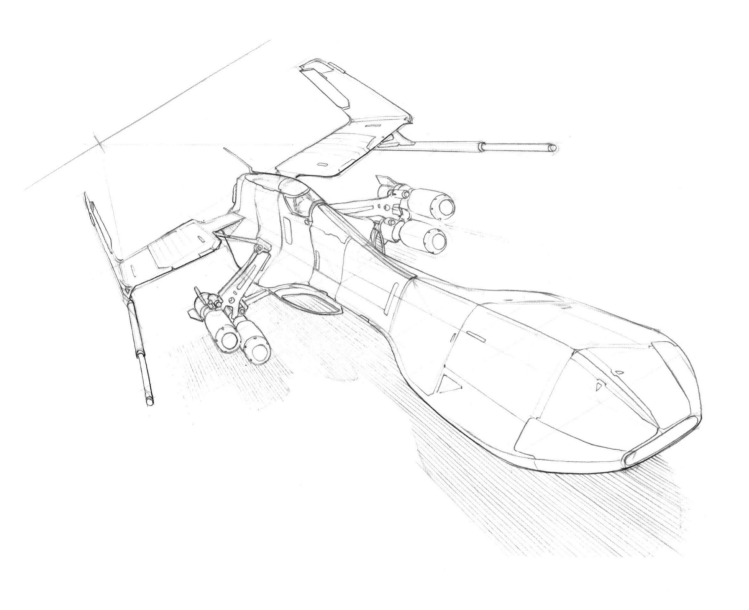

5 Overlay with tracing paper, or ink the final lines over the construction drawing and erase the pencil layout drawing. Small details should fall in line with the same convergence of lines. A perspective shadow underneath can add realism.

PLANNING AHEAD

Perspective grids are useful for accurately drawing your design, but you should have a good idea of your design direction through rough sketches and thumbnails before you use this method.

It may also be difficult to foresee the locations of your perspective vanishing points. Try making small, loose sketches of the type of perspective drama you want for your object, like in the thumbnail below, then estimate from the rough sketch where the vanishing points would be in the full-size drawing.

TWO-POINT PERSPECTIVE

For vehicle design, the most frequently used perspective construction is two-point perspective. For spaceships, cars, jets, and other long forms without a lot of height, having a vanishing point for both the length and width is enough structure to give the image realism and show the form in a way that appears natural.

When using two vanishing points, the distance between them will change the "lens" of the scene or distortion of the object. The closer the points are together, the closer the object will look to you, but place them too close and the results will appear unnatural. It is often necessary to put one or both vanishing points off of the page for a view that shows the object with some drama, but does not distort the shape too much.

Constructing the perspective of an object will become easier with practice, and you will eventually be able to sketch partial guidelines without having to locate vanishing points; you will just develop a feel for where they are.

REVERSE YOUR IMAGE

When practicing perspective sketching by eye, it is helpful to check to see if things are looking strange by looking at the image in the mirror. Reversing the image tricks your brain into seeing the image anew, making it easier to spot any mistakes.

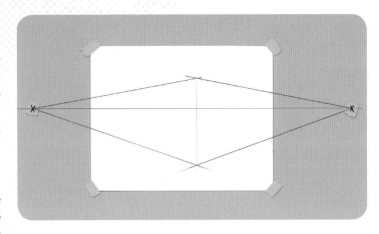

1 Establish a horizon line and then two vanishing points. The closer the points are to each other, the closer the object will look to the viewer. Placing the vanishing points for this 8.5" × 11" image on pieces of tape on the drawing surface, 3" to the left, and another 5" to the right gives me a comfortable viewing perspective.

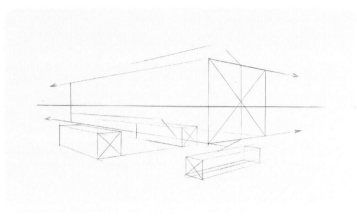

2 Begin by creating the main mass of the object with boxes. The visible faces of the box are made up of lines going toward the vanishing points off the page on either side, and straight up and down vertical corners. Making an "X" from corner to corner of a square will help you to easily locate its center.

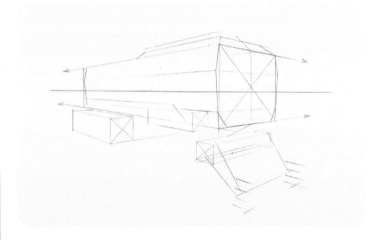

3 Chiseling off the edges ("chamfering") in perspective is a good way to start to add volume to otherwise slab-sided boxes. You will discover that mixing perspective construction with visual estimation is more efficient than completely drafting everything out, but developing the eye to do so takes practice.

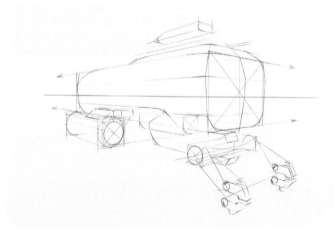

4 Now add smaller details, rounding off edges and creating some fluidity. Start to concentrate detail in areas of mechanical function, like the jointed arms, and the thrusters, leave some areas of the design open and simple for contrast. An ellipse should touch all centers of the four edges of the surrounding square in perspective.

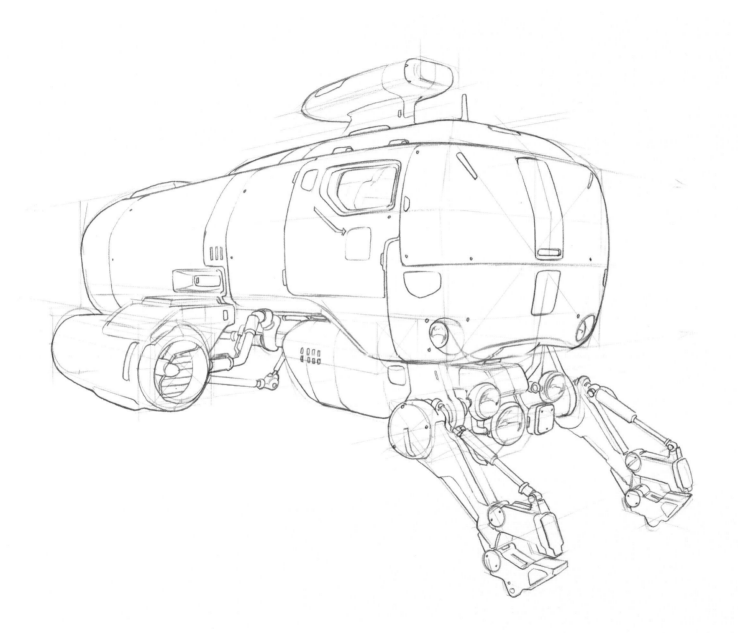

5 Adding small shapes integrated into the forms: sensors, lights, bolt holes, and creating cut lines and panel lines that follow the contours of the form express shape without using any shading or value. Organic lines and fluid hoses contrast with the hard edges and add life to stiffly constructed mechanical objects.

THREE-POINT PERSPECTIVE

The additional vertical vanishing point in **three-point perspective** is useful for expressing a feeling of height. While the mass of most vehicle designs is longitudinal, you will have instances for taller designs, such as standing mechs, where some vertical perspective convergence adds drama to the image. Three-point perspective is limited to objects either completely above or below the horizon line. If the object passes over the horizon line, there will be an appearance of distortion. Three-point perspective is commonly used for environments, especially while creating environments with strong vertical elements such as skyscraper-dense cityscapes. Keeping all three vanishing points in the periphery of the drawing is important to make the perspective look natural and not distorted. A low vanishing point ends up being a good distance below the paper, making the drawing position somewhat awkward, so it is a good idea to lay out a light grid of perspective lines from all three vanishing points, then work independently of the points using the grid as a guiding reference.

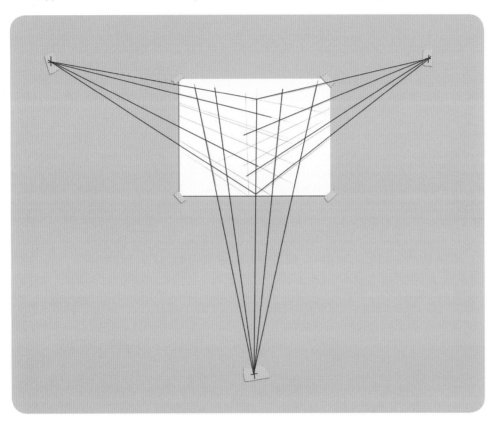

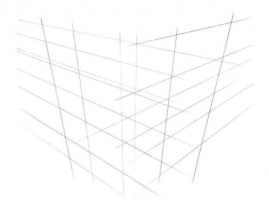

2 Create a light grid of lines from the three points and then move the paper to a comfortable drawing position, working from this point on by estimating the projection of lines to the vanishing point by referencing the grid you have created.

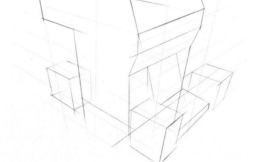

3 Begin to box in the masses as you would in two-point perspective, but in this case, vertical lines should be converging to the vertical vanishing point. Depending on the design you are creating, you may find that it fits on a vertical page layout.

1 Set up three vanishing points off the page. Here, with objects seen from above, the vertical vanishing point is below the drawing page. Conversely, for objects seen from below, the vertical vanishing point would be above the drawing page. You will quickly see how this perspective has a feeling of depth.

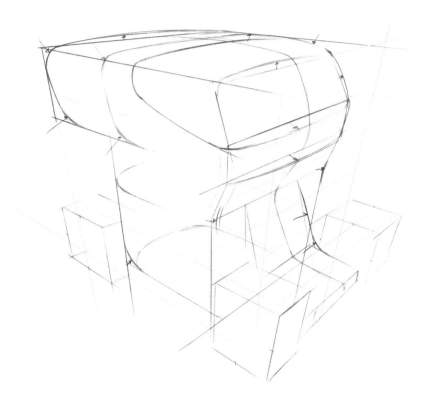

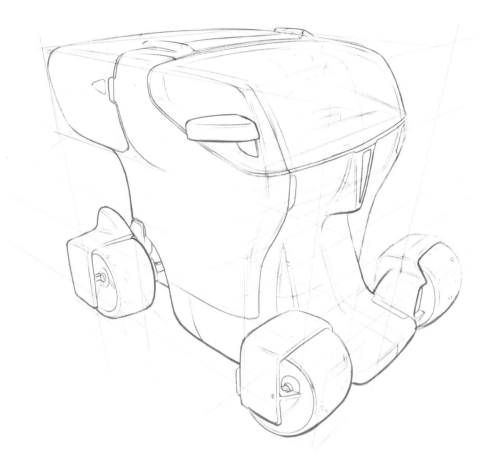

4 Begin to add volume to surfaces by "pumping up" the curved edges and adding radii. Think of this step as filling the volumes with pressurized air and sanding off corners. The amount of volume and soft feeling is subjective to the design.

5 On another layer of tracing paper, tighten and clarify the design and add detail. Small chamfered edges, like the one below the windshield, add the realism of a manufactured appearance. The angling and sweeping lines are no longer boxy and stiff, but still have perspective accuracy.

GEOMETRY, LIGHT & MATERIALS

BY JOHN A. FRYE

fryewerk.com | All images © John A. Frye

Drawing a representation of a three-dimensional object on a two-dimensional surface is all about using line and value to trick the eye and brain into seeing form. Beginner artists understand the outline of an object, but getting deeper into rendering the form and creating a believable surface that feels like it has shape takes some basic understanding of how light interacts with an object.

Once you start to take notice and observe the interaction of the environment – lights, the color of the sky and ground, the atmosphere and time of day – you will see that an object's appearance and color varies dramatically based on any changes to its surroundings. Creating a beautiful and impactful illustration takes the best-case scenario for lighting and environment and makes an object look its very best: easy to see, attractive, and with an understandable description of form and detail.

The most important aspect of the look of a design is its overall form. Using basic geometry to block in your design's shape will guide you through making strong, dynamic mass before you add detail. Working with "primitive" shapes (such as cubes and spheres) is also a good way to simplify the rendering of lighting and material, which we will touch upon later in this section.

USEFUL GEOMETRY

Vehicles and mechs should generally look like they came from a factory, with a feeling of underlying structure. Using basic geometry as a foundation for more sophisticated forms helps to make complex objects feel solid and rigid.

Getting a good handle on quickly sketching basic geometric forms will enable you to assemble a variety of designs that lead to more complicated forms. Taking primitive shapes like a cylinder or cube and modifying them – by stretching, pulling, cutting off corners, adding roundness to surfaces, and intersecting them with other objects – is a great way of creating different combinations of forms that belie their simple origins.

The overall form draws the eye if it has some interesting imbalance to the weight or size of the main components, which helps the overall appearance look as if it wants to move in a particular direction. Objects that move generally should look like they have an inherent direction. What makes it possible to immediately understand which direction a vehicle or spacecraft travels is just as much about the underlying geometry and how it is laid out proportionally as the details that go on top of the form.

The lighting basics that are studied with these primitive shapes are the same essential properties that can be used for more complex versions of the shapes.

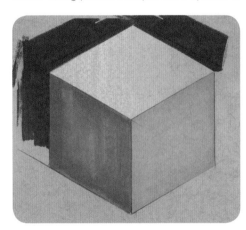

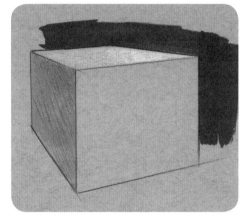

Cube

1 In this isometric view, for best legibility of form, light should be coming from a side upper angle so that all visible sides have their own value (which is how light or dark they are).

2 Adding two-point perspective and a lower eye angle to the cube increases the feeling of size. Using a lower eye level increases the scale of the subject and can be used for dramatic effect.

3 Slicing off edges is called chamfering. By chamfering the sides and extending the cube, a very static-looking cube can start to look like it has a direction of movement.

Cylinder

1 The cylinder is created by taking a circle and stretching or "extruding" it in a perpendicular direction. You will see sections of cylinders, modified somewhat, at the sides of vehicles.

2 Sketched in perspective view, cylinders' parallel edges converge toward a vanishing point. The ends are now ellipse shapes, varying in appearance from near (tight/narrow) to far (more open/rounder).

3 Taking a primitive cylinder, chamfering the edges, and adding a groove very quickly indicates that it is a functional object or product.

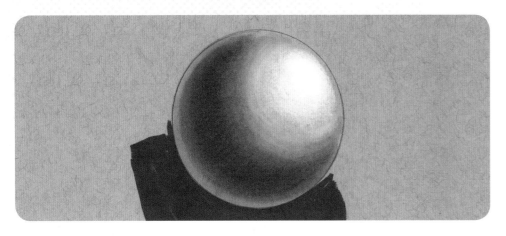

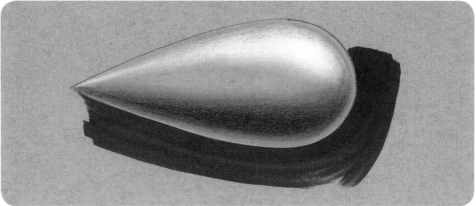

Sphere

1 A sphere, much like a cube, is very stable and static as it is perfectly evenly proportioned. In design, spheres express light and form, and are a contrast to flat, cubic surfaces.

2 Taking a sphere and resolving one end with a pointed cone gives it a feeling of direction along one axis. We can begin to mentally feel the object in motion.

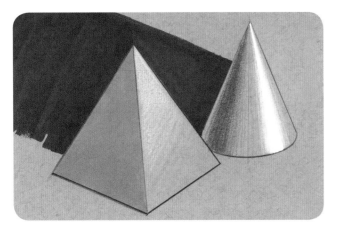

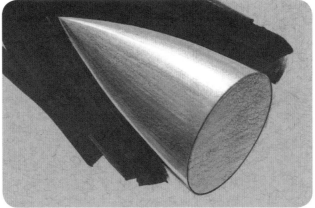

Cone or pyramid

1 The weighting of the base of a cone or pyramid can be used to stabilize a design. Sideways, it gives a feeling of movement.

2 Simple forms have a feeling of life when you add roundness (volume) to the surfaces. Rounding the sides of a cone gives it a streamlined appearance.

3 To slice off a large part of an object is called truncating. Truncating a cone gives it some imbalance, which can make it more interesting as a shape.

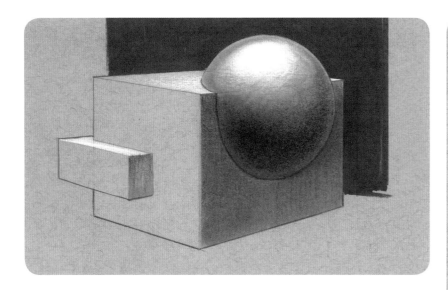

Boolean processes Intersecting two geometries to create new combinations of forms is a "Boolean process," as is commonly found in 3D modeling software.

Advanced geometry This cube has angular chamfered bottom edges, and curved radius added to the top edge, creating a striking contrasting form using very simple base geometry.

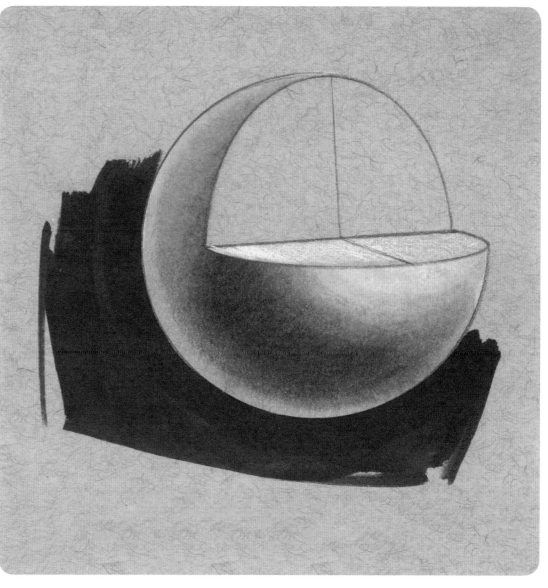

Subtracting shapes Intersecting volumes such as a cube and a sphere, and then removing the cube's intersected area from the sphere, is also a Boolean process that can start to produce interesting shapes.

BUILDING A SHIP WITH BASIC GEOMETRY

Using combinations of various geometries in perspective, then truncating them, using Boolean processes, chamfering, and adding volume is a good foundation for a vehicle design. This ship appears complex when the small details are added, but the underlying structure is made entirely from basic geometry such as the shapes we've just looked at.

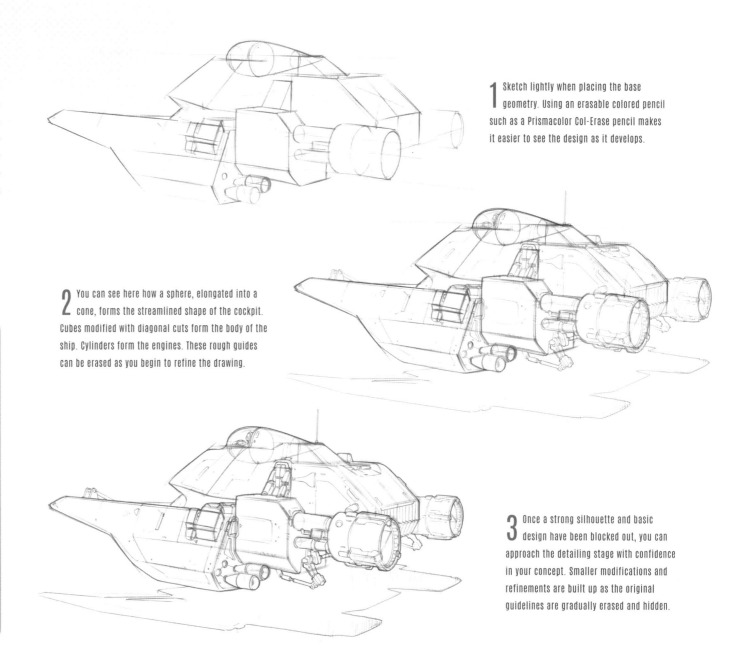

1 Sketch lightly when placing the base geometry. Using an erasable colored pencil such as a Prismacolor Col-Erase pencil makes it easier to see the design as it develops.

2 You can see here how a sphere, elongated into a cone, forms the streamlined shape of the cockpit. Cubes modified with diagonal cuts form the body of the ship. Cylinders form the engines. These rough guides can be erased as you begin to refine the drawing.

3 Once a strong silhouette and basic design have been blocked out, you can approach the detailing stage with confidence in your concept. Smaller modifications and refinements are built up as the original guidelines are gradually erased and hidden.

STUDY ICONIC MEDIA

Study some of your favorite movies or video games and observe how forms are developed. In *Star Wars: Episode IV – A New Hope*, the designs are very simple, using combinations of basic geometry, spheres, and flat planes. Simplicity is good for iconic, memorable designs.

KEEP A COLLECTION

Successful designers collect scrap for future reference. Keep an eye out for photobooks and magazines on vehicles and technology. Having a small collection of reference nearby to draw detail and design inspiration from is like being able to pull colors from a paint palette.

4 Details such as panels, moving mechanical parts, and dirt and scratches are built up with darker lines, until the underlying geometry has been fully refined into your final vision of the design.

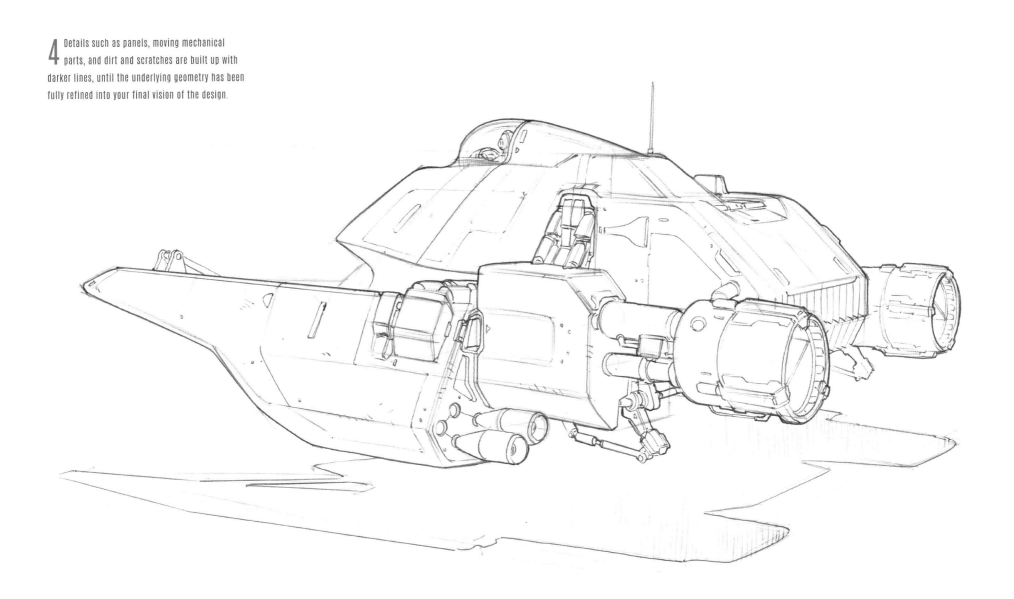

LIGHT AND SHADOW

Using value shading (lightness and darkness) to create light and shadow adds another layer of reality to a drawing and gives it a more apparent feeling of form. You can show form simply by thinking of three values: light, medium (the midtone), and dark. As you can see on page 32, a cube would show the three individual values on its different faces. When you have a rounded object, as shown here, you are still working with three main values logically, but the values are blended smoothly between them to create seamless transitions from light to dark.

A light source coming from somewhere above is a clear way to light an object, but other lighting scenarios, such as a strong light from below or from behind, can be used to add drama or mystery to a drawing. Adding shadows can be learned with observation and practice, and is well worth the effort to highlight both the form and details of your design.

You can practice lighting and shadow using simple forms, then progress to more complex surfaces and multiple shapes in one scene, studying how the lightings of shapes interact with each other, bouncing light from one surface to another, and how a shadow's shape changes as it drapes over other forms.

In terms of the drawing equipment necessary for this subtle work, you will need to use tools capable of variable values and pressures, such as a pencil and blending stump, or markers that can be layered or blended.

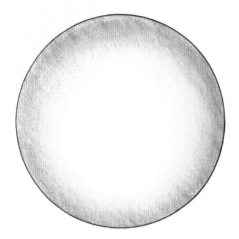

Ambient light This sphere is only lit with ambient non-directional light. When the scene has even lighting from multiple directions, no one direction being stronger than another, the sphere's values are limited, with only subtle indication of form.

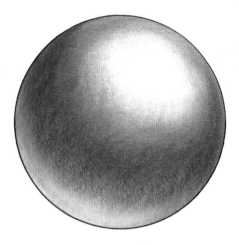

Bounced light This sphere is lit from two sources: the established directional lighting, and a bounced or secondary light. Bounced light is often softer or less intense, coming from another direction, such as the ground or a nearby surface.

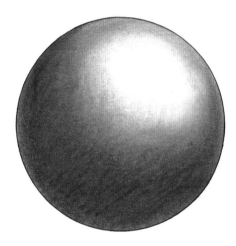

Strong light This strong directional lighting shows the sphere's form clearly, with a "hot spot" of bright value in the most directly-lit area, then darkening to the sides opposite the direction of the light source.

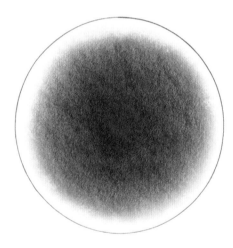

Rim light Used dramatically, often to show an aggressively approaching back-lit object, rim lighting puts the brightest values at the perimeter of an object and the darkest in the direction facing you.

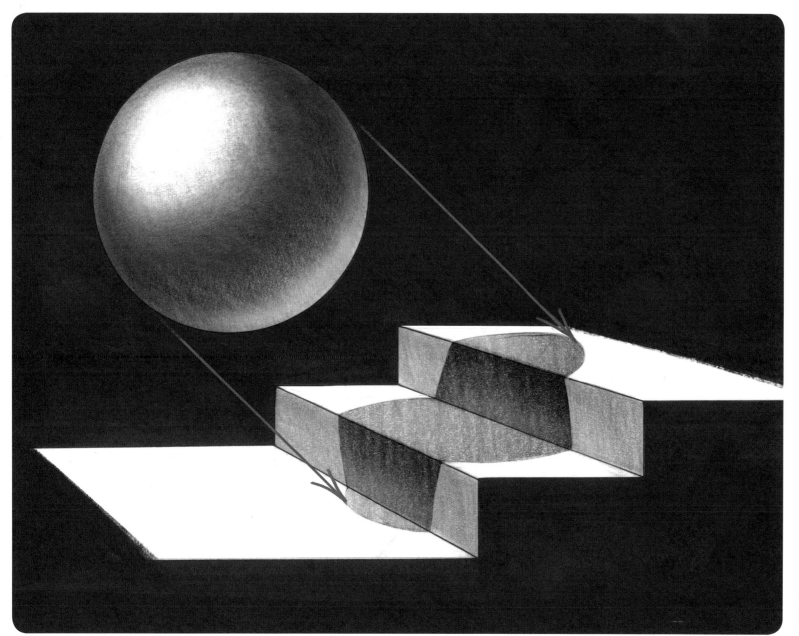

Shadow projection To "project" shadows from one object to another, consider the rays of light shielded by an object to create a silhouette of dark value on another surface. Here, a sphere projects a cylinder of shaded light rays that fall upon a surface.

STUDY FORMS

Art schools always emphasize drawing simple forms such as cubes and spheres from life with different lighting. You can do this by spray-painting a smooth ball with white, and another with chrome or silver, and then practicing observing and replicating color and light with varying environments.

WORK QUICKLY

Reflections and the subtle influence of the environment upon surfaces in your drawing can be complex, but concept sketching is about creating ideas quickly. Try to observe and develop an efficient and minimal style. For example, a simple horizon band and a glint of sun may suffice to indicate the shininess of a glossy surface.

TEXTURE AND MATERIAL

The material that makes up your design will affect the appearance of light, shadow, and reflection in your image. You can create a design that looks realistic by knowing how the material interacts with different lighting situations. Each project in this book will contain a guide to rendering that concept's surfaces, but we will look at some commonplace hard-surface materials here.

Materials are most easily portrayed in real-world lighting with the light source coming from above. Color further clarifies the material, and the material itself has its own color that interacts with the color of the environment. Typical outdoor lighting is simplest to depict, with the cool blue influence of the sky tone above, and warmer earth tones below. This effect may be subtle but helps the viewer to read the material and form easily. Studying reflections is an advanced technique, but can be used simply with great visual impact.

Use colored pencils and markers for color, but be careful not to oversaturate colors or make them look cartoonishly bright. Neutralizing colors can be done by overlapping them, e.g. example, overlapping bright blue with warm gray will desaturate the blue and make the tone more subtle and realistic. Additional hue variations in the sky can be replicated in a surface's reflections. Toward the zenith, or top of the sky, the blue becomes darker and more purple, while the sky toward the horizon becomes warmer, slightly greener, and lighter in value because of the dust and pollution in the air.

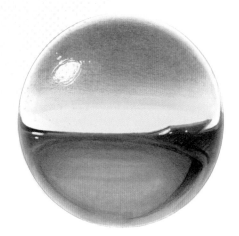

Chrome or shiny metal On a chrome sphere, the true colors and value of the environment reflect more directly and distinctly. The horizon is a sharp contrasting line dividing the reflections of the sky and ground.

Brass Different types of metals can be indicated by working in a predominant hue over the metal's reflective properties. For example, use a desaturated yellow hue for brass, or a dark grayish blue for gun-metal.

Matte or diffuse metal Showing scuffing or a finely textured metal surface can be done by creating a chrome sphere with a blurred contrast of values, and a wider, diffused hot spot. This creates a duller effect than the chrome shown above.

Weathered metal Indicate dents in metal by reflecting the sky tone on the lower parts of dents. Surface seams that run through the dents help to show form. Add dust in a red-orange color for rust streaks, and muddy up the colors to indicate dirt.

Glossy paint job Shiny painted surfaces look more reflective of the environment as they angle away from the viewer (this is called the "Fresnel effect"). The horizon picks up the same paint color but has a distinct darker value. The hot spot is tight and clear.

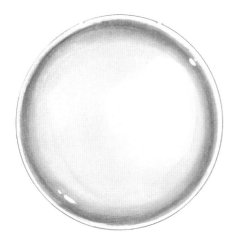

Glass A glassy lens should have a dark or light tint, which gets darker toward the edges where the material is thicker. A tight hot spot or glint of light may refract through the material.

REFLECTIVE SURFACES

For more complex reflective surfaces, think about areas of the surface and the directions they face. Like on the spheres shown to the left, the upward-facing surfaces would reflect sky tones, while downward-facing surfaces would pick up the horizon, darkening down into the ground reflection. Neighboring surfaces will reflect into each other, much like a boat on a lake.

If a surface has curvature, it will stretch the reflections. Cylinders stretch light, color and reflection in a linear direction. I often take mental note of glossy objects that I see around me as inspiration for how I will draw objects in the future.

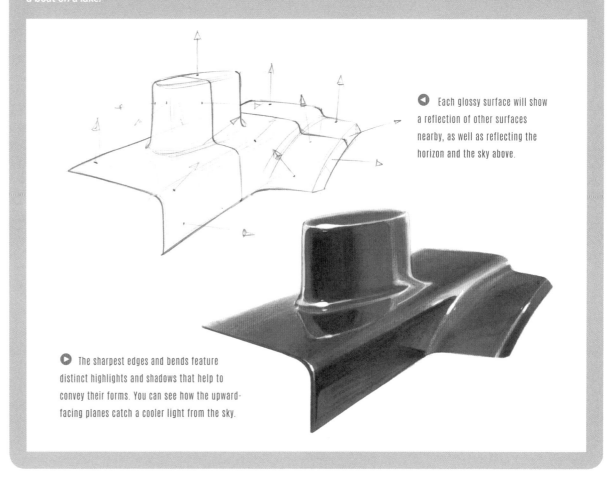

◀ Each glossy surface will show a reflection of other surfaces nearby, as well as reflecting the horizon and the sky above.

▶ The sharpest edges and bends feature distinct highlights and shadows that help to convey their forms. You can see how the upward-facing planes catch a cooler light from the sky.

CONCEPT DESIGN BASICS

BY JOHN A. FRYE

fryewerk.com | All images © John A. Frye

In this final section of our introduction, you will begin to understand how to take the tools and skills that were outlined previously and merge them with a logical creative flow.

In a concept designer's role, design is not simply drawing for your own pleasure, but focusing your creative vision to satisfy many parties. When given a task to create a design, you immediately need to be thinking about who you are designing for: your customers. These may be a design director, the creative team, and the consumer watching the movie or playing the video game.

Keeping your customers in mind is the key to success, as is research into the area of design you are working in. What is the universe you are designing in? Who are the characters and what are their personalities and styles? These are all checkpoints with which to be self-critical of your work throughout the design's development. If the design is not suited for the character or the character's universe, or doesn't make your end customers inspired and engaged, then you need to continue to develop your design.

Being realistic and self-critical about the design throughout the sketch phase steps will help you to narrow your focus and reach the best solution more quickly.

PROCESS

- Research your subject
- Explore potential ideas with thumbnails
- Create rough sketches in perspective to solidify the best ideas
- Narrow down your final direction
- Prepare the sketches and layout for the final design
- Make a clean final line drawing
- Add dark values with markers
- Finish the image by adding lighter values and a background

RESEARCH

Before concept sketching, start to gather reference materials. Work to build up a comprehensive library of photo books on vehicles, robots, and technologies. Photo collection websites like Pinterest are a fantastic resource for digital image scrap-collecting. Whenever possible, visit museums and the street to photograph your own reference and see things in reality. Start to build up a mental database of designs and details by sketching from reference. Be analytical and ask why things look the way they do. What are the functional parts and how do things work? A good general understanding will inject realism into even the most fantastic designs.

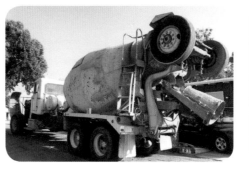
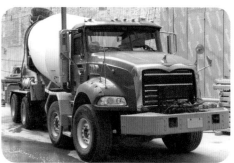

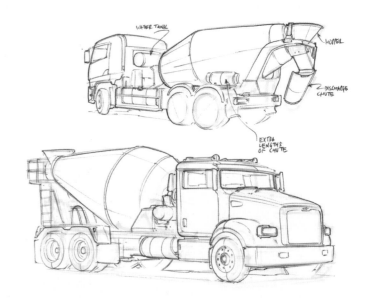

Photo studies Given the general assignment of designing a futuristic cement truck, I start building up some working knowledge by sketching out contemporary vehicles from my reference scrap.

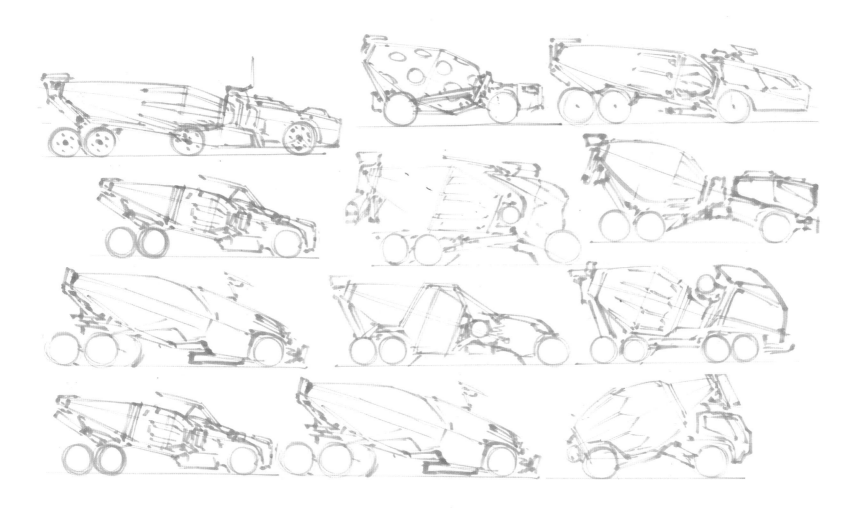

THUMBNAILS

Working in profile, you can concentrate on the design's volumes and outline, thinking about how light and background flow around the shape.

Massing and volume is essential to the visual impact of any great design. Combinations of forms and shapes that are completely balanced can lack a feeling of movement. If there is some heaviness in one area with large forms, then lightness in another with thin, lithe shapes, you can create an imbalance that feels like it wants to move into balance, which creates a feeling of motion. Taking something familiar and dramatically changing these proportions can create newness.

ROUGH SKETCHES IN PERSPECTIVE

In the early stages of design development, you need to start thinking about the design in three dimensions. As most concepts will be enjoyed by your customer from many views, beginning to draw the forms in perspective will start to address the design on all sides. Consider masses and volumes that were successful from the previous step and rotate them on the page, considering depth, height, and length. When you modify these proportions, do the changes make things more sporty, more tough, more futuristic? Be critical of what works for the design direction and what does not.

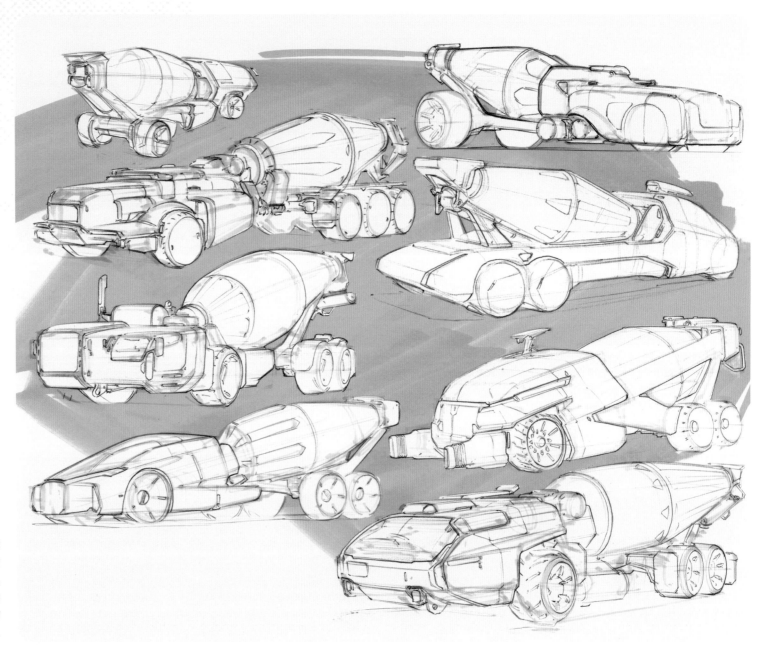

Add perspective Be aware of silhouette by using a broad marker to highlight outlines. Work quickly, but thoughtfully. This is a balancing act of speed and a distinct variety of design possibilities.

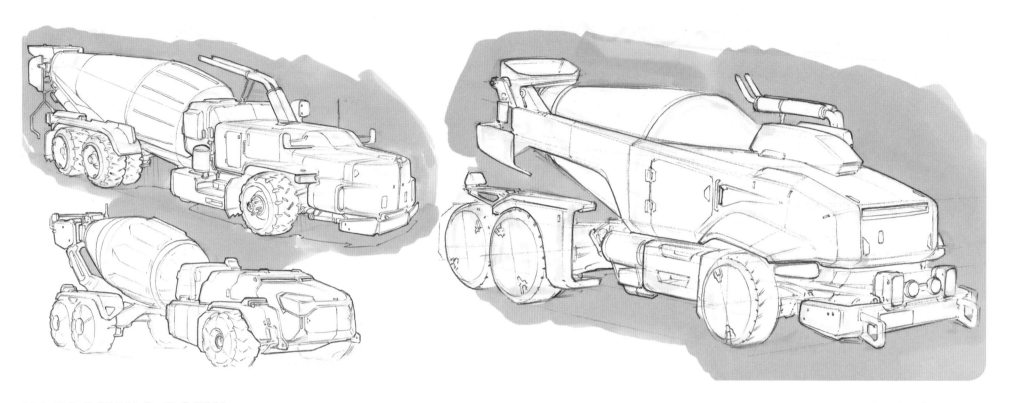

NARROWING DOWN DIRECTIONS

Throughout the sketching process, communicate the design directions with your team, or have a critical overview of your own work, again thinking of the customer, the universe, the character, and – very importantly – the overall impact of your design. Does it look cool? Is it fresh? The next round of sketches eliminates the directions that are not successful, and more carefully starts to redraw elements of previous sketches with attention to detail. Think about how characters would interact with the vehicle as a guide for adding logical functional details such as steps, doors, lights, guards, and access panels that enhance realism.

Choose the final direction Sketches at this stage may be close to the final design, so consider surface shape and small details. Distinctive silhouettes are still paramount, so use a bright background to clarify them.

USING A GRID

A tracing paper grid over the key sketch is used to locate lines and points on a double- or triple-scale grid on toned paper for the final illustration.

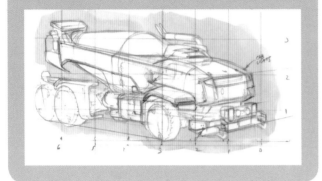

FINAL ILLUSTRATION PREP

Once you are satisfied with a direction, you can bring it to a finished presentation level. Rough sketches are good for communicating with a small team, but for working to bring a concept to reality, such as with a 3D modeler, a small sketch is too rough and vague. Careful rendering of shape and detail with a drawing is necessary to avoid miscommunication of your design's intent. If a small sketch has the gesture and character you like, draw a grid to help retain the essence of the proportion when creating the larger version on a larger grid.

FINAL LINE DRAWING

One of the most challenging things to do when creating a careful illustration is to keep the energy and excitement of a small sketch and translate the loosely indicated detail to a more defined drawing. When drawing on a larger scale, with finer linework, you may be tempted to add detail where space is empty. You need to be confident in the original sketch and retain the essential detail layout and gesture. Don't overuse a straightedge or ruler, as they can create a stiff drawing with a lack of volume and sensitivity.

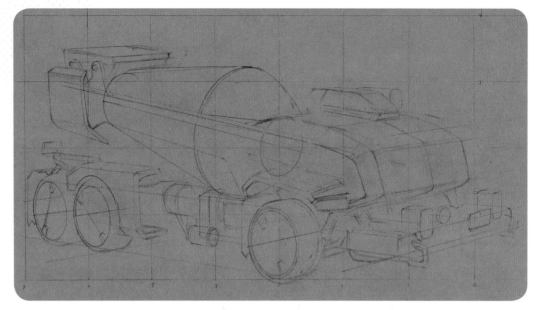

Prep for the final Here is the base pencil sketch transferred to a sheet of toned paper, at its final scale, based on the small gridded sketch to the left.

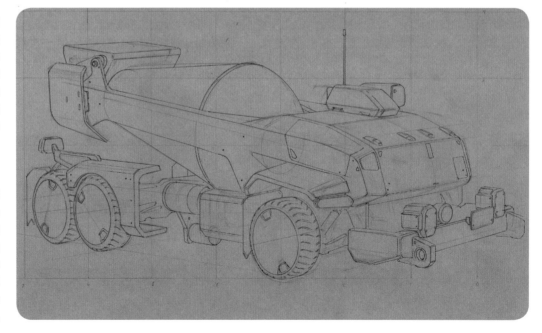

Draw the final details While the surfacing is simple and geometric, interest can be added with strong angular movement like the horizontal beam, and asymmetrical elements like the sensor pods on the cab.

When creating planar surfacing, incorporate some radii and fillets (rounded corners or edges) where the surfaces break or bend, instead of cold, sharp edges.

MARKER VALUE

When beginning to apply value, it is important to clearly communicate shape. Lighting the design with standard highlighting from over one shoulder will illuminate a boxy form so that the front, side, and top have different essential values, clearly defining the form. Sometimes it is useful to create a small value study beforehand, to make sure the surfaces read clearly and the form is obvious. By blocking in the main values with a range of gray markers on toned paper, you are setting up the image from the medium or midtone value (the paper color) to the darkest value (black marker).

LIGHT VALUE AND BACKGROUND

Finishing an illustration is often accomplished with highlights and bright detail. Using bright values against dark values attracts the eye. When creating an image, an area where the detail, value contrast, and design interest come together is called a focal point. To help a drawing feel more three-dimensional, bringing the nearest corner of a vehicle forward to the viewer using a strong focal point gives the image depth. Lower contrast, with less use of white and black, pushes the surfaces away from the viewer, such as toward the back of the vehicle. Don't overuse white or the drawing will start to feel flat and overworked.

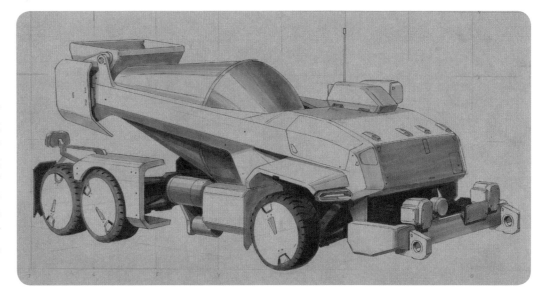

Midtones and shadows Remember that if you are using toned paper, markers can only get darker, so values added will be from medium lighting to dark shadow. Tire rubber provides a strong contrast against the body surface.

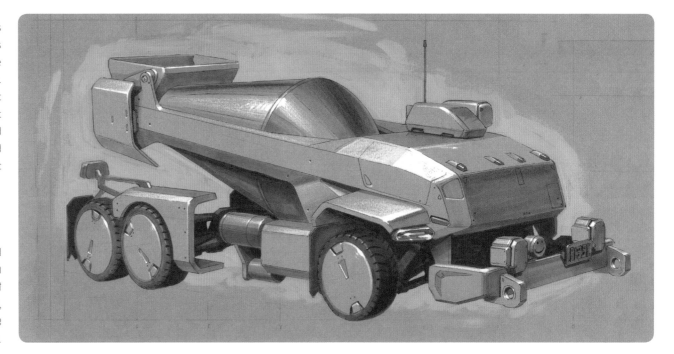

Final presentation White pencil and white gouache form the highlights, such as the strong white reflected light off of an angled panel against a dark wheel well, pulling attention and creating dimension. Blue gouache accentuates the playful silhouette.

PROJECTS

· ·

Now you should be primed to tackle this book's main tutorial projects. In the following chapters, join a range of talented concept artists as they develop eight different sci-fi subjects from rough doodles to a final colored image. Each project begins with all-important research into real-life references, which helps to make a concept more believable, before the artist branches out into exploring their own fictional creations. The design will be built up from simple geometry, as covered in the Getting Started chapter, and gradually refined into a line drawing that's ready to be colored. There will then be a quick breakdown of two important surface materials which comprise the design, so you can practice your texture-rendering skills before diving into coloring the whole piece. Finally, each artist will guide you through filling out the colors and final touches, resulting in a polished, well-presented final concept.

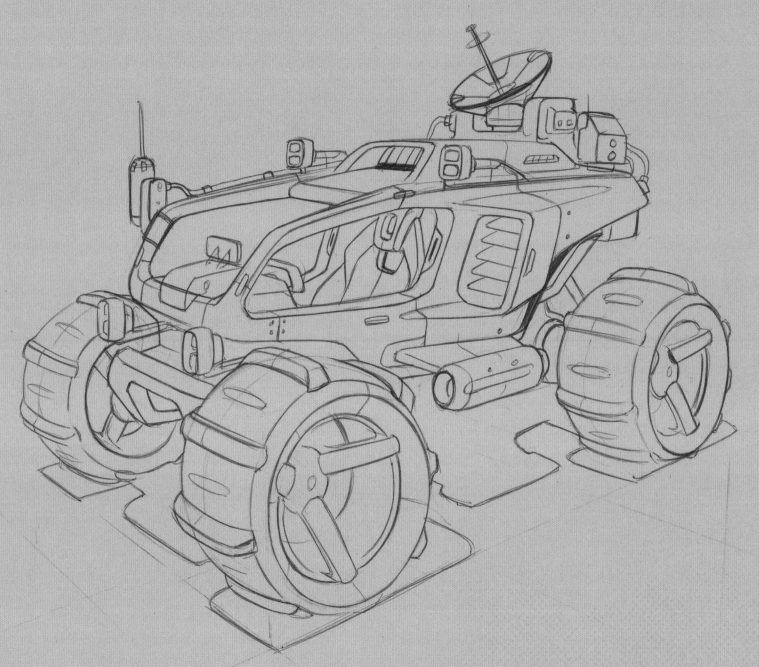

COMBAT SPACESHIP

BY LORIN WOOD

lwoodesign.com | All images © Lorin Wood

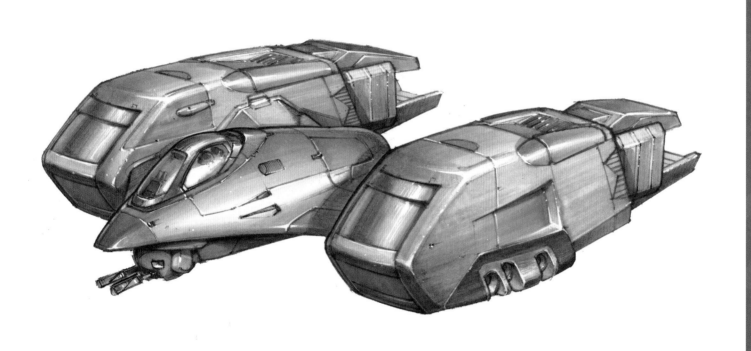

Over the next few pages, concept designer Lorin Wood breaks down the process of creating a sleek combat craft. Drawing inspiration from real-life fighter planes will give the design believability, while large engines will add a powerful futuristic edge. A simple two-point perspective view will give a clear overview of the ship's features, and gray markers will be used to capture its brushed metal surface.

TOOLBOX
- Ballpoint pen (or pencil)
- Cool gray markers – Copic C1, C3, C5 and C7 (or other markers in 10, 30, 50 and 70% gray)
- White paint marker, white-out, or white gouache
- Black marker (optional)
- Ruler

RESEARCH

When it comes to designing for science fiction, the best resource is always going to be reality. For this design I want to focus on some contemporary fighter planes for reference, specifically experimental aircraft. In these types of craft, while the engineers have limitations to what they can create, the forms are often pushed to the limits of the familiar. I also include some older retro-experimental aircraft with shapes that can easily be identified at a quick glance. This will ground the design and bring a logic to the craft: where the pilot sits, which direction it moves, where the exhaust comes out, and so on. I also want to research some small and interesting details, even if they don't get used, as they'll sit in the back of my mind and help to inform the shapes as I create the design.

I want to stress the importance of *the idea*. It is always good practice to develop a simple narrative or scenario before the drawing starts, to give it purpose. Why does this thing exist? That question will dictate the visual function and aesthetic of the design (such as textures or wear and tear). The tools are secondary; they always will be.

Drone exhaust I like this drone exhaust detail because it is embedded into the fuselage of the plane as part of its stealth design. I am also a fan of the simplistic X-15 rocket plane exhaust and angular "wedge" tail fin.

Supersonic bomber In contrast to the X-32, one of my favorite planes from the 1960s is the XB-70 Valkyrie, a huge experimental supersonic bomber concept. The timeless "classic" retro shapes appeal to me. One look at the long, slender neck and wedged features, and instantly the plane reads as "fast." The monster engine housing holding the six engines is the specific detail I want to utilize from this plane.

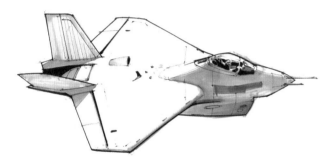

VTOL (vertical take-off and landing) I am thinking of a stout ship for my final design. The X-32 was an experimental VTOL (vertical take-off and landing) fighter plane that was being designed for multiple branches of the military. I want to implement some of these exaggerated shapes into my spaceship.

Space shuttle As my design would operate in orbit, I think some obvious details from this space shuttle are in order. At a distance, the shuttle appears simple, but upon closer inspection, it is actually covered with scale-like heat-shielding pads that break up the overall hull. To help it manoeuvre in the vacuum of space, there are embedded vectoring rockets in the nose that are very interesting details.

Bomber turrets There will be a weapons turret on the final design somewhere. I look initially at World War II bomber turrets, but find them to be too utilitarian to pass for sci-fi. Fortunately, drones and science aircraft have them in spades. I look at smaller drone turret shapes and details, which can all easily pass for a spacecraft weapon of some sort.

Vectoring flaps The F-22 and X-Plane vectoring flaps will add functional movement to my design. The toothy exhaust of the F-22 is visually striking, as are the brick-like X-Plane flaps.

FLAT THUMBNAILS

It is good to churn out as much variation as possible to explore all proportion options before settling on a single design. As the ship does not exist in reality, this should free up your imagination. Keep your research sketches in mind, but do not be a slave to those designs. Since this craft will operate primarily in space, there is no need to worry about aerodynamics, but I still add a relatively sleek look to the first few thumbnails. At this stage, my sketches are loose, exploring shapes with relatively little fine detail. There is no elaborate rendering at this stage, so you can use a ballpoint pen (or pencil) to draw these. I use a ballpoint pen and a touch of gray marker.

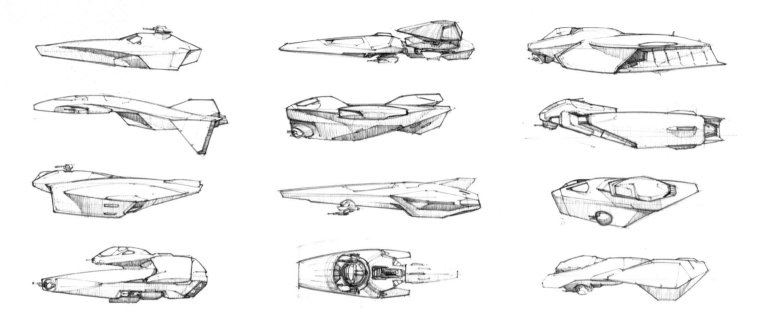

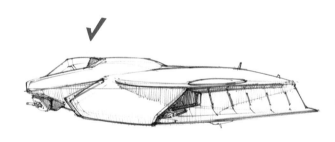

Accessible realism This design has a couple of features that will really sell it as fantastical while still maintaining an accessible realism. The engines being separate from the fuselage is a composition used on some World War II fighter planes, so the design has a base in reality, as I wanted. Minor alterations to the exhaust will take this design from mundane to science fiction. The nose turret was not just used on fighters and bombers during the war, but is used on modern-day drones as well.

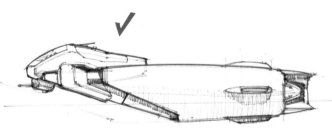

Extreme and minimalist This one is a more extreme and minimalist version of the previous thumbnail. I envision much larger and longer engines than the previous, thus making the cockpit a minor element to the overall design. What I want with these two thumbnails is a "fast read" - the viewer can identify this craft in a matter of seconds and understand its function, as with modern-day planes.

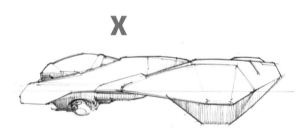

Over-complication Here I've gone too far into the "nonsense realm" that science fiction artists tend to fall into quite often. As a designer, I always try to find a shape language that is not only familiar to the real world, but simply "feels right." This thumbnail shows me arbitrarily making overly complicated forms for the sake of making them - science fiction for the sake of science fiction. A good design rule of thumb is "less is more."

PERSPECTIVE THUMBNAILS

Taking the two thumbnails from the previous section, I draw some variations of these designs in a two-point perspective view to establish the proportions. This is an important step as we rarely, if ever, see anything as a flat profile. Perspective fleshes out a design and helps the designer and viewer to understand the dimensions of the vehicle by providing more information.

Like the previous thumbnails, I keep these sketches simple. I am still focusing on the shapes, while loosely incorporating some of the design language and elements from my research sketches. I recommend roughing out the basic proportions with light cool gray markers (10% to 30% gray), then adding details with ballpoint pen.

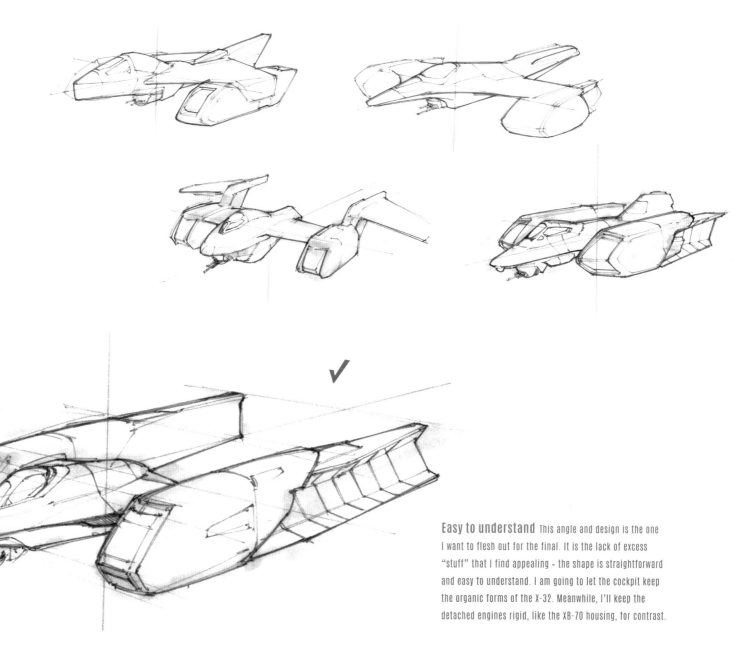

Easy to understand This angle and design is the one I want to flesh out for the final. It is the lack of excess "stuff" that I find appealing - the shape is straightforward and easy to understand. I am going to let the cockpit keep the organic forms of the X-32. Meanwhile, I'll keep the detached engines rigid, like the XB-70 housing, for contrast.

BASIC SHAPES

For the final design, I begin by laying down a basic grid of perspective lines in pencil to help to keep the general proportions and angles relatively accurate and symmetrical. The grid includes center lines for the main body of the ship, and two for the front and rear for reference. Notice the vertical lines angle inward as the "camera" perspective is higher than the ship, and so all vertical lines should adhere to these. As this is only going to be a presentation of the design of the vehicle itself (as opposed to a fully rendered scene in an environment) this three-quarter angle will suffice.

1 A simple three-quarter view ensures that all the key details will be visible. Draw a central line with some intersections to indicate the front, middle, and end of the ship.

2 Use a ruler to help roughly establish the base geometry of the ship. It is always best to reduce a complex form down to its most rudimentary shapes (e.g. cones, cylinders, cubes, or spheres). The most fundamental shapes for this ship are three elongated cubes.

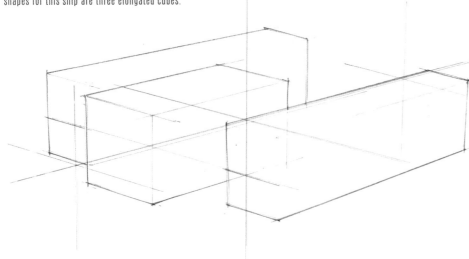

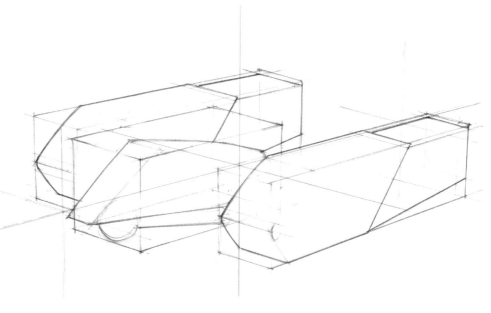

3 Begin to "carve out" the more refined shapes of the ship. The engines and cockpit module are going to be more aerodynamic, so cut some swept-back angles for the fronts of those. The exhaust cowling, just over halfway down the rear of each engine, is angled backwards. It's possible to approximate that these details will be symmetrical by measuring them against the perspective guides. Loosely rough in a sphere near the nose for the base of the weapon turret.

4 Begin refining the rigid shapes by adding some gentle angles to
the engine pods and fuselage/cockpit module. Cut in the shape
of the exhaust, and add soft corners (chamfering) to the edges of the
engines by drawing smaller concentric lines. Make sure to keep the lines
relatively light in case anything needs to be erased. On the cockpit, I
add a pseudo-wing to connect it to the engine and make the shape more
streamlined - from this angle you only see the foreground wing-edge.

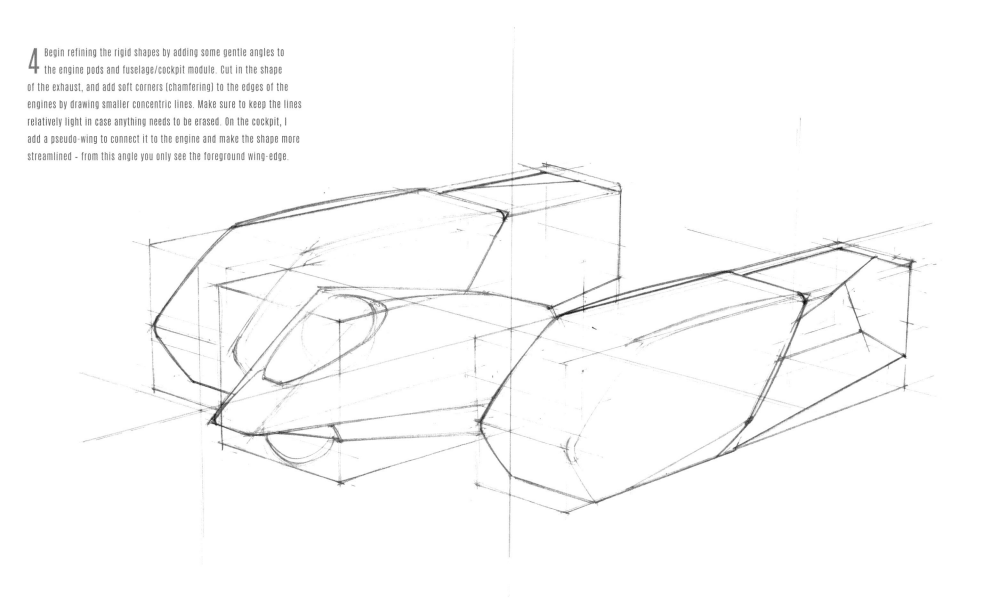

DETAILS

This series of steps will clean up the previous sketch, further refining the shapes and adding finishing details to the ship. I will also be adding specific details that were captured in the research steps, which will add some realism to the final design. Remember to continue to keep your lines fairly light throughout the following steps in case you need to make corrections, as we will begin to add more compound and complex forms to make the ship sleek and appealing.

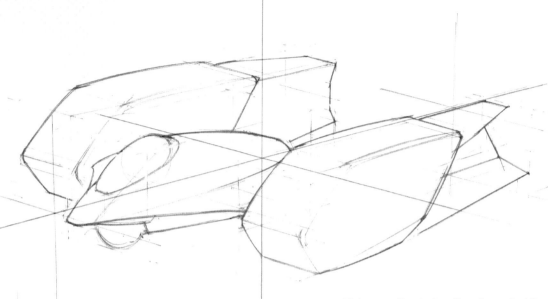

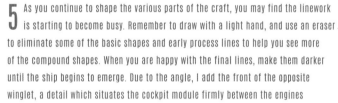

5 As you continue to shape the various parts of the craft, you may find the linework is starting to become busy. Remember to draw with a light hand, and use an eraser to eliminate some of the basic shapes and early process lines to help you see more of the compound shapes. When you are happy with the final lines, make them darker until the ship begins to emerge. Due to the angle, I add the front of the opposite winglet, a detail which situates the cockpit module firmly between the engines

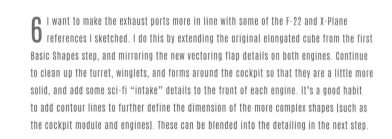

6 I want to make the exhaust ports more in line with some of the F-22 and X-Plane references I sketched. I do this by extending the original elongated cube from the first Basic Shapes step, and mirroring the new vectoring flap details on both engines. Continue to clean up the turret, winglets, and forms around the cockpit so that they are a little more solid, and add some sci-fi "intake" details to the front of each engine. It's a good habit to add contour lines to further define the dimension of the more complex shapes (such as the cockpit module and engines). These can be blended into the detailing in the next step.

7 Continue adding details as you see fit, to break up the large and empty shapes and ensure that the overall ship is more visually interesting. For example, I have added the space shuttle manoeuvering rockets (from my research) to the sides of the engine pods.

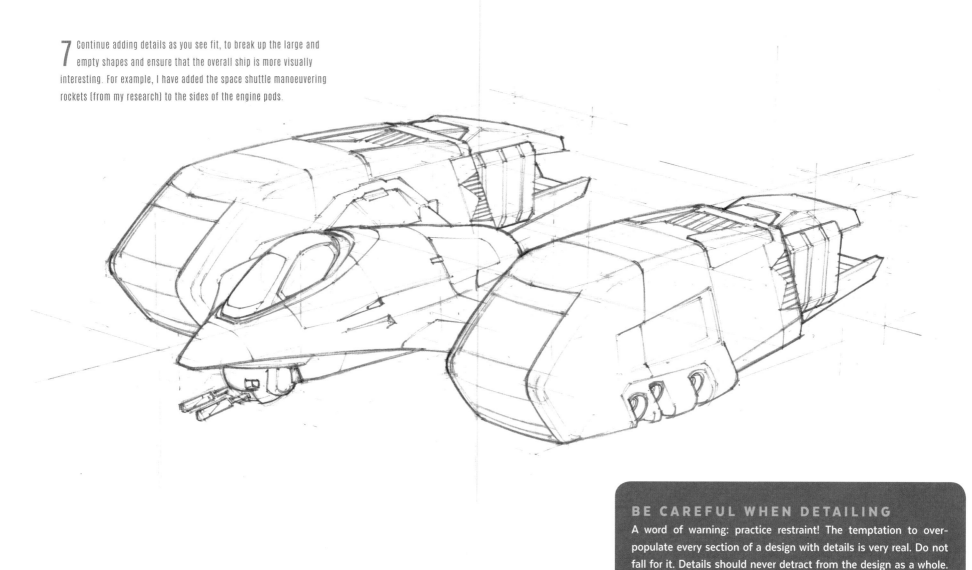

BE CAREFUL WHEN DETAILING
A word of warning: practice restraint! The temptation to over-populate every section of a design with details is very real. Do not fall for it. Details should never detract from the design as a whole. Ideally, every part of the design should work in unison.

FINAL LINE DRAWING

Once I have added enough detail to the final, I begin to erase any excess guidelines and rough sketching. At this point, be aware of the importance of lineweight to help to convey separate shapes and important details that you want to stand out. For example, notice the slightly darker outline around most of the foreground engine and the cockpit module. This provides a quick "read" of the shapes, so that they do not blend together, and helps to make the major details pop out as focal points.

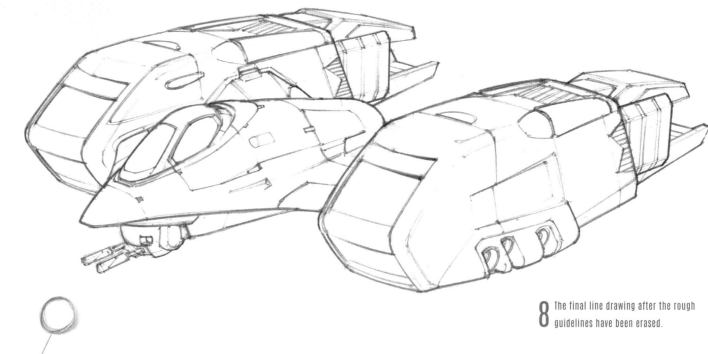

8 The final line drawing after the rough guidelines have been erased.

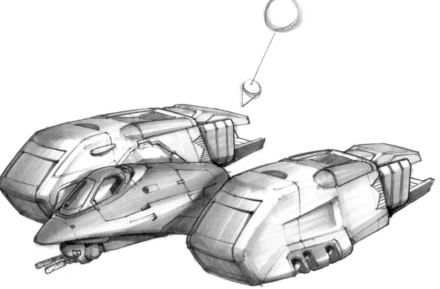

9 A good idea at this point is to either scan your final drawing and print a copy, or make multiple photocopies to render on. Before committing to any final rendering, it is vital to figure out how the ship will be lit. I choose a "beauty pass" with the primary light source coming from just behind the viewer's head (if we were standing in the same space as this craft, from this height, with the sun behind us). I want the ship to be fully illuminated. Again, the focus is on the ship, not an environment or scenario, so we can feel free to shine as much light as we need on it.

MATERIALS: BRUSHED METAL & GLASS

Brushed metal

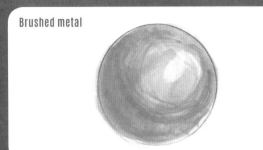

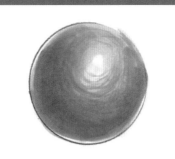

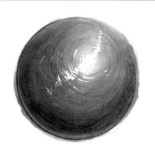

A Create a base tone with a 30% cool gray marker. This base should be neutral and even, so that you can build up highlights or shadows easily in subsequent steps. Since this type of metal is not highly reflective, it will only reflect bright highlights and dark shadows without the detail. Make several passes with this marker tone so that there is a build-up around the lower-left side, imagining that the light is coming from the top-right.

B Take a 50% cool gray marker and "wrap" it around the lower-left of the sphere to add some shadow to the metal. Do this with several passes, so that the marker blends smoothly. Make lighter, sporadic circular motions on the lightest area to simulate the brightest spot on the sphere. These circular touches will add the brushed metal texture. You can go back over this step with the 30% marker to add more subtle circular strokes as well.

C Use a 70% cool gray marker to create a crescent rim of shadow in the areas farthest from the light. With a white pencil, start at the brightest spot on the sphere and make circular motions outward, getting lighter the farther out you go. Take a paint pen, white-out, or white gouache, and create an intense white hotspot. Note how the light is diffused into flecks that follow the brushed surface of the sphere.

Glass

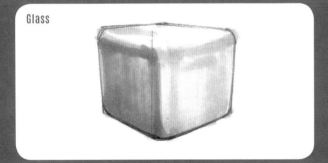

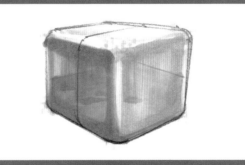

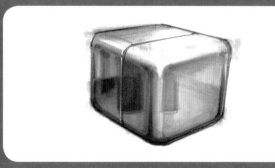

A As with the brushed metal, we start this glass cube with a neutral tone of 30% gray, but do not fill in the entire cube. We'll create what's called a "1-2-3 read." This helps define an object's form by lighting three sides in three different values. Intuitively, we perceive light coming from above (sunlight), so the top of the cube will be the lightest value. One side will be darker and the third side will be a value in-between.

B Glass on cockpit windows or cars has a darker tint, so the interior contents essentially become silhouettes. At this stage, sketch in some flat, perpendicular reflections on two of the sides (as if the cube is sitting on the corner of a table, reflecting two of the table edges). Shade the lower sections in, but not too dark. Use a 50% gray marker on the darkest side of the cube. To understand how the reflection will wrap around, add a central contour line.

C Add some random shapes inside the cube to suggest transparency. Go over the *reflected section only* with a 70% gray marker, on the darkest side of the cube. Within that section, go over the interior forms so they pop. A dark outline around the base suggests the "table" shadow visible through the glass. Use white to add a hotspot on the facing corner and extend the hotspot slightly across the three facing edges.

RENDERING PROCESS

Now we can make a start on rendering the final
design. I will be using a range of four gray Copic
markers (swatched to the right), with a white paint
pen for picking out the final highlights. You can
use an optional black marker to add a geometric
backdrop to the scene, to make the design pop
and provide a very simple environment.

10 Use the lightest gray marker to create the base tone. Lightly block in
the slightly darker areas of shadow, such as the shadow cast by the
foreground engine, to establish the lighting setup we planned earlier.

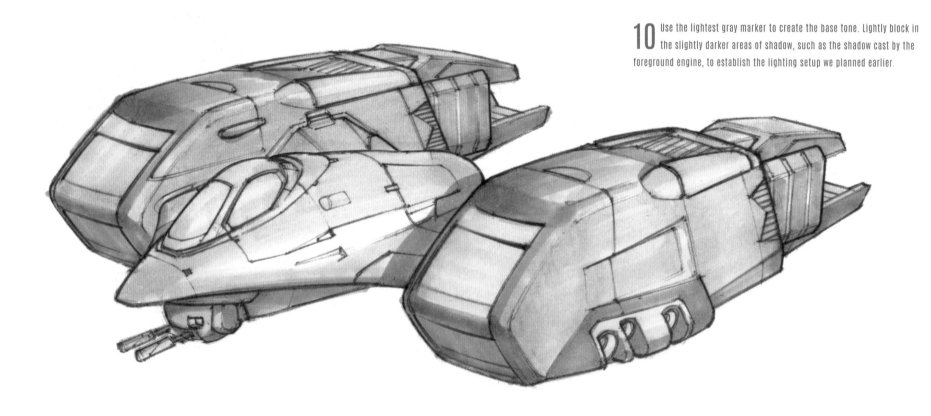

11 Now use the full range of four gray markers to build up more depth. Reserve the darkest gray for the deepest shadows and limited details such as the engine fuselage. Note how the highlight on the side of the cockpit is kept bright to convey its streamlined shape.

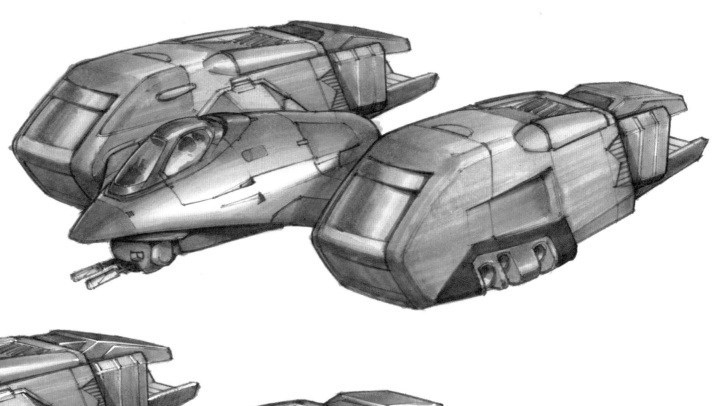

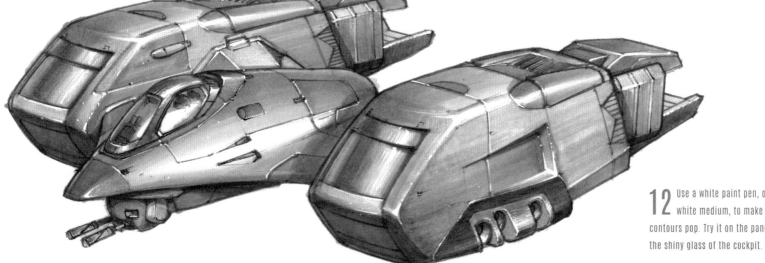

12 Use a white paint pen, or another opaque white medium, to make the surfaces and contours pop. Try it on the panels, grooves, and the shiny glass of the cockpit.

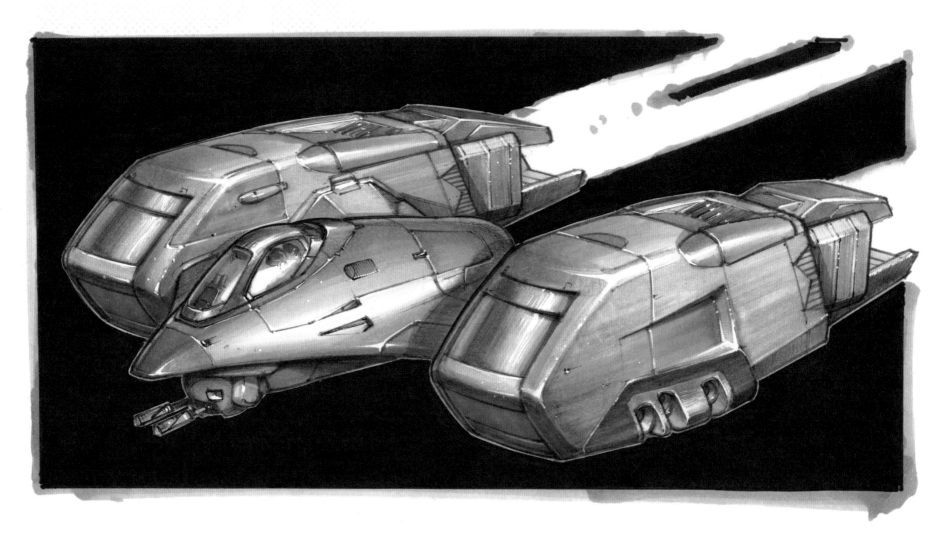

13 To add some action and context, and to make the design stand out, you can use black and gray markers to block out a simple backdrop.

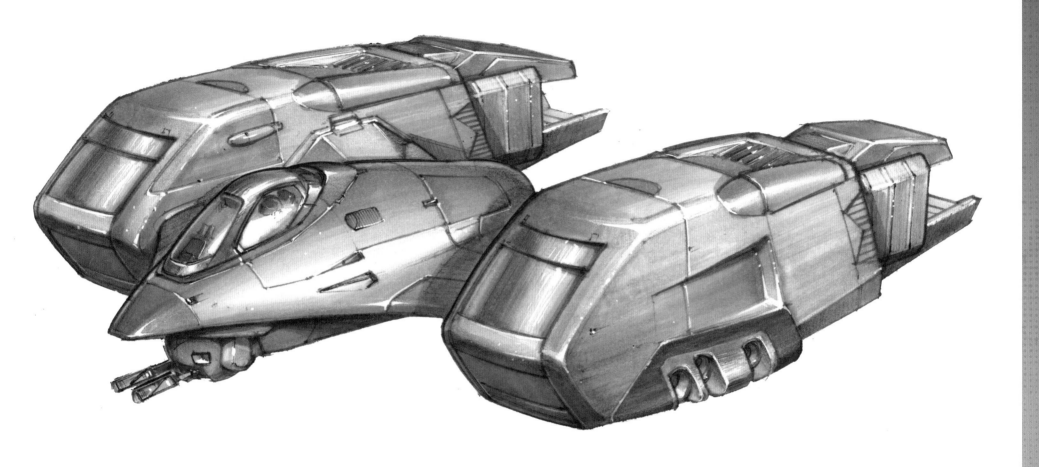

CONCLUSION

There are invaluable steps used here that I hope you will find helpful as you continue your journey of learning the craft of design. As I mentioned earlier, research is key. This is a critical part of good design as you want your final product to be both fresh and new, but remain familiar enough that your audience will easily understand its function.

Do not be afraid to make alterations as the design evolves. I feel this ship is successful and I am pleased with the final result, despite some minor changes made along the way, but remember that there is always room for improvement. A healthy mindset is to always be learning and trying new techniques and methods. Try new things, practice, and have fun. Now, on to the next design!

LUNAR ROVING BUGGY

BY MILEN IVANOV

milenskyy.artstation.com | All images © Milen Ivanov

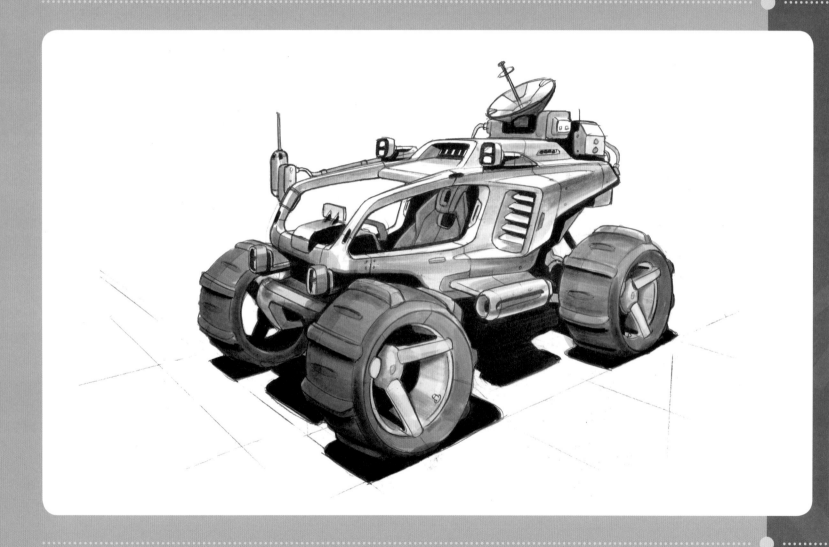

In this tutorial, 2D and 3D concept designer Milen Ivanov will be creating a buggy inspired by real-life lunar exploration equipment. Light gray marker will create the main body color, giving the impression of clean, bright metal, while a subtle three-point perspective angled from above will help to enhance the design's huge rugged tires and peripheral gadgets.

TOOLBOX

- Black ballpoint pen
- 2B pencil
- Titanium white pastel
- Water-based brush markers:
 - black
 - light gray
 - medium gray
 - dark gray
 - orange

RESEARCH

Before starting any actual sketching, it is important to make yourself aware of how other people have approached this subject. In this case, I decide to look through a few different research topics: vehicles, space-related facilities, and astronautical equipment.

Drawing these research subjects helps me to understand their design language and how they are made. When I have acquainted myself with a few different design languages (mechanical, aerodynamic, and practical), I can then apply them to my own project, combining the new knowledge acquired from my references with my own personal design style.

UTV (utility task vehicle) Smaller than a buggy, the UTV can pass through narrow and bumpy terrain more easily. The whole chassis is coated with protective metal plates to prevent damage from beneath. It has lightweight, wide tires so it can move freely on deep sand.

Buggy tires I focus my attention on the suspension, clearance, and tread of these tires. The deep fenders allow this buggy to move along extremely bumpy, rocky terrain without the tires ever touching the body. There is also a roller attached to the body, and large shock absorbers to ensure a smooth ride on any surface.

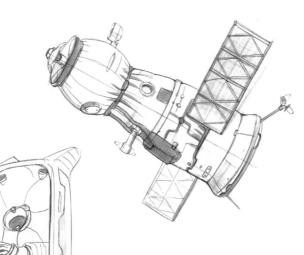

Satellite Interesting materials such as fireproof fabric, super-light metal, and ceramic are present. The solar panels have a special construction which allows them to unfold and extend. There are also multiple detectors directly attached to the main body for weight reduction.

Moon lander This consists of many complex pieces. This reference shows how I could easily combine oval and cubic shapes, which would be very beneficial for the design I want to create. This particular design is more practical than it is good-looking.

Astronaut's backpack This shows a lot of components in a confined space. There is an oxygen canister, many tubes of different sizes, ventilation system, and many more items. The backpack itself is made of very strong and durable cloth. All of these details would match perfectly with our sci-fi lunar buggy theme.

Antenna Mounted on top to send and receive data effectively, the antenna should be able to turn 360 degrees so it can scan a larger area. Many of its hardware components and cables could be housed in protective compartments around it.

FLAT THUMBNAILS

A small lunar buggy needs to be as light as possible, so it appears easy to transport and navigate. I intend to put only four wheels on my design. My intention is for the buggy to look attractive, sporty, and elegant, yet its large wheels should imply some serious off-road capabilities.

The materials I use for this thumbnailing stage are water-based brush pens in light gray and dark gray. I use these because they enable me to easily draw lines with a wide variety of thicknesses, and to build up multiple layers of shading with the same brush pen.

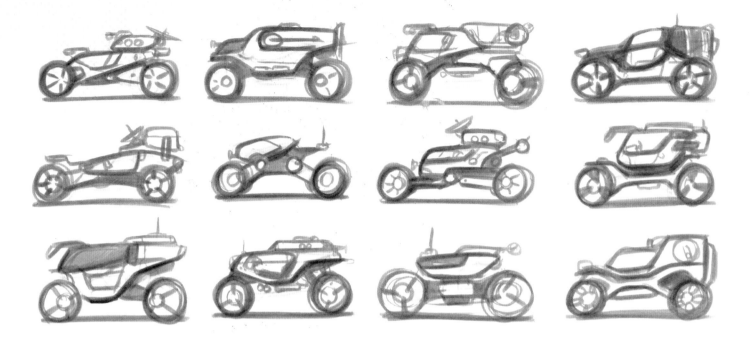

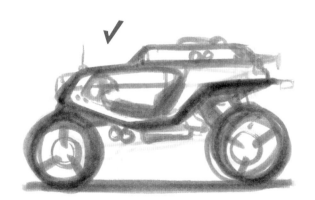

Well-balanced ideas This sketch is my choice for the strongest thumbnail. It seems to be the best in terms of proportion, while also successfully combining a sci-fi feel with the look of a real-life buggy.

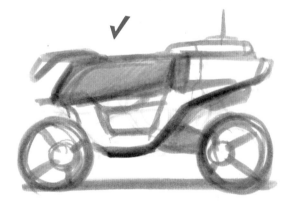

Spacious design This vehicle's larger size offers more space for equipment. It departs somewhat from the open-framed buggy look, appearing a bit like a small truck, but is still a strong design.

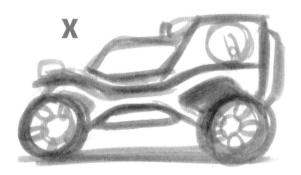

Wrong impression In my opinion, this idea is the weakest. The proportions resemble a car, which is too far removed from the idea of a lunar buggy. It looks more like a wagon or a delivery truck.

PERSPECTIVE THUMBNAILS

Once I have chosen the strongest silhouette, I start to rough out the proportions by exploring the thumbnail idea in three-dimensional angles. It is useful to create a few sketches with varying perspectives, as they offer a chance to generate more ideas for the design.

Continue using two markers for this stage: one light gray and one dark gray. The first marker is used for making a light sketch, defining the perspective and the correct silhouette. The second marker is used for emphasizing the shapes and defining large, recognizable details.

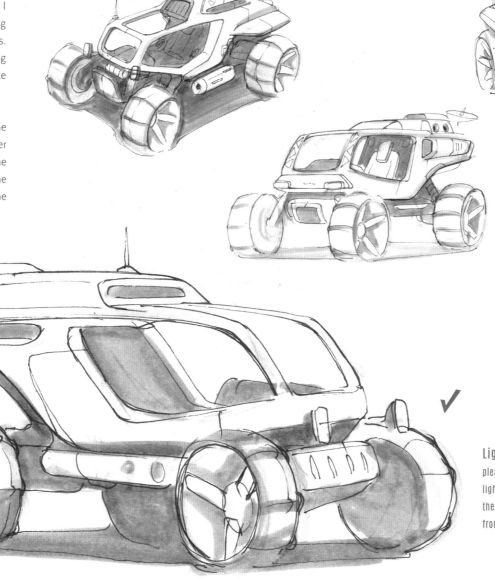

Light and simple My aim is to find a design that pleases the eye the most. I decide on this one because it's light and simple. However, you shouldn't completely exclude the rest of your ideas; you can still extract the best qualities from all of them, and apply those to the final version.

BASIC SHAPES

When building up the basic shapes, it is essential to carefully consider the position of the design. The tools I use for this stage are a simple 2B pencil and a ruler. I recommend choosing a viewpoint that allows the most information to be on display: for example, an angle with the front, top, and side of the design visible. In order to emphasize a design's impact on the viewer, you can strengthen the perspective by applying more dramatic devices, such as a fish-eye lens effect, as long as they do not interfere with the clarity of your design. The essential part of this stage is showing the most original and innovative pieces of your concept, so it's imperative to show these at the most flattering angle. The idea is for the viewer to fall in love with your work the moment they see it!

1 Place some simple perspective lines with a ruler and pencil before starting to block out the geometry.

2 Begin building the design using cubes and rectangles, guided by the two-point perspective grid. The grid enables you to mark the positions of the tires and body, defining the vehicle's "footprints." The tires will have a heavy emphasis in the design, so it is helpful to establish them first.

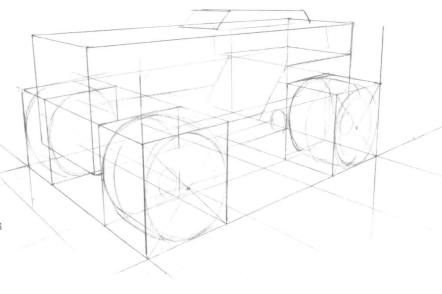

3 Start to block in all the larger elements, using cubes and cylinders which are slightly modified but still simple. At this stage, the geometry is transparent, which allows you to depict elements on the opposite side of the vehicle that will later be hidden. This will help to maintain your confidence that the perspective is correct.

4 After defining the most important structures, start to use diagonal lines to make the design more smooth and streamlined. If your perspective is well-built, it is easy to find the points of intersection and separation when adding these shapes. Start to roughly sketch in some smaller forms like lights and spokes.

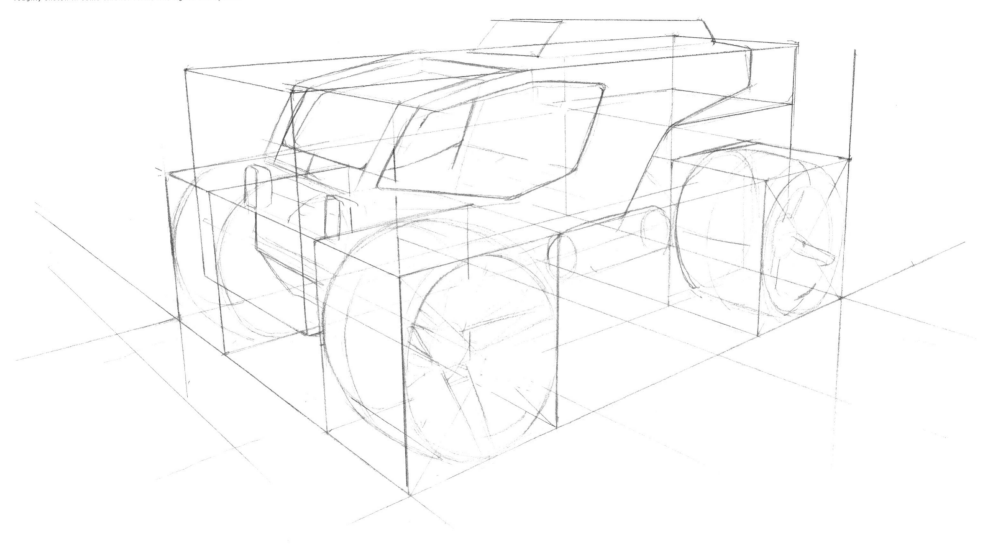

DETAILS

Defining a concept's details is a complex process, requiring a carefully chosen design language. In this case, I want the design to look streamlined and sleek, so before adding any detailed elements, I start to clearly define the curves and shapes of the main body. After cleaning up the largest shapes, I start to draw the details, in descending order from the biggest ones to the smallest. During this stage, the design will start to display more vision and character, as you begin to add more elements from your research as well as your own personal twists.

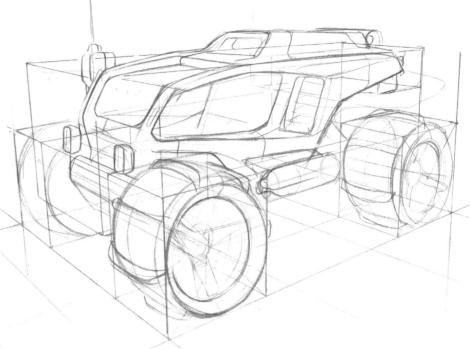

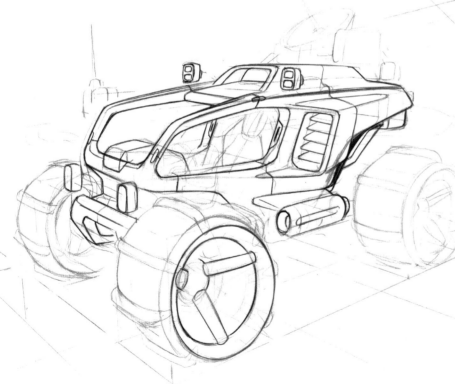

5 Carefully clean up the body and base of the design, making the forms smoother and more distinct. Define the larger proportions first, so that the smaller elements can be added more easily. The blocky edges of the base sketch are now becoming sleek and refined.

6 Switch to a black ballpoint pen to begin drawing cleaner, darker lines. After outlining the essential parts of the vehicle's body, start to add in the finer details, such as grooved surfaces and lamps.

7 To keep the line art clean, erase the pencil underdrawing from each area as you finish lining it with pen. However, if you are not sure about a certain shape, continue to revise it with pencil first until you are happy to line it with pen.

▶ This satellite dish enables the buggy to transmit data, emphasizing its purpose as an exploratory or research vehicle.

◀ Like the vehicles in my research, this buggy's open frame helps to make it lightweight, and enables spacesuited passengers to easily climb in and out.

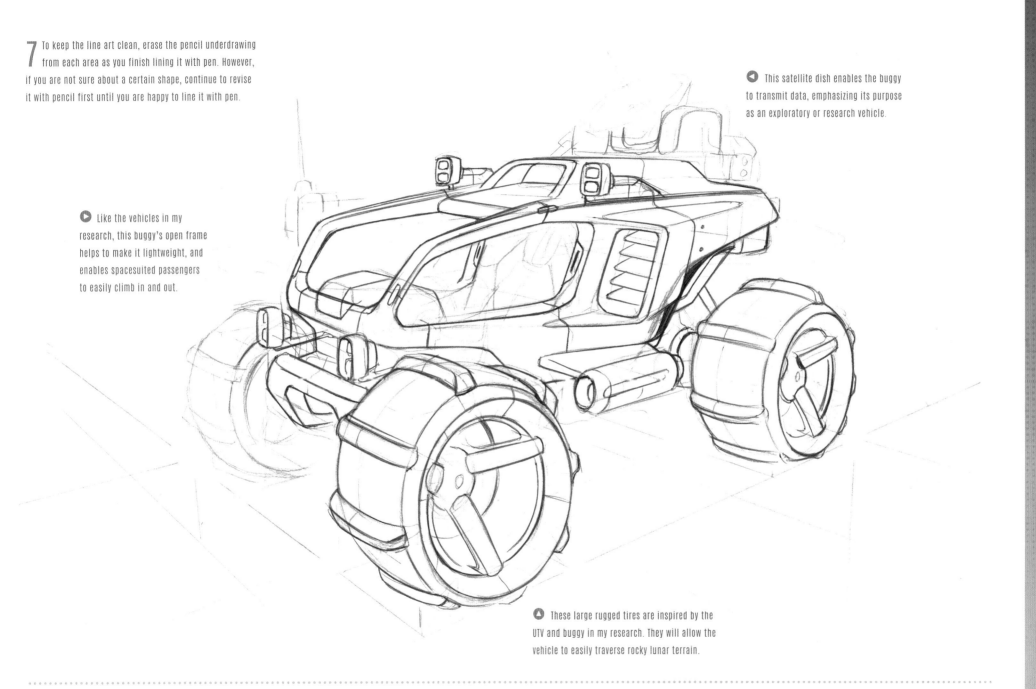

▲ These large rugged tires are inspired by the UTV and buggy in my research. They will allow the vehicle to easily traverse rocky lunar terrain.

FINAL LINE DRAWING

The final line drawing is now fully created with black ballpoint, with the pencil sketch erased. In the following steps, I will use water-based markers to shade the buggy with a simple grayscale palette that suits its light metal and dark rubber surfaces. I will start with the darkest marker to shade areas like the ground shadow, radiator vents, and some small holes. I will then use the light gray marker to project where and how the light flows, and how it should be shaped. Researching and studying the vehicle's materials beforehand is helpful for deciding which tones of marker to use.

8 The final line drawing is now ready for color. The shadow beneath the buggy has been blocked out for ease of filling it later.

9 Lighting is extremely important to how a drawing looks and how clearly a design appears to the viewer. In this case, the light will fall from above the vehicle at a 70-degree angle. This resembles sunlight and will give the final concept a realistic look.

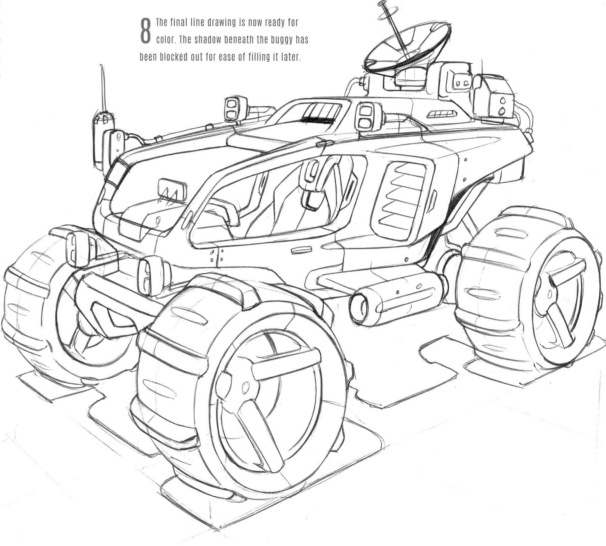

MATERIALS: SHINY METAL & DARK RUBBER

Shiny metal

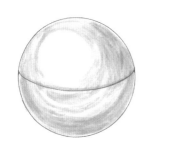

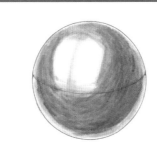

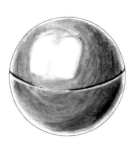

A. In order to research a material, it helps to examine it in real life. Most metals have a light-reflecting property, and the intensity of this reflection depends on how much the metal is polished. This will be a matte rather than glossy metal, so the surface will not be mirror-like in its reflection. Start by applying a base of light gray marker, intentionally leaving a white patch for the highlight.

B. Apply layers of darker gray marker around the underside of the sphere, using curved lines that follow its rounded surface. This shadow helps to create a three-dimensional shape. Leaving a little glimmer on top of the shape also enhances its spherical form. For the sake of this demonstration, I visualize the material as if a bright artificial light is shining nearby.

C. Continue building up more contrast with the dark gray marker. This is how to attain the metallic effect I am aiming for. Brighten up the lower rim of the sphere, because metals always capture the light reflecting from the base they are situated on. Add a highlight with a white pencil as a finishing touch for the edges and grooves.

Dark rubber

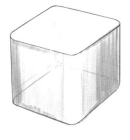

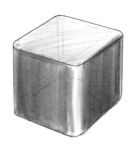

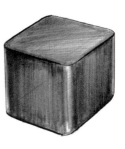

A. Rubber is a simpler material. There are many different types of rubber, some with higher degrees of glare, but this design will be using a more commonplace matte rubber. Unlike the metal, this material will reflect almost nothing from the surrounding environment. If you want to research this material in real life, observing a car tire is a good place to start.

B. Apply a light gray marker base, hinting at where the light will fall. Gradually apply a darker gray marker in a steady gradient that suggests the matte surface of the rubber. You can see there's a slight highlight on the corner, where the edge of the shape hits the light, but no reflections or glare. Don't be concerned about "dirty" coloring when it comes to the tires, as they will look rugged and dirty anyway.

C. Exaggerate the final contrasts and give the rubber a darker color. Emphasize all the corners and edges with a dark gray marker that is carefully blended with the base color. As a finishing touch, you could also add some extra definition to the edges with a black pen, mimicking a slightly rugged texture.

RENDERING PROCESS

To keep the design clean and simple, with a "lunar" look inspired by our real-life references, the buggy will be mostly monochrome in color. The body will be a light gray metal, with dark rubber tires, and some small elements like the interiors will be picked out with an accent color to make them eye-catching. This accent can be any color you like, but in this case, I will use an orange marker. A black pen and white pencil will be used for additional lines and other final touches.

10 Use a black water-based brush pen to fill out the blackest shadow areas. This is very useful to do first because it immediately makes the materials and forms look stronger, and makes the vehicle's shadow "footprint" more realistic and three-dimensional.

11 Leave some areas pure white when shading, to give the impression of a bright environment reflecting off the light metal frame. It's a good idea to use all your shading resources like this, applying them sparingly at first, but you will need to think one step ahead before applying your markers.

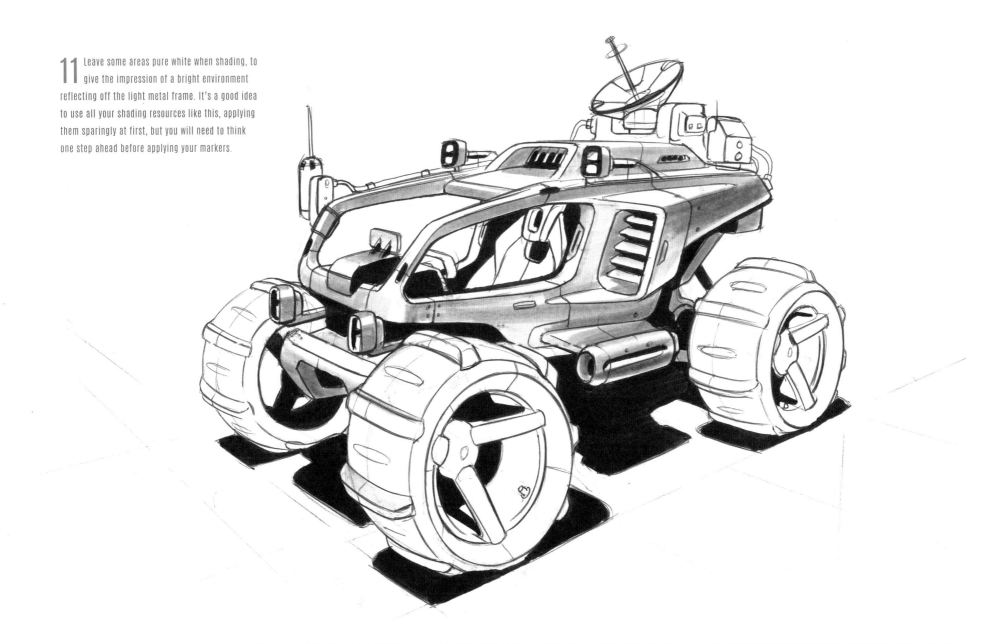

12 Fill in the tires with layers of darker gray, leaving fewer highlights to differentiate the matte rubber from the metal elements. Add some accents to the design with an orange marker or other color of your choice. This is always a good idea when creating an otherwise grayscale design, as the extra color makes your design come alive.

To add extra shine to the final presentation, I plan to use a titanium white pastel to add a subtle highlight to some edges and colored areas.

To finish off the final piece, you may need to use an eraser to clean up the drawing, and a black pen to go over some lines again.

CONCLUSION

My aim for this project was for the viewer to immediately recognize my design as a type of lunar buggy. To achieve this, it was essential to choose the correct subjects to research, and to draw inspiration from many real-world references. Following that general process, it's possible to create almost any kind of sci-fi vehicle. By combining strong research with your own ideas, you can author your own unique designs more effectively. If you find you're not satisfied with the final result, having a clear process allows you to work your way backwards through the steps until you can locate and resolve the issue.

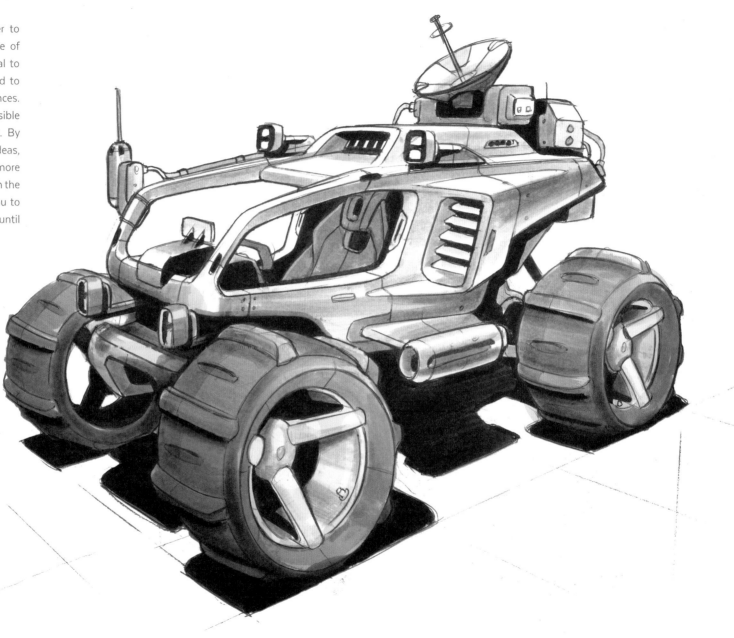

PREFAB COLONY DWELLING

BY ROB TURPIN

thisnorthernboy.blog | All images © Rob Turpin

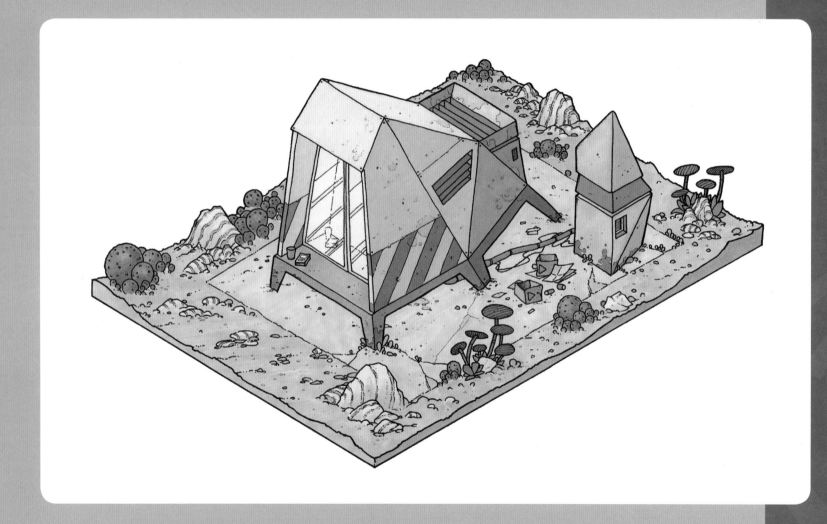

In this tutorial, illustrator Rob Turpin shows how to create a small prefab dwelling, which an intrepid explorer or researcher might use on a newly inhabited planet. Its design elements will make it appear hardy and self-sufficient, and it will be rendered in an appealing isometric style that can be colored with your choice of markers.

TOOLBOX

- Pencil
- Markers
- Fineliners
- Lightbox
- Ruler

RESEARCH

The brief is to draw a sci-fi colony dwelling using an isometric view. The illustration or concept should have a lived-in look to it, and include a little of the environment.

Your initial research for any project should be wide and varied, before homing in on something more specific. If you have one very particular image in mind from the outset, it might mean you overlook other, possibly better, avenues.

For this project, I start by thinking of what a one-person colony building might be – something to sustain a lone explorer, perhaps the first person on a new planet, waiting for backup. I look at a range of subjects that could suggest a way forward, including modular tents, one-person submersibles, garden offices, and Arctic research stations. There's enough variety among these subjects to offer some interesting routes.

Arctic research stations I draw some ideas from Arctic research stations, as they need to be hardy and secure, and are sometimes modular and transportable. They often have legs to keep them above the snow.

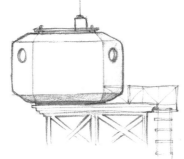

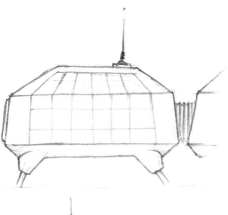

Garden offices There are many garden offices with a funky futuristic style and pod-like shape that could work as inspiration for this building.

Small submersibles I also consider one-person submersible vehicles as an inspiration, as they suit the needs of a lone, isolated explorer in a foreign habitat.

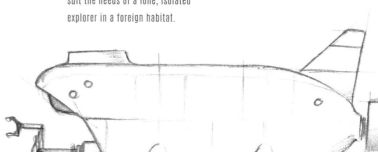

Modular tents I study some modular tents, as they would be useful for housing an explorer, and often have interesting futuristic shapes.

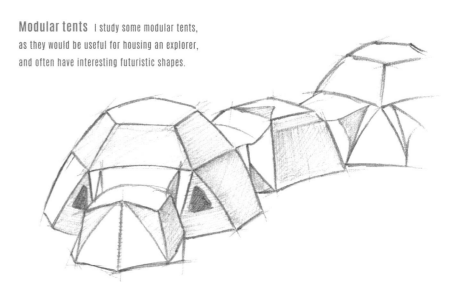

FLAT THUMBNAILS

Drawing "elevations" (flat horizontal plans that show the front and sides of a building), even when the final illustration is to be in a 3D view, is a good way to get an idea for silhouettes, shapes, and proportions.

These thumbnail explorations quickly become a cross between an Arctic research station and a funky garden office pod. I want the building to be on legs, to protect it from the environment, and to have a viewing area at the front so the colonist can survey their new planet.

Some of these ideas are a little impractical in shape, being too low or too elongated to be of much use, and some are just too fussy.

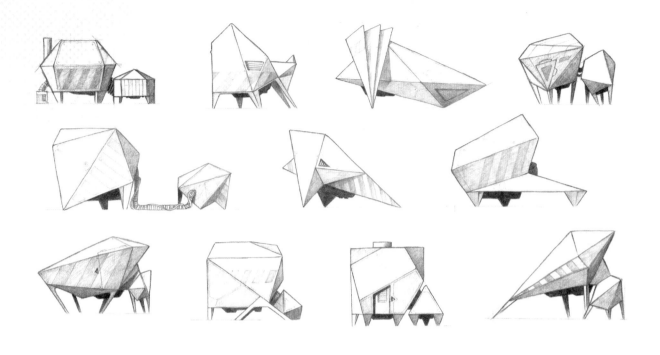

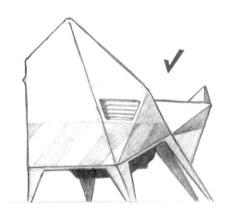

Weirdness and practicality I like this design best because the shapes offer visual interest and a good balance between weirdness and practicality. The silhouette calls to mind a tent, but the legs hold it safely above the ground.

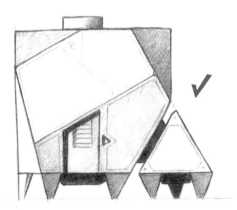
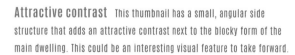

Attractive contrast This thumbnail has a small, angular side structure that adds an attractive contrast next to the blocky form of the main dwelling. This could be an interesting visual feature to take forward.

Obscure shape This thumbnail has an intriguing shape but does not immediately read as a habitable structure. The design should ideally look more welcoming and familiar.

PERSPECTIVE THUMBNAILS

My final image will be drawn in a straightforward three-quarter isometric view, which will not feature any dramatic distortion, so at this stage I focus on creating a clear blueprint of my design rather than exploring different perspective options. I initially expand on the idea of the compact, blocky design with an additional side unit, but once I begin exploring the design in 3D, I decide it's overly complicated and clunky.

I focus instead on my other strongest thumbnail idea, the small pyramid-like dwelling. I sketch a larger profile view, and then extrapolate the front and back from it by using horizontal ruler lines to measure out the proportions. At this stage I'm still trying to get a feel for the overall shape and elevation of the building.

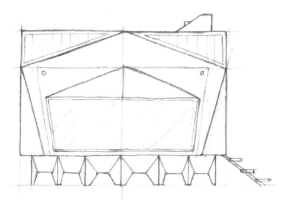

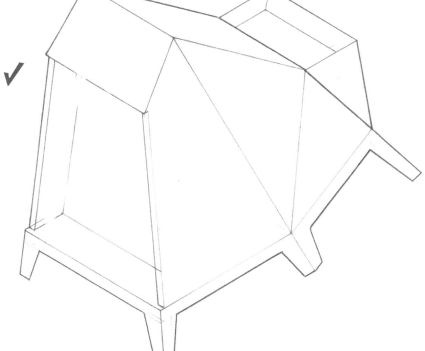

Safe and elevated I feel that this is the best design. The living space seems reasonable and the unit is elevated for insulation and protection purposes. I like the little humpback addition on the rear of the building, which could be an atmospheric scrubber or anti-toxin filter, depending on just how habitable this planet is!

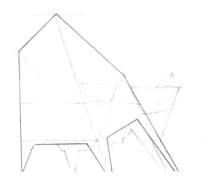

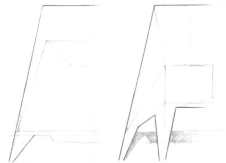

BASIC SHAPES

Creating the isometric structure for the chosen design starts with building up an isometric grid, with planes at 30 degrees, and blocking in the rough shapes. Depending on how complex the final design is, this can sometimes take a little trial and error. Do not be afraid to change the design at this stage – the isometric view can be quite unforgiving, and it's always going to show more of some things (such as the top of the design) and hide others. You may find that details that work in a loose thumbnail do not translate well to the rigid structure of an isometric view.

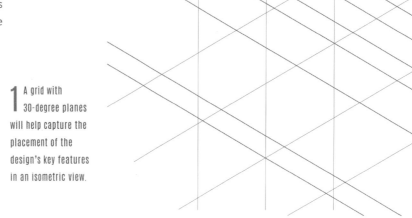

1 A grid with 30-degree planes will help capture the placement of the design's key features in an isometric view.

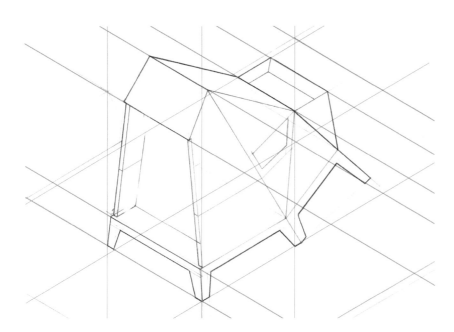

2 The isometric grid helps to place the major lines and forms of the design. Establish the parallels and diagonal parts of the structure that follow the guidelines first, before adding the lines that head in the opposite direction. The guidelines here are shown in red for reference, but you can draw them in faint graphite pencil or on another sheet of paper that you can trace over.

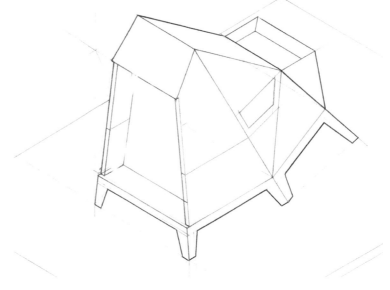

3 Once all the basic forms are established, it's safe to begin erasing the guidelines and tidying up the design. Precision is key to a stylized isometric piece such as this, so use a ruler to steady your pencil.

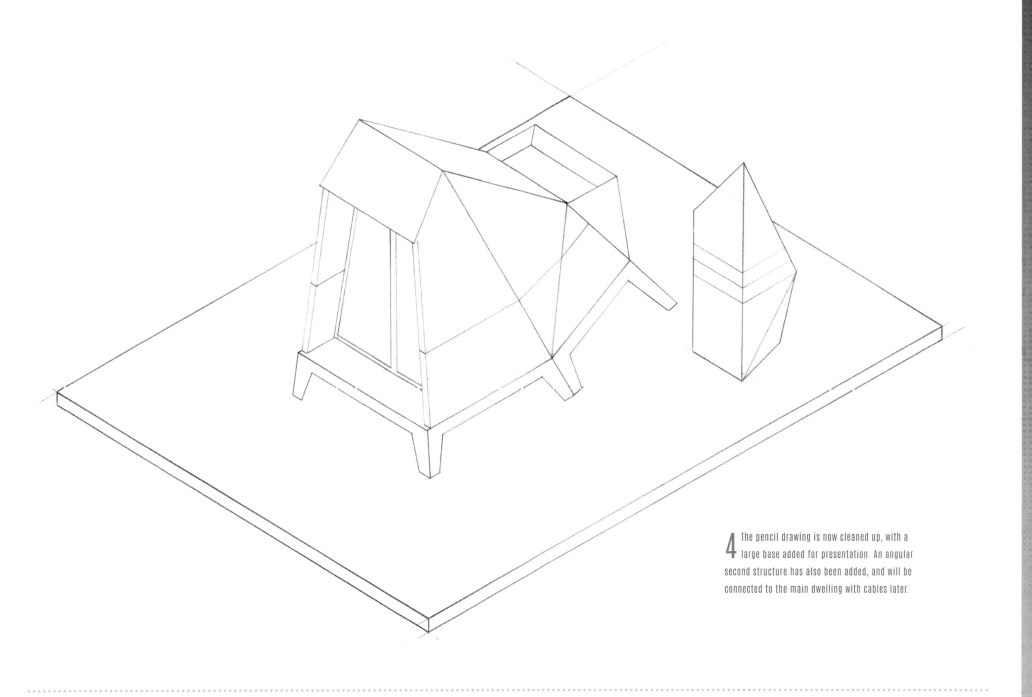

4 The pencil drawing is now cleaned up, with a large base added for presentation. An angular second structure has also been added, and will be connected to the main dwelling with cables later.

DETAILS

In addition to the design of the habitat, it's always good to include some other environmental details that help to set the illustration in a space. The square of dirt or rock that the illustration stands in, along with rocks and alien plant life, creates a more believable look. I always like to have a definite edge to the environment, almost as if it's a model diorama, which is a personal style decision that I think gives an appealing look to the whole illustration.

Once the main shapes and forms are drawn, I always add some detail - usually to make the illustration believable and a bit more gritty. Panel lines add realism and interest, hinting at a more complex structure beneath the simpler overall form. Little dinks and scratches make it look like the habitat has been lived in and has experienced a bit of weather - they are not necessary for selling the shape and form, but they add to the story.

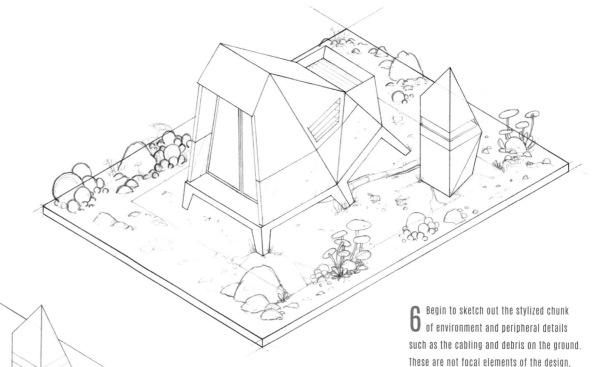

6 Begin to sketch out the stylized chunk of environment and peripheral details such as the cabling and debris on the ground. These are not focal elements of the design, but will add a lot to its presentation.

5 Continue working in pencil for this stage. Add ventilation and panel details, and you will find the design begins to look more like a specific outdoor structure.

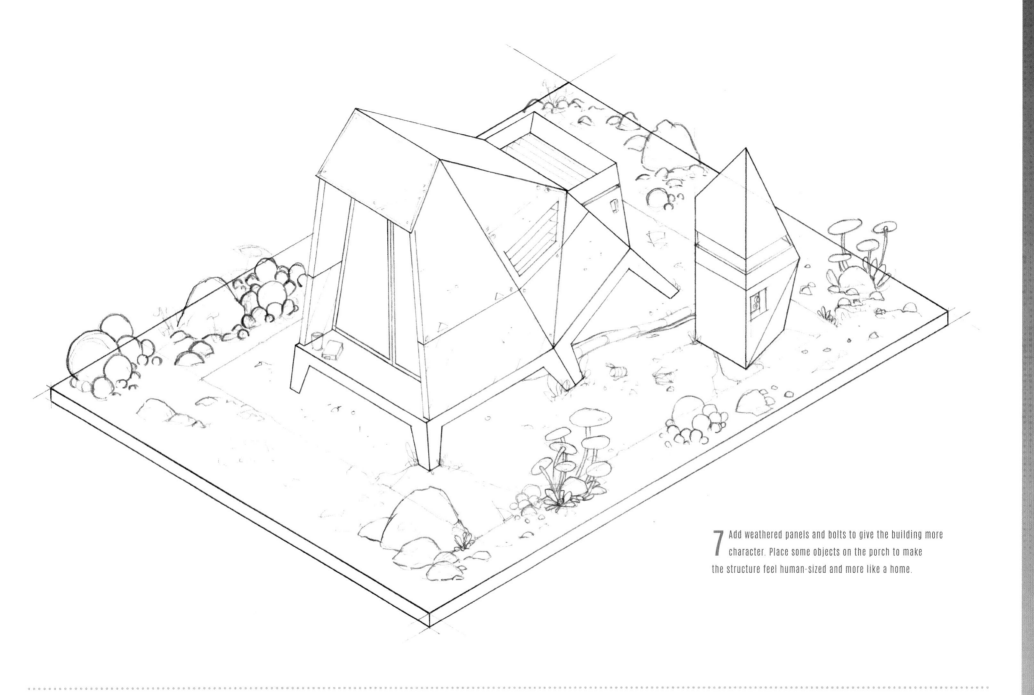

7 Add weathered panels and bolts to give the building more character. Place some objects on the porch to make the structure feel human-sized and more like a home.

FINAL LINE DRAWING

Refining the previous sketches is just a matter of cleaning up the lines, erasing them where needed, and making sure everything still looks right. At this stage you can still modify details - whether that's the way the corners of a shape meet, or the amount of texture on a surface.

The final inking stage (shown right) is where you can add all those little bits of detail that add life and character - scratches and dents in hard materials, textures and patterning in rocks and plants, and adding decals or panel lines. This stage for me is the most fun. All the hard work is over, and you can just enjoy adding the details.

At this stage I try to vary the lineweight or thickness a little more. Applying a heavier line to the main shapes makes them stand out and draws your eye to them. Small details are rendered in a thinner line. I also have a habit of drawing a thicker line around the image as a whole, which I think makes it jump off the page a little.

USING A LIGHTBOX

I use a lightbox for refining my drawings and creating the final inking. A lightbox enables you to develop and refine a drawing, with the freedom to change any little details required. Lightboxes used to be very cumbersome and hot, but the new slim-line LED versions are fantastic.

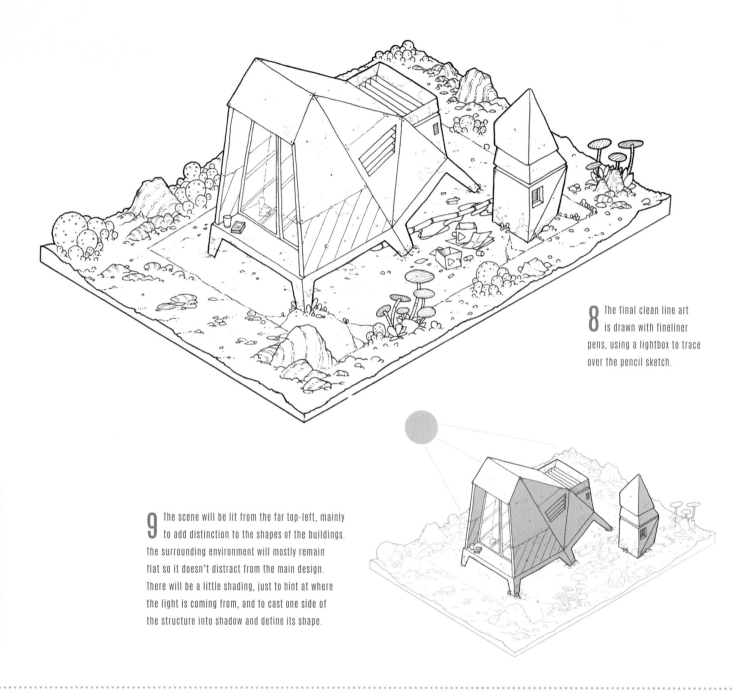

8 The final clean line art is drawn with fineliner pens, using a lightbox to trace over the pencil sketch.

9 The scene will be lit from the far top-left, mainly to add distinction to the shapes of the buildings. The surrounding environment will mostly remain flat so it doesn't distract from the main design. There will be a little shading, just to hint at where the light is coming from, and to cast one side of the structure into shadow and define its shape.

MATERIALS: WEATHERED ROCK & COMPOSITE PANELS

Weathered rock

A The environment will feature some rocks that are quite weathered, with obvious seams of different material in them, like some sedimentary rocks you find here on Earth. Start with the inked outlines, keeping the seams consistent to add realism and sell the "look."

B As with any textures in an image, it is good to have a contrast between areas of high detail and areas of low detail. Too much detail all over an element of a drawing tends to make it confusing. You should show just enough to suggest what the object is.

C Though the final image will be colored with quite a flat, stylized approach, layers of shading still help to convey form and surface. Here the shadowed side of the cube features darker pinks and grays, and dabbing with the marker gives a sense of the rock's uneven texture.

Composite panels

A Drawing a modern or futuristic material can be quite tricky, particularly if, like me, you do not really render surfaces in color. The habitat is built of a plastic/ceramic composite material which is light and hard-wearing, and won't be particularly shiny. Instead of focusing on surface texture, drawing panel lines, decals, and little vents will immediately help to show it as a hard-surface design.

B Even without a shiny finish, the details are now almost enough on their own to suggest the material. Adding a few little scratches and marks reinforces that. Although you have not rendered a specific material, this is very obviously something futuristic and sci-fi. A flat marker base establishes the local color, with some lighter panels and bright orange details to add interest.

C A darker layer of marker on the sides and indented areas of the cube lend it greater dimension, while maintaining the appearance of a smooth metallic or plastic material. You can build up quite a difference in color and tone like this, first laying down one color, waiting until it's dried, and then repeating it to create shadow.

RENDERING PROCESS

The rendering style for this image will mostly be flat, even layers of marker. I plan to work with two or three depths of shadow to emphasize the shape of the dwelling: unlit areas, unlit and "below" areas, and a shade between for facets of the structure that are angled out of the sunlight.

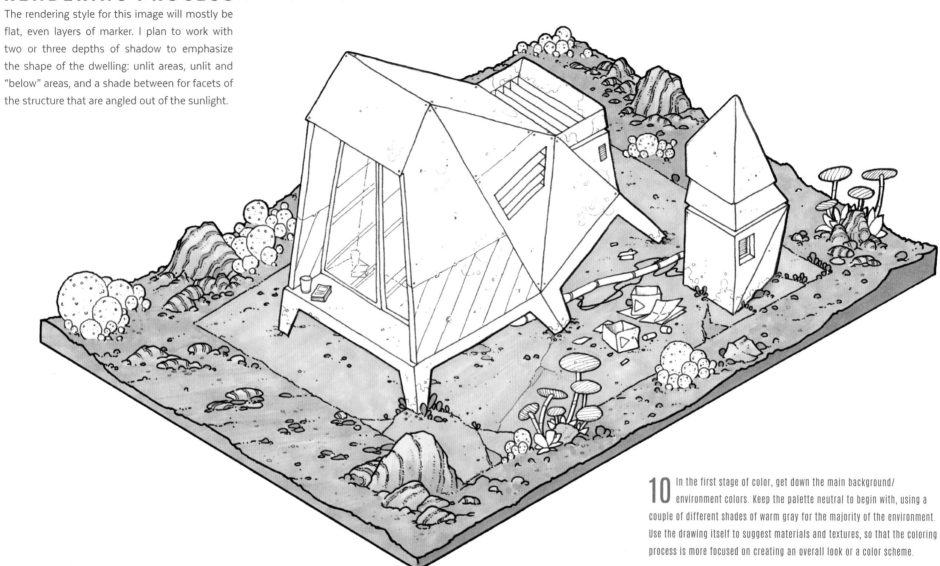

10 In the first stage of color, get down the main background/ environment colors. Keep the palette neutral to begin with, using a couple of different shades of warm gray for the majority of the environment. Use the drawing itself to suggest materials and textures, so that the coloring process is more focused on creating an overall look or a color scheme.

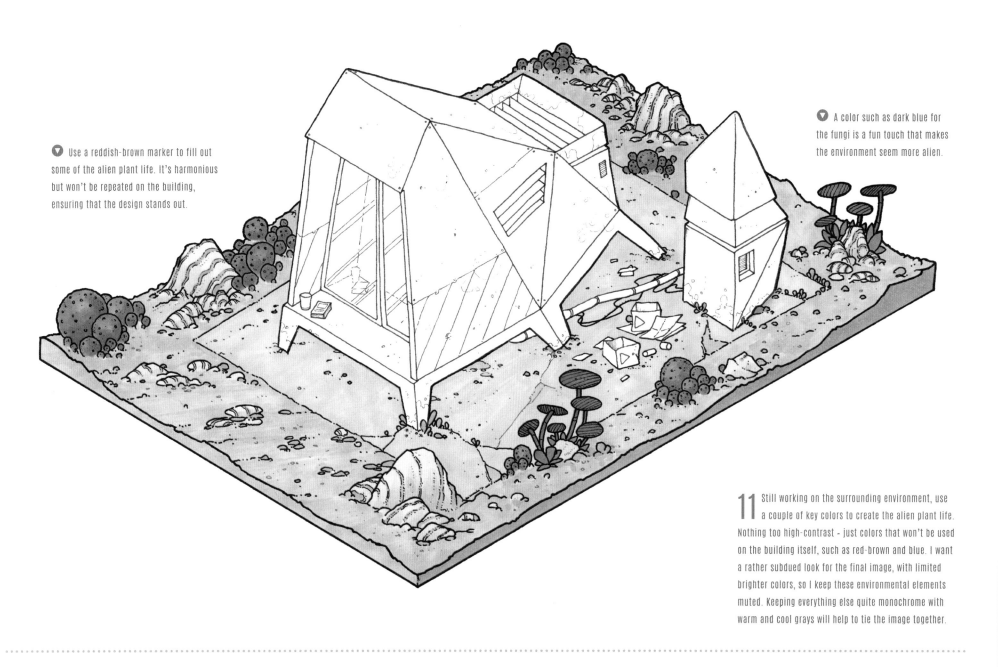

Use a reddish-brown marker to fill out some of the alien plant life. It's harmonious but won't be repeated on the building, ensuring that the design stands out.

A color such as dark blue for the fungi is a fun touch that makes the environment seem more alien.

11 Still working on the surrounding environment, use a couple of key colors to create the alien plant life. Nothing too high-contrast - just colors that won't be used on the building itself, such as red-brown and blue. I want a rather subdued look for the final image, with limited brighter colors, so I keep these environmental elements muted. Keeping everything else quite monochrome with warm and cool grays will help to tie the image together.

12 Now apply the main colors and tones for the habitat itself, using the same colors as in the previous section, but building them up in layers to create shadows on the unlit (lower right) sides of the structures. You can add a little color borrowed from the alien plants onto the structures, as if a lichen or algae has started to encroach, as I've done here.

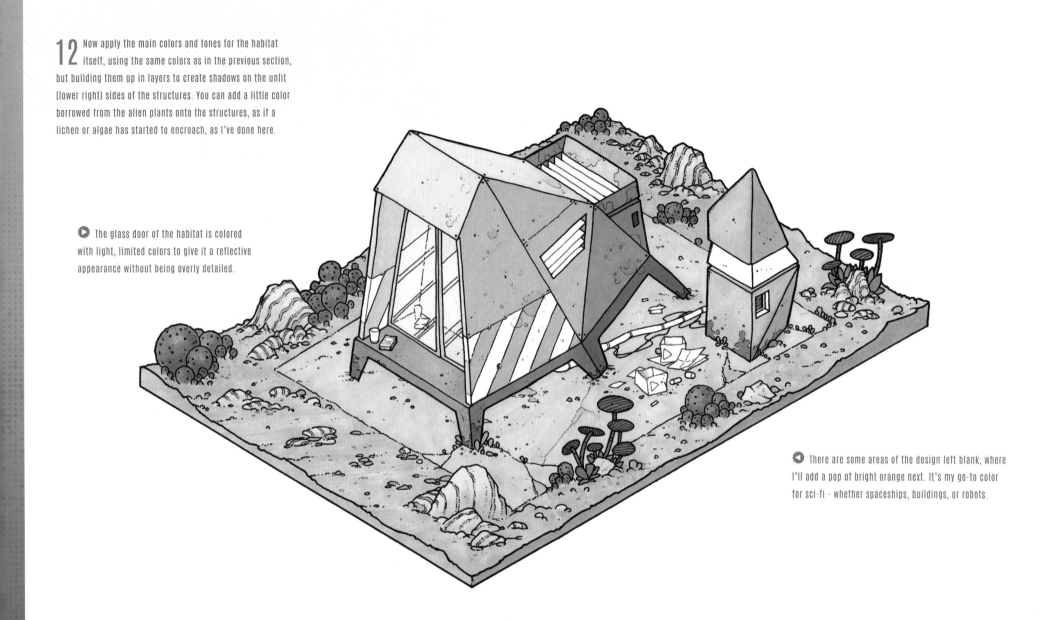

▶ The glass door of the habitat is colored with light, limited colors to give it a reflective appearance without being overly detailed.

◀ There are some areas of the design left blank, where I'll add a pop of bright orange next. It's my go-to color for sci-fi - whether spaceships, buildings, or robots.

CONCLUSION

I am really happy with the final result of this project. It certainly fits the brief, and there is a clear development from those initial reference sketches of Arctic research stations and modular tents. The most important question for me is, "Is it believable?", and I think it's easy to imagine this as a real habitat on a newly colonized planet. It's structurally compact, and looks strong and stable. I wouldn't mind living there – depending on how friendly the neighbors are!

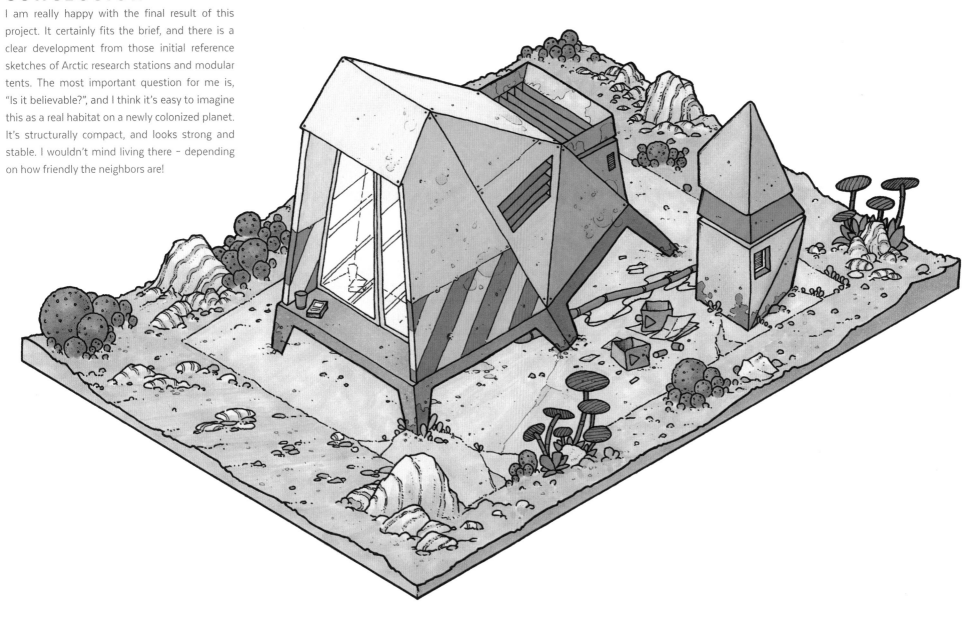

ALL-TERRAIN MINING MACHINE

BY GUIDO KUIP

guidokuip.artstation.com | All images © Guido Kuip

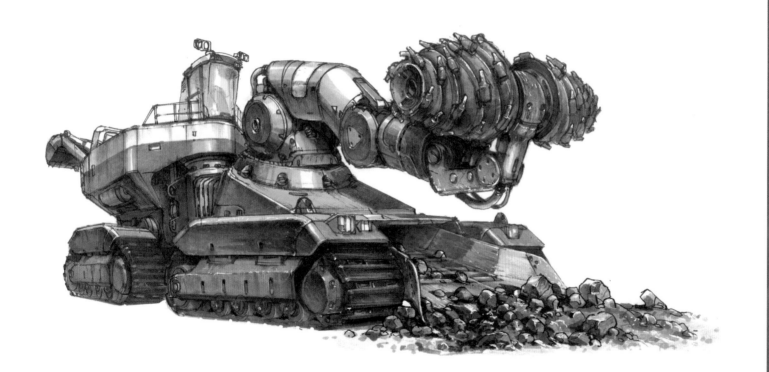

In this tutorial, concept designer Guido Kuip will be creating a powerful mining machine: a bulky, weathered vehicle that might be used for shifting heavy rocks and rubble across rugged terrain. Colored markers will make the design pop, and colored pencils will add dirt and staining to the machine's surface. Guido includes tips for drawing individual features in perspective which will be useful to practice for later chapters.

TOOLBOX

- Fineliner pen
- Markers (light gray for sketching and shading, and your choice of vehicle colors)
- Colored pencil (red-brown)
- White gel pen
- Lightbox
- Scanner (optional)

RESEARCH

Strong trees have deep roots. The very first – and often underestimated – step in any design process is research. In its most basic form, this usually means looking up a few reference images, but it can be a much more powerful tool by also analyzing your findings through words and sketches. This creates criteria to judge design sketches by further in the process. Ideally, this way you've already set out a few clear design directions before ever putting a pen to paper.

In this project we'll be making a heavy-duty mining mech. As you'll see, the mining industry and mining equipment is rather straightforward, but for more complex design briefs the research phase can be incredibly important in clarifying a brief and guiding design decisions later on.

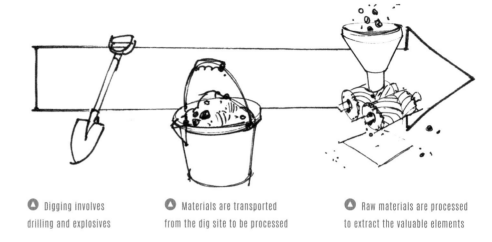

△ Digging involves drilling and explosives

△ Materials are transported from the dig site to be processed

△ Raw materials are processed to extract the valuable elements

Key elements When doing studies based on reference images, it helps to not just copy them but also figure out common elements. In this case, mining is quite a straightforward business: economy of scale and optimization for a single purpose seem to be the guiding principles. Simplicity is also a factor, as it cuts down on maintenance; these mining vehicles feature large, clunky elements and blocky, industrial shapes with no decorative styling or organic forms.

Mining process The process of mining can be roughly separated into three parts: excavating material, transporting raw material and, finally, processing the raw material - usually by grinding it down or heating it to extract the useful product from the ore.

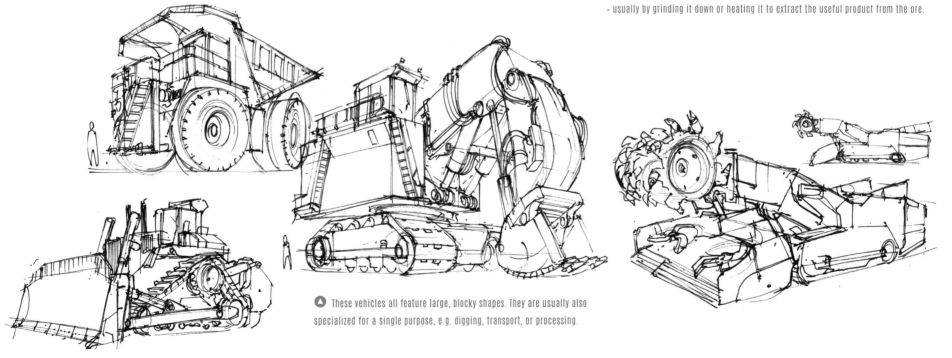

△ These vehicles all feature large, blocky shapes. They are usually also specialized for a single purpose, e.g. digging, transport, or processing.

FLAT THUMBNAILS

With a few general guidelines set down, it is time to explore design ideas with some initial sketches. Consider this step part of your research; you'll often find, through sketching out the first rough ideas, that there are new areas to explore with further research before moving on to perspective sketches and detailing.

Starting out in a plain side view helps to focus on the idea, overall proportions and shape rather than also having to worry about perspective, foreshortening and dramatic points of view. Keep in mind, however, that the design ultimately has to be viable in three dimensions – an interesting silhouette in side view might change dramatically once the point of view shifts. I sketch silhouettes in gray marker, and add rough lines over them in pen where an idea shows potential.

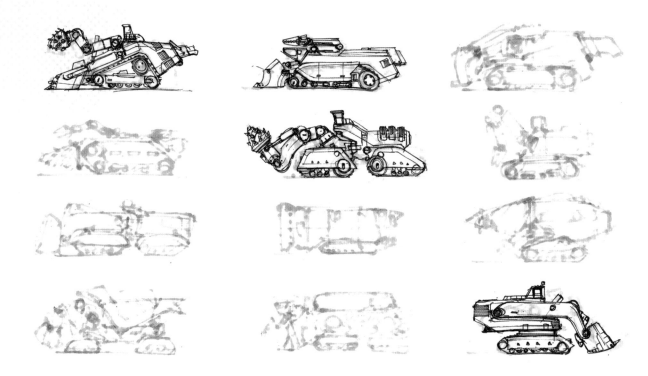

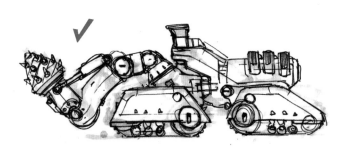

Tracks and drill arm I like the split tracks and the futuristic-looking drill arm in this thumbnail, as opposed to the clunky hydraulic arms on modern mining equipment. However, the overall body shape still needs work.

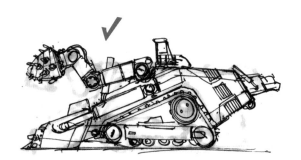

Conveyor belt The design feels a little too close to a standard bulldozer, but I like the idea of the mined material moving through the interior onto a conveyor belt and out of the back – much like a combine harvester.

Too unrelated The general idea was a cylindrical tunnel drill on tracks, but the overall silhouette is somewhat boring and doesn't relate back to the ideas established in the research phase. A tunnel drill performs a lot of different functions integrated in a single package, as opposed to actual mining equipment, for example.

PERSPECTIVE THUMBNAILS

Now that we have a rough idea of the direction for our mining vehicle, we can start to invest some time into figuring out the three-dimensional shape and detailing. It helps to stay loose and be open to "happy accidents" - sometimes mishaps in early sketches can create the most interesting design elements. It can be tempting to stick to a single point of view for every sketch, and although it can aid in comparing the different ideas at the end of this phase, it can be equally helpful to change the point of view often so you get a better sense of the overall design.

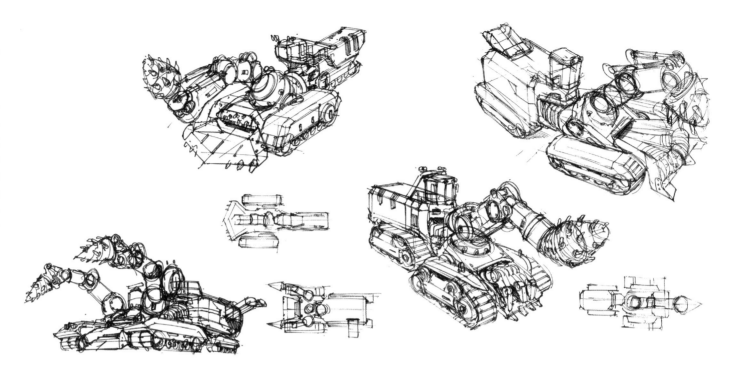

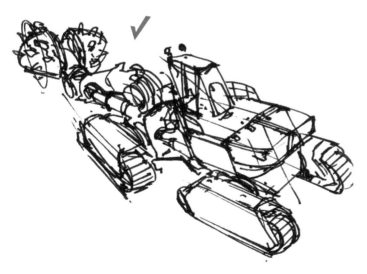

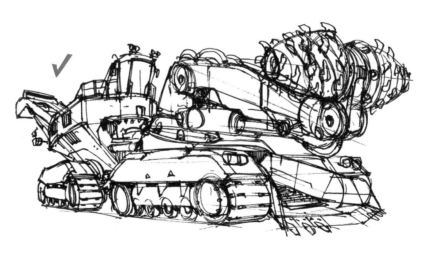

Ideal proportions Sometimes a quick and tiny sketch can ignite a fresh spark. The early sketches all felt ill-proportioned, but in the end this was easily solved by enlarging the drill part on the arm. I discovered this by making a quick and wobbly sketch on the side, and later expanding it into a more presentable form.

BASIC SHAPES

For a somewhat complex design like the mining machine concept we have ended up with, it helps to break the concept down into its separate elements. In this case, that would be the four tracks, the front, the rear body, and the drill arm.

Each of these can then be broken down into their respective base shapes and combined into a single final line drawing. For example, the drill arm is simply comprised of cylinders, and you can see the process for breaking down its shape on the opposite page.

1 A basic two-point perspective grid will help to place your vehicle's major shapes, though with experience you can learn to do this by eye.

2 Block out a solid base for the design with light gray marker, establishing a more dramatic perspective that will emphasize the machine's bulk, as if the viewer's looking up at it. Start from the elements nearest to the ground or the horizon line, then work your way upwards.

3 Sketch rough lines with black pen over the base to map out the details. Don't worry if this sketch is messy, as we'll be redrawing it later.

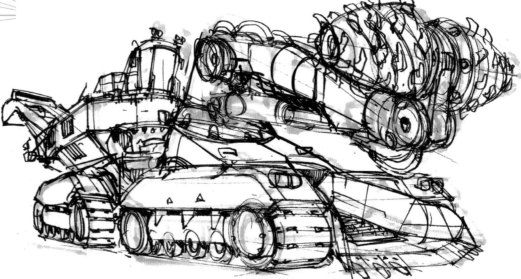

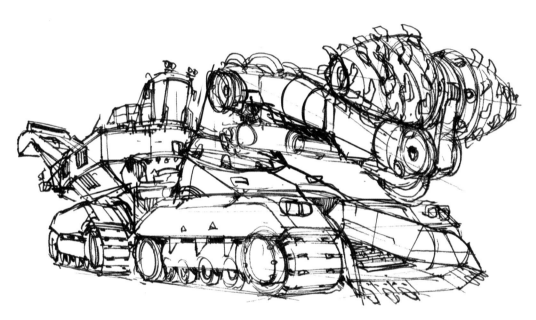

4 Now the whole design and angle is mapped out, including
most of the smaller details. The line art is still unrefined, but
it's clear enough to form the basis of the final drawing. You may
wish to scan and brighten the sketch to remove the underlying
marker, as I've done here, to make the next stage easier.

THE DRILL ARM

The drill arm seems complex
but is in fact fairly easy to
construct using its central
axis. Notice how the axis of
each joint is already present,
pointing towards the virtual
vanishing point on the right
to match the perspective of
the rest of the lines.

The drill head, being closest
to the viewer, is drawn in
first, followed by each joint
– in this case, represented
by a simple cylinder. These
can be detailed later on.
Next, connect the joints
with solid geometry – either
rectangular shapes, which
are potentially easier to block
in, or cylindrical shapes.

By using a cylindrical shape
in this design, a new axis of
rotation can easily be added,
allowing the drilling head
more freedom of movement.

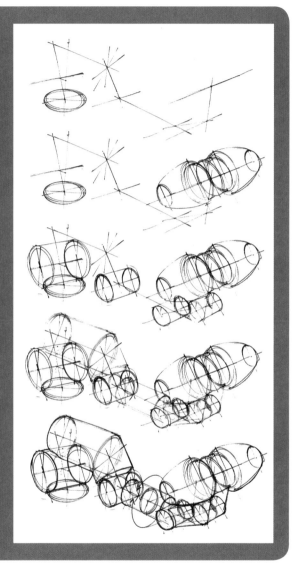

DETAILS

The final drawing has a dramatic point of view, as this machine is supposed to be powerful and large. This does, however, hide some of the design; when opting for a dramatic angle, it might sometimes be necessary to include drawings of other viewpoints to get the overall shape across to the viewer. But in this case, this angle shows off the key features that will make an impression on

the viewer: the machine's large drill head and the rugged tracks. I'll be focusing the most detailing in these areas. They might seem complex and hard to draw, but – as I'll demonstrate as we go along – starting from their basic shapes is a straightforward, logical process to develop them without losing track of their established perspective and proportions.

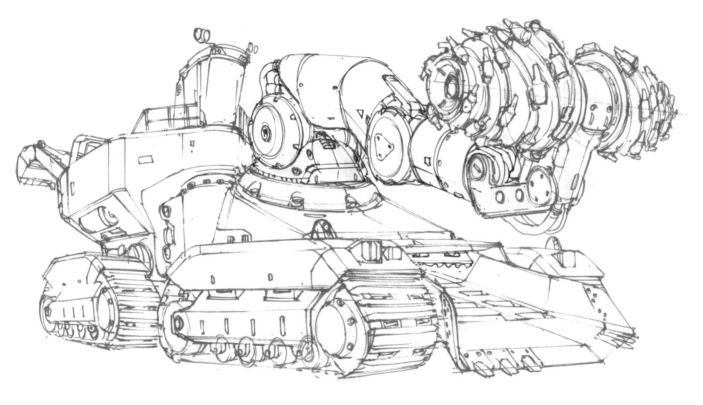

5 This cleaner version of the design is drawn with a finer pen on a new sheet of paper. This can be done using a lightbox, or by printing out a very faint copy of the rough sketch to use as a guide.

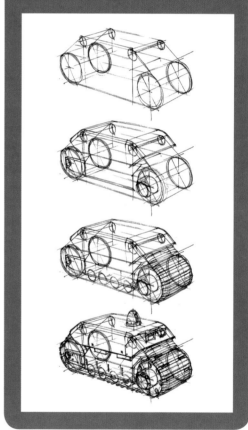

THE TRACKS

The tracks are essentially four rollers with a "band" connecting them all the way around. From this basis, we can extrude parts to create cowling and other elements. Each track link is then created, starting out by dividing the band into equal parts that can then be further detailed. Sometimes it is enough to just suggest details rather than attempting to draw out each one.

THE DRILL HEAD

The drill head is a complex curved surface, and the teeth are arranged on a spiral. It can help to carefully construct this part in a separate sketch first to get a feeling of what it looks like in perspective, so you can "eyeball" it in the final without needing all the extra construction steps. Dividing the head into sections helps to find points along the spiral path, which can then be connected to create the actual spiral over the surface of the drill head. The same points can then be used to space out the teeth evenly.

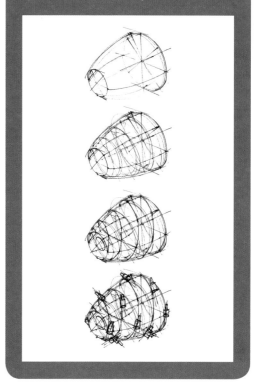

6 Rubble and rocks help to convey the machine's function. Additions such as this can be drawn on separate paper, then scanned and pieced together in Adobe Photoshop, or placed together and then traced over on a new paper.

FINAL LINE DRAWING

The final line drawing is now complete and cleaned up. If you have not already been scanning the drawing as you go along, it's valuable to scan the work at this stage, so that you can make adjustments to the proportions or print multiple copies to color without damaging the original or having to redraw everything from scratch.

For coloring the final concept, I will use markers, pastels, colored pencils, and a white gel pen for the final highlights and white spots. The machine's body will consist of a rusty green metal, while the rocks in the foreground add an organic element that will require a slightly different shading approach.

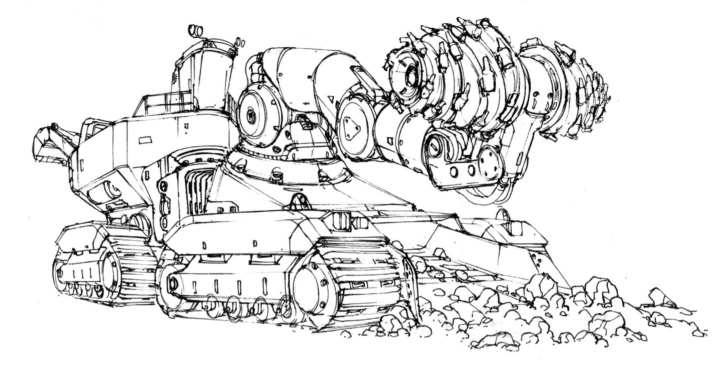

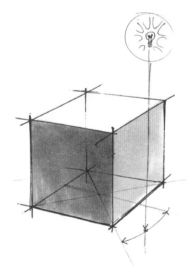

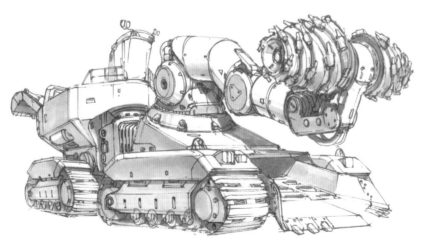

7 The final line drawing features the addition of rubble in the foreground, which helps to show how the machine operates.

8 It's good to aim for a lighting situation where each visible side of an object has a distinct tone from the other sides: shadow on one side, full color on the adjacent surface, and usually a gradient on the top surface. While there are more dramatic ways to light an object, this approach generally makes a design easier to "read," and informs the shapes best.

MATERIALS: RUSTY METAL & WEATHERED ROCK

Rusty metal

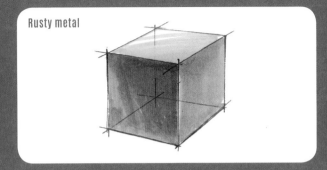

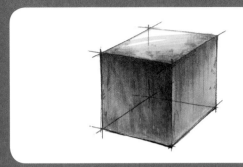

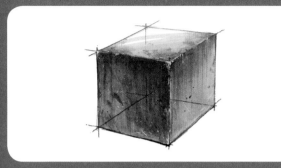

A The initial marker pass establishes tone and color. Add a first light gradient of dust from the bottom up, the way it would build up on vehicles moving around in a dry and dusty environment like a quarry. Don't go all-out with heavy pencil right away, as it might seal the paper from any other medium to be layered on top; instead this is done with a light amount of pastel. Scrape some powder off a soft pastel onto the paper, then brush it in with a piece of paper towel in long, linear motions, and erase where necessary.

B The second step is adding rust. Again, use pastel, as it is easier to erase and layer pencil on top of. Rust can appear in many forms, but in this case I choose a streaked look, as is common with vehicles left out in the rain. This effect is easy to achieve by following the top edge of the form with a direct stroke of a red/brown pastel, and then brushing it downwards with a piece of paper towel. Repeat this a few times for a stronger effect, or use a colored pencil to accentuate the edges.

C In the last step, add dents, scrapes and further rust with colored or gray, black or white pencil. Add some chipped paint with the white gel pen or pitting with a black pen. You can even layer more marker on top of some areas, but keep in mind that it tends to seal any pencil or pastel marks underneath it.

Weathered rock

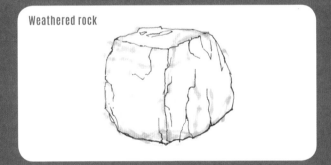

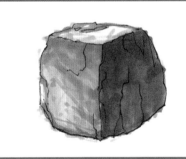

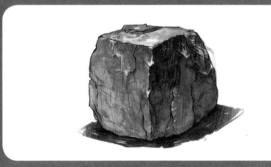

A Rock is a natural material, and it does not tend to come in neat cubes or other regular shapes. The silhouette is irregular and, depending on the type of rock, can be smooth, jagged, sharp or anything in between. Looking up some reference images here can be very helpful.

B Despite the irregular shape of rock, it is still good practice to start out by establishing the shape. Note that some rocks can be reflective (especially on the surfaces facing away from the viewer) while others are more matte. In this case, the top surface is kept fairly light except where there are cracks and bumps in the shape.

C The last step is detailing, which is largely done with pencil and some sharp white highlights with white gel pen. Rocks are also rarely monocolored, so it can be very effective to mix in some cooler colors like purple or green in the shadow while adding warmer hues on the lit sides.

RENDERING PROCESS

To render the final design, we will begin by shading a monochrome base with markers, over which the vehicle's colored paint job and rusty weathering will be added with markers and pencils. White gel pen highlights will be applied at the very end.

When choosing markers to color over a grayscale base, note that not every marker color works well with each shade of gray or brand of gray marker, so occasionally this will influence which colors you can put down first. For example, blue colors are notorious for mixing badly with grays, fading and becoming murky rather than becoming a darker blue. I suggest to do a little test on the side to see what works best for the colors you choose. In this case, my design will be mostly green.

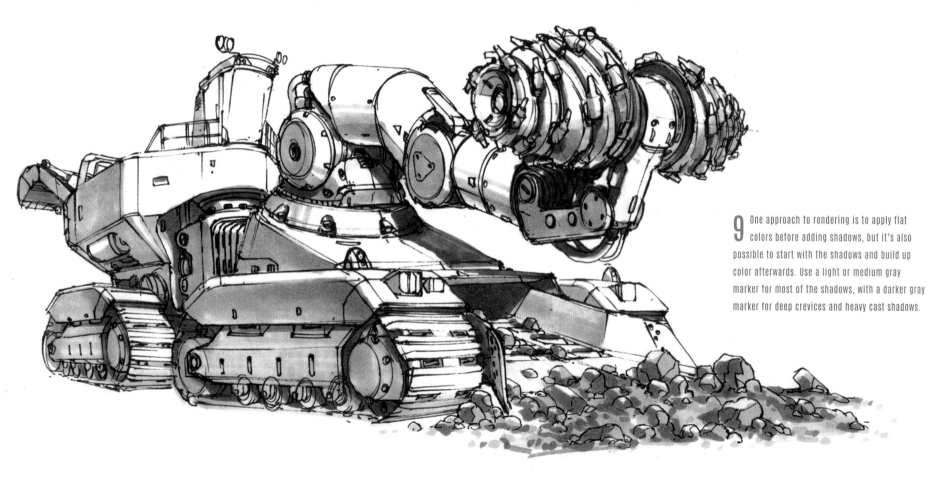

9 One approach to rendering is to apply flat colors before adding shadows, but it's also possible to start with the shadows and build up color afterwards. Use a light or medium gray marker for most of the shadows, with a darker gray marker for deep crevices and heavy cast shadows.

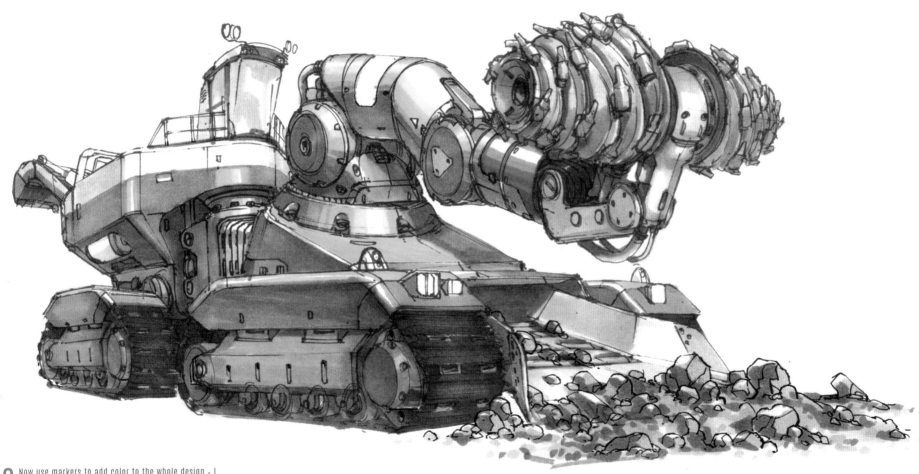

10 Now use markers to add color to the whole design - I choose a striking green with a warning red accent on the drill arm. Areas of pure white paper are left on some curves and corners to indicate the machine's metallic surface.

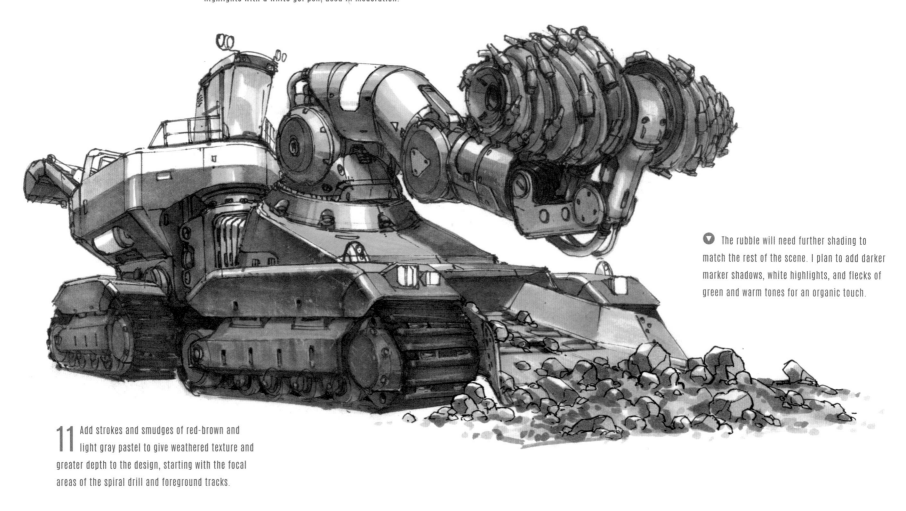

▼ I plan to flesh out the rest of the vehicle with rust, weathering, and darker shadows. I will also add final highlights with a white gel pen, used in moderation.

▼ The rubble will need further shading to match the rest of the scene. I plan to add darker marker shadows, white highlights, and flecks of green and warm tones for an organic touch.

11 Add strokes and smudges of red-brown and light gray pastel to give weathered texture and greater depth to the design, starting with the focal areas of the spiral drill and foreground tracks.

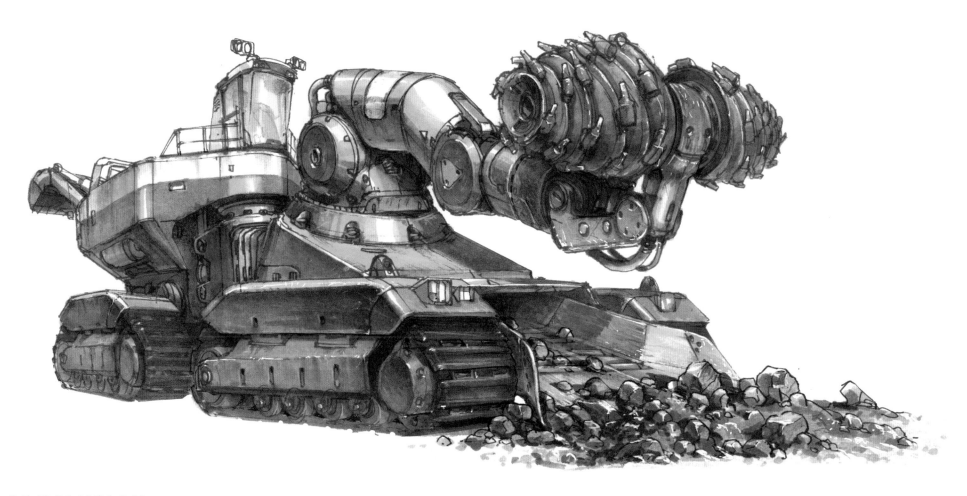

CONCLUSION

Sometimes it can be really tricky to have a relatively open brief, such as this one, with no established universe that the design needs to suit. Research helps to provide restrictions and goals that you need to achieve. Taking the time to write these out explicitly can be a very powerful tool to make decisions later. For example, during the sketching phase the proportions were not quite working out, which was solved by simply enlarging the drill head; it was the main operating element of the machine, and something that we established as one of the three distinguishing elements of large-scale mining equipment.

► TRADING SHIP

BY LORIN WOOD

lwoodesign.com | All images © Lorin Wood

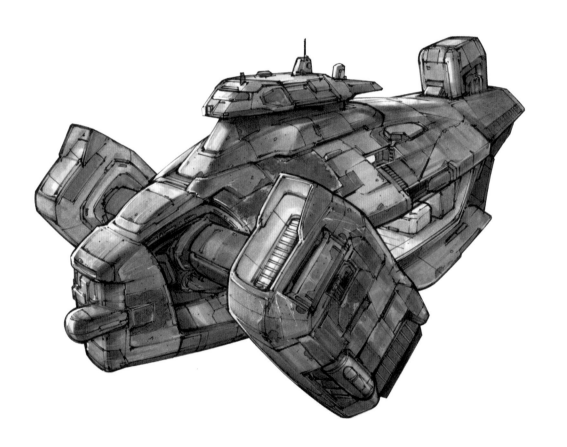

In this tutorial, concept designer Lorin Wood will talk through his process of using pens and markers to create a bulky cargo-bearing spaceship. A subtle three-point perspective view will lend an exaggerated edge to the design, emphasizing its size, and weathered metals will give it the appearance of a hard-working utilitarian craft.

TOOLBOX

- Ballpoint pen (or pencil)
- Cool gray markers – Copic C1, C3, C5 and C7 (or other markers in 10, 30, 50 and 70% gray)
- Black fineliner pens (0.2 mm, 0.3 mm, and 0.5 mm)
- Black and white colored pencils
- White paint marker, white-out, or white gouache
- Ruler

RESEARCH

Texture is a critical element of design because it helps to tell the story of the design subject. You learn how it was and is being used, where and by whom, without a great deal of explanation. The intent of this craft design is to portray a vehicle that has been cobbled together and serves a utilitarian purpose, such as a trading vessel. I'll reference several images of large aircraft, namely old and dilapidated Russian planes. These details have clearly been exposed to the elements, which has caused the weathering of the metals, and the patina that results when they deteriorate.

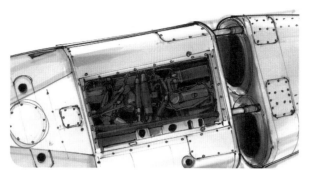

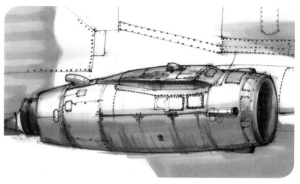

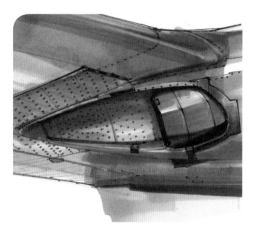

Exhaust pipe This particular angle is fascinating because of the way the exhaust pipe is embedded into the fuselage. Look for details like this. Even if they are not used in the final design, it is good imagery to have floating around in the back of your mind because it is unorthodox.

Exposed elements This exposed plane element is interesting because of the segmentation and interior details. It's important to try to notice as many of the construction details (e.g. bolts, rivets) as possible. This exercise creates a mental database of miscellaneous details that add a dose of functionality and realism to a design.

Engine function This engine is wonderful because it is all about function. It is ugly and shows visible signs of deterioration and weathering from years of use in extreme conditions.

Weathering This detail is a great example of the weathering we want to implement into the final design. The airplane is enormous and demonstrates the disparate way the rust streaks down the varying sized panels and other surface details.

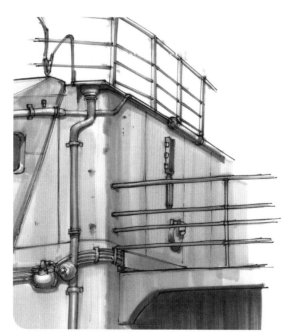

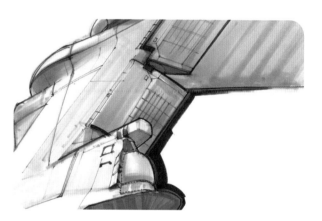

Pipes and railings Since the design is a trader ship, it would be a good idea to look over some micro details found on actual ships, such as these pipes and railings. These again emphasize the utility of the craft.

Aircraft tailfin This detail of a Soviet aircraft tailfin is interesting because it shows function and dynamic movement with the two rudders in a lop-sided position.

FLAT THUMBNAILS

At this stage we are exploring the basic shape of the ship we are going to design. Keep in mind, one of the primary goals of this step is to establish the scale. How large is this craft going to be? This will determine the level of detail, weathering, and the overall complexity of the design later on.

The appropriate approach for this task is to start large – I use a wide marker of about 30% gray to sketch out large, simple shapes in flat profile.

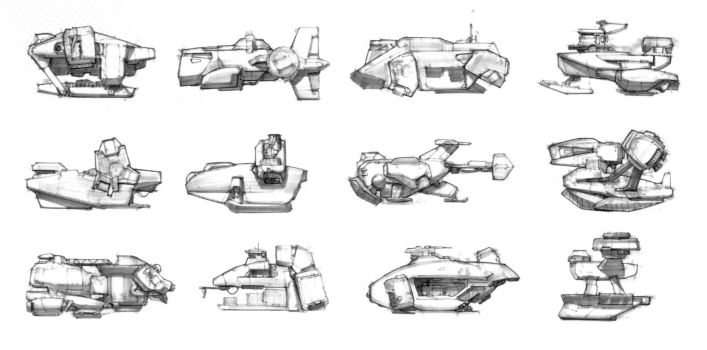

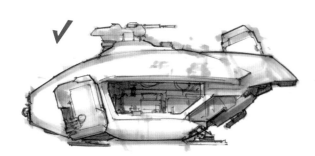

Submarine-like shape This thumbnail leans towards the "ship" aspect a little more literally than some of the others, with a sleek, submarine-like feel to its shape, which is easy to read. I like the tri-engine configuration on this one (two external engine pods on the nose and the third being embedded in the tail region).

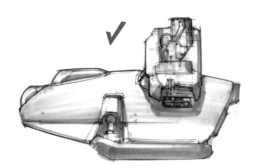

Recognizable logic This has a recognizable shape. Virtually everyone has seen an aircraft, be it a helicopter or plane, and the shape of this one fits within that familiar logic. I also like the shape and configuration of the engines, which are connected to the ends of small winglets.

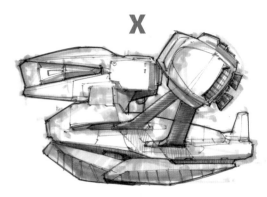

Incoherent design This is the weakest thumbnail. There is zero design sense; it is complete chaos. There is a lack of any coherent shapes or logic to any of it, which can be said for a few others, but this one is the worst!

PERSPECTIVE THUMBNAILS

Referencing the thumbnails from the previous section, we can now explore and refine the details that are the most appealing. With this information we can come up with a final direction in which to take the design. Aim for a design with a neat hierarchy of shapes, which feels like a solid foundation for fun exterior details.

Like the previous section, I start off by sketching broad shapes with a 30% gray marker. The final design will be rendered in three-point perspective, which is a relatively wide angle, so there will be some exaggeration and distortion because the perspective points are at more of an extreme. My chosen thumbnail on this page illustrates this, as opposed to the other three sketches.

Another good thing to remember is to either elevate or lower your point of view to above or below the vehicle. This will create a dynamic angle of the ship that makes it easier for the viewer to understand what they are looking at.

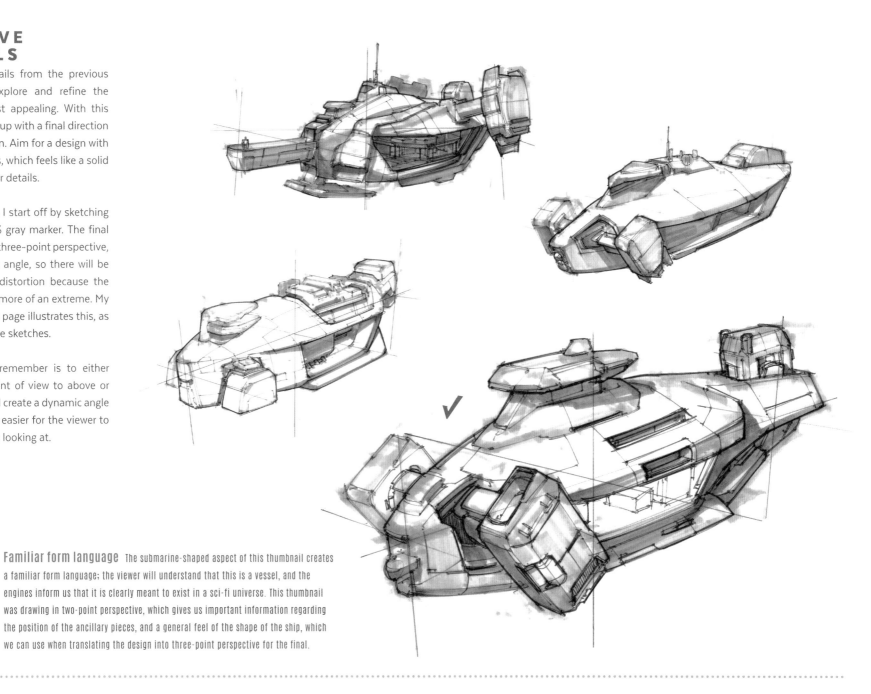

Familiar form language The submarine-shaped aspect of this thumbnail creates a familiar form language; the viewer will understand that this is a vessel, and the engines inform us that it is clearly meant to exist in a sci-fi universe. This thumbnail was drawing in two-point perspective, which gives us important information regarding the position of the ancillary pieces, and a general feel of the shape of the ship, which we can use when translating the design into three-point perspective for the final.

BASIC SHAPES

Here we will begin the final design steps by first establishing a three-point perspective grid. The third perspective point will give the design a slightly exaggerated appearance, which is closer to the way our eyes naturally perceive the world around us. This wider view will also be helpful in selling the scale of the ship. I start by drawing a horizontal line, which serves as the horizon for my eye. It is raised up near to the top of the page, which means the point of view is going to be above the ship. There is a vertical line down the center and a point near the bottom of the page.

The other two vanishing points can be placed wherever you wish on the horizon, depending on what angle you want the ship to be seen from; for example, if you want to view the facing side of the ship and less of the opposite, move the right point further to the right and the left point closer to the center). Depending on how "wide" you wish the angle to be, compress or spread out the points on the horizon line. For this example, we will keep them equidistant on the line from the center point.

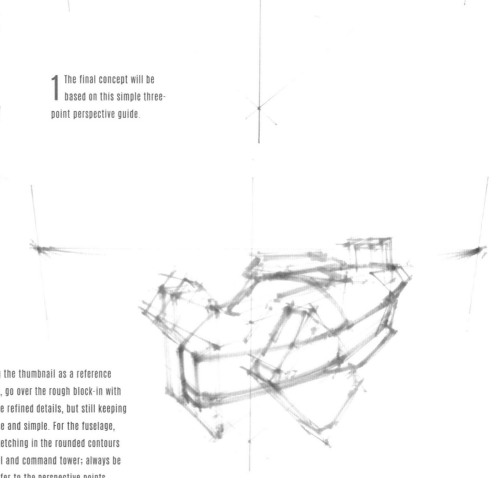

1 The final concept will be based on this simple three-point perspective guide.

2 Begin blocking in rudimentary shapes that will represent the primary parts of the ship: fuselage, engines, tower, and so on. Sketch in the shapes using a light gray marker (10% to 30% gray). Be sure to use the perspective points and guidelines to gauge how exaggerated the ship will be.

3 Using the thumbnail as a reference point, go over the rough block-in with some more refined details, but still keeping them loose and simple. For the fuselage, I begin sketching in the rounded contours of the hull and command tower; always be sure to refer to the perspective points.

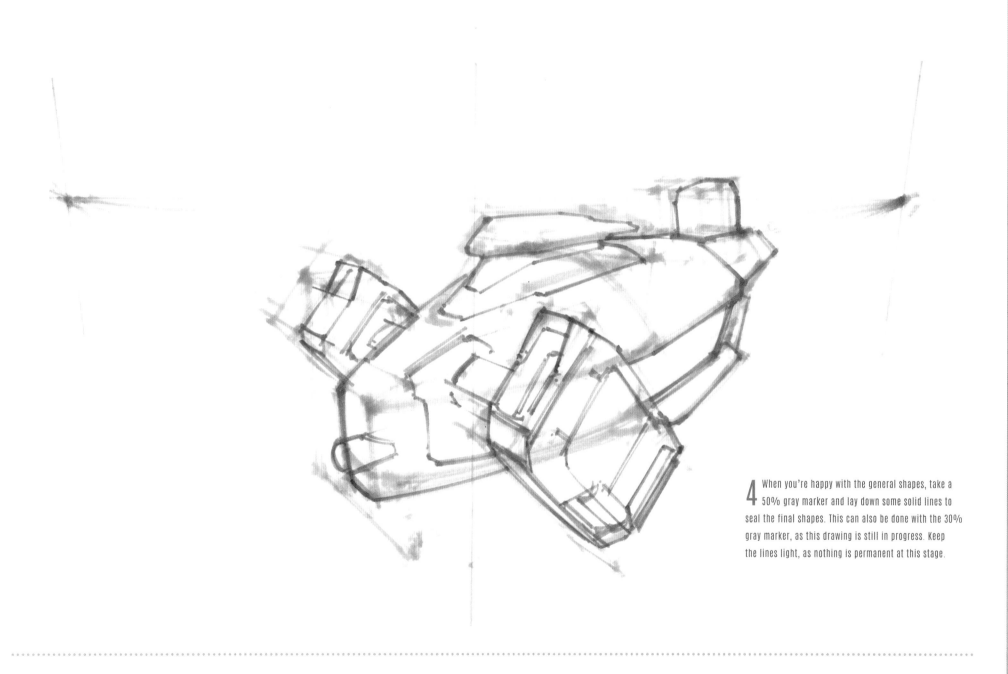

4 When you're happy with the general shapes, take a 50% gray marker and lay down some solid lines to seal the final shapes. This can also be done with the 30% gray marker, as this drawing is still in progress. Keep the lines light, as nothing is permanent at this stage.

DETAILS

In the next few steps, we will begin establishing the final shape of the craft using pens. Until the final image is set I need to emphasize that the linework is kept to the broad shapes unless otherwise noted. Be sure to keep the lines relatively lightweight; thin lines are best at this juncture. If you mess up, keep going. This ship is going to have a rough exterior of wear, so you can work any mistakes into the final texturing.

5 Once you are happy with the marker layout, take a fineliner pen and follow the same steps as before: outline the broad shapes; no minute details. Keep the lineweight as even as possible.

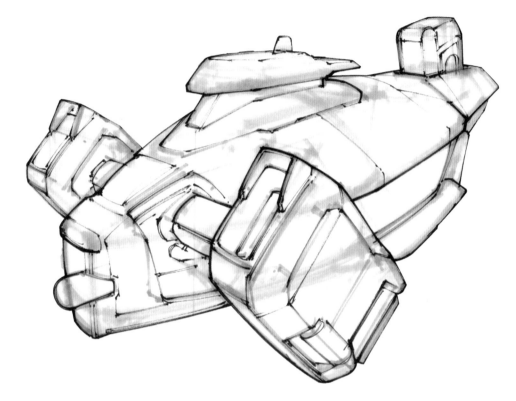

6 Begin to add details, but still keep them broad. Add some contour lines over the hull to help define the rounded shape (these will be worked into the paneling details later). Go over some of the primary shapes in a slightly heavier lineweight (such as the foreground engine and the fuselage silhouette). This will help you to separate the pieces and make the design easier to read.

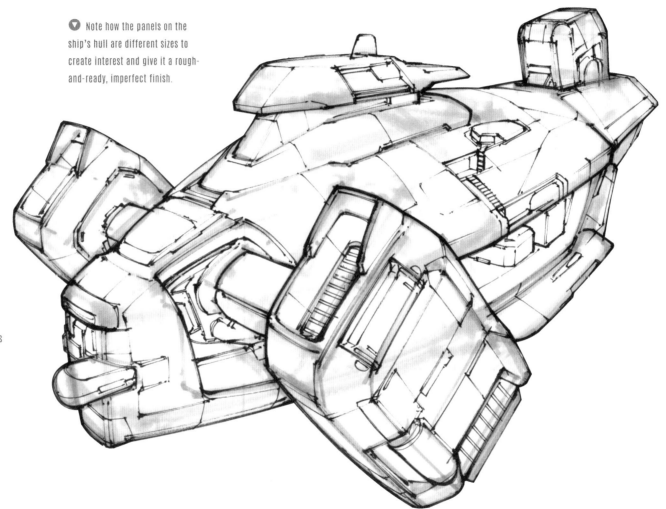

Details such as the open cargo door, ladders, and walkways on the ship's side help to create scale by showing how crew members access and traverse areas of the craft.

Note how the panels on the ship's hull are different sizes to create interest and give it a rough-and-ready, imperfect finish.

7 Continue adding detail, specifically cut lines (the manufactured pieces that create a tapestry on the surface of the ship). Be sure that they are of varying sizes and unevenly dispersed all over the hull to help sell the size of the ship. Save the minute details until later.

FINAL LINE DRAWING

In preparation for the final rendering stage, gather up 30 to 70% gray markers, black fineliner pens (0.2 mm, 0.3 mm, and 0.5 mm), black and white colored pencils, and white paint pens for the highlights and texturing. These will be used to render two types of metal material. The sides of the ship facing the primary light source will be broadly lit and only the wear and tear will catch the light, creating little "hot spots" (sharp faces that catch direct light) on the surface.

LIGHTING DIRECTION

Making a copy (or a very rough sketch) of the final line art, I decide to place the global light source on the opposite side of the ship. This will throw the facing side into shadow and create a bold silhouette.

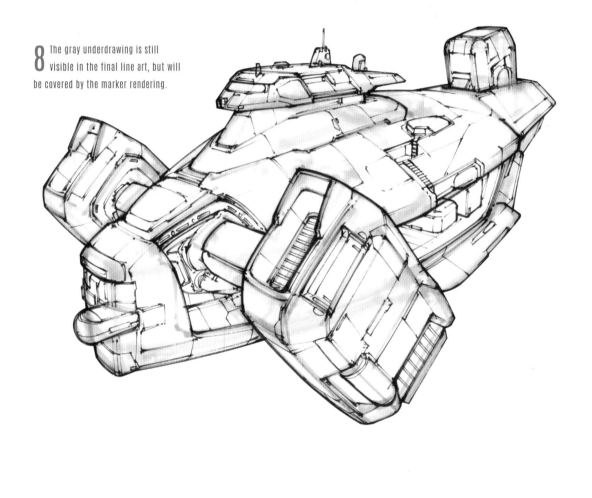

8 The gray underdrawing is still visible in the final line art, but will be covered by the marker rendering.

MATERIALS: WEATHERED METAL & SCRATCHED METAL

Weathered metal

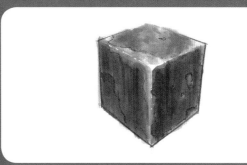

A For the rust, visualizing it on a solid surface is preferred. Start with a box and fill it with the 10% gray marker so that it is slightly darker than the paper. This will be the exposed "reflective" part of the metal showing through the rust. The rust will eat away at the surface layer paint and expose the base that's underneath.

B Take a sharp black pencil and lightly create erratic patterns on the edges and corners. Most erosion will take place on connection points or any part of the shape that is directly exposed to the elements. You can even add little chips of paint in the center of the faces as well. Now take the 30% gray marker and fill in the "paint," or the unaffected areas.

C Let the ink dry, then use the 50% gray marker to darken the unaffected areas, but do so unevenly to create flaky weathering. Go back over with the 10% and 30% gray to "dirty up" the exposed metal. Add streaks of black pencil as if rust has leaked down the faces, then use white paint to add an uneven highlight to the corner.

Scratched metal

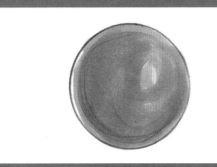

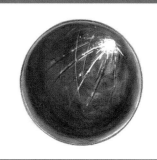

A Like the rust texture above, fill in the circle with a flat 10% gray marker to form the base tone. Repeat a couple of times more, so that the gray tone is just darker than the paper. Unlike rust, scratches on a metal surface will be abrupt. There is distinct chipping of paint and harsh scratches into the metal face, where debris has impacted the surface and left a small ditch, much like a cracked windshield.

B Using the 30% gray marker, "wrap" your strokes in a sickle-shaped movement to create a light spot on the upper right side of the sphere. The opposite lower side should be darker as the light falls off and rounds the edge of the sphere into shadow. Light will reflect onto the sphere from the environment, so the edges should remain slightly brighter than the center of the sphere. As a point of reference, use the black pencil to lightly create a guide for the next step so you know where to avoid shading.

C Fill in the sphere with the 50% gray marker so that it is much darker. In the brightest spot on the sphere, take a white pencil and lightly trace sharp streaks that fall off as they go around the sphere edge. Criss-cross a few smaller streaks. Take a black pencil and create shadows on the opposite sides of the white scratches to give them depth. Create a bright hot spot with a white paint pen, then trace the scratches with a sporadic dotted line to create an uneven edge on the scratches.

RENDERING PROCESS

The ship is going to be opaque and mostly non-reflective, as its surface is made up of welded metal plating. Multiple passes of gray Copic marker (colors swatched below) will be used to gradually build up this matte effect, with some panels darker than others to lend a weathered, heavily-repaired appearance to the hull.

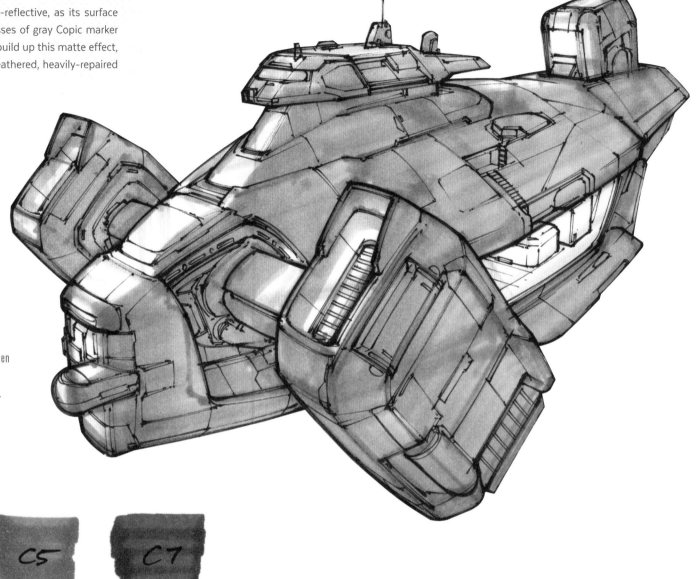

9 Begin with a first pass of light gray marker to establish the basic light source and shadow shapes. Leave the insides of the engines and the open bay on the shadowed side of the ship unshaded for now, as they will be illuminated by an interior light.

 C1

 C3

 C5

 C7

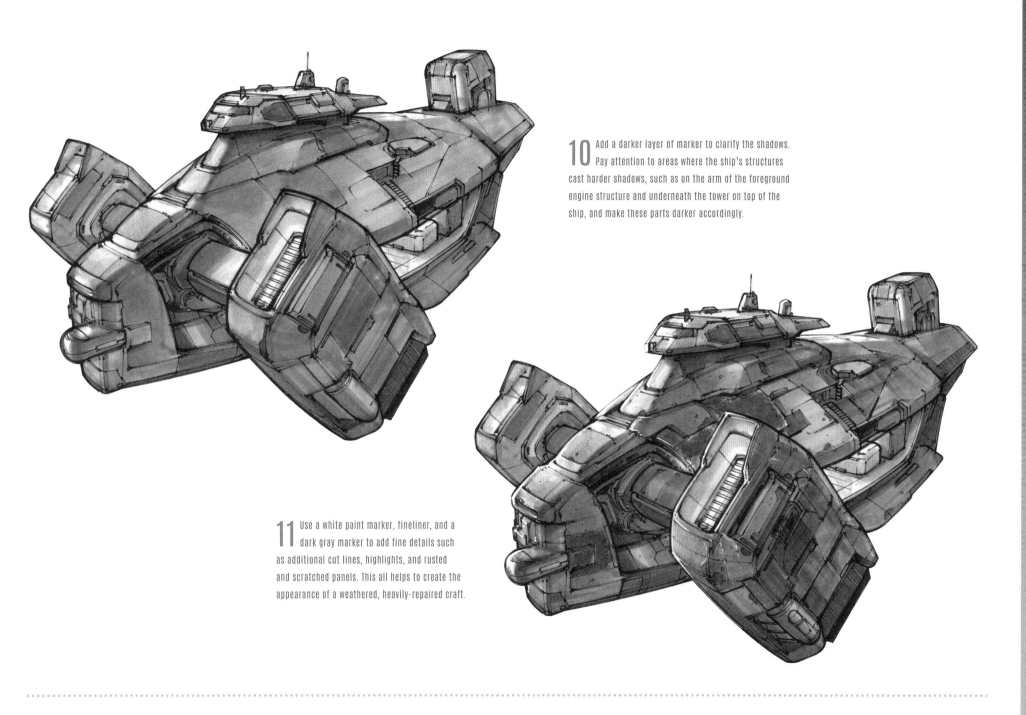

10 Add a darker layer of marker to clarify the shadows. Pay attention to areas where the ship's structures cast harder shadows, such as on the arm of the foreground engine structure and underneath the tower on top of the ship, and make these parts darker accordingly.

11 Use a white paint marker, fineliner, and a dark gray marker to add fine details such as additional cut lines, highlights, and rusted and scratched panels. This all helps to create the appearance of a weathered, heavily-repaired craft.

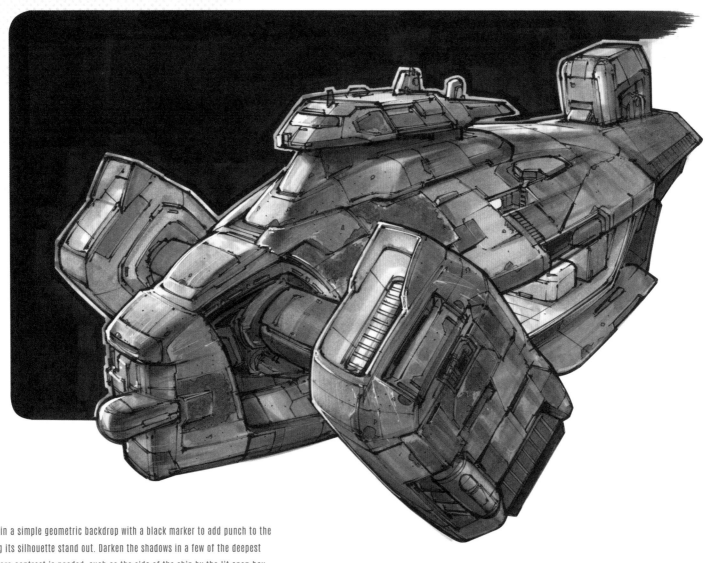

12 You can block in a simple geometric backdrop with a black marker to add punch to the design, making its silhouette stand out. Darken the shadows in a few of the deepest crevices and where more contrast is needed, such as the side of the ship by the lit open bay.

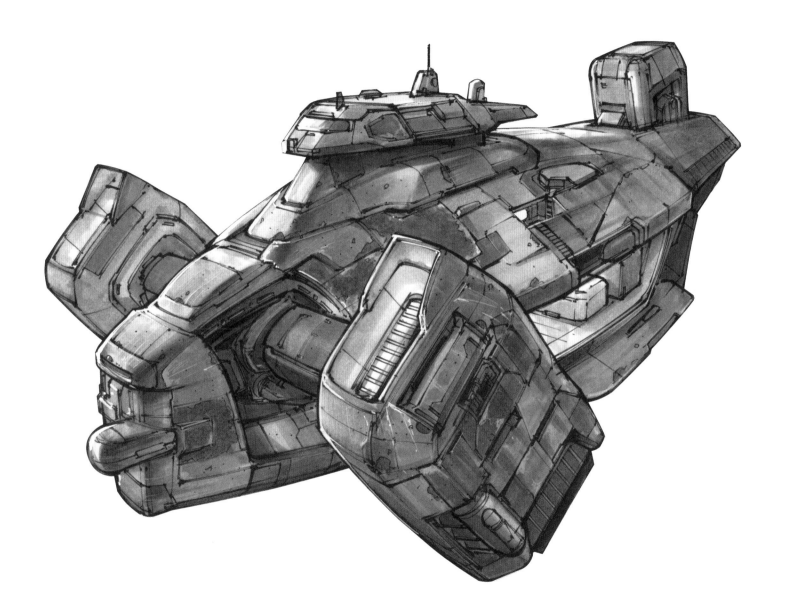

CONCLUSION

This design was enjoyable for me to create because it's basically stream-of-consciousness design – improv for the imagination. I began with a basic idea, and drew from real-world shapes and forms that I had in mind thanks to my years of designing. The initial thumbnail is quite close to the final image, with the added twist of the new perspective, and that is the key to good design: taking the mundane or familiar, and looking at it from a new angle. I liked the profile view, but perspective added a great deal of personality to the final design.

First and foremost, this design process should be *fun*. I cannot stress that part enough. We're drawing spaceships, so there should be zero stresses! Going hand in hand with the "fun" is the research; I would encourage you to have a camera (a phone, for most people) and/or a small sketchbook that you carry wherever you go. Inspiration is everywhere, and when designing for science fiction – or even fantasy – you must always observe and reference reality to some degree.

HIGH-TECH LUXURY HOME

BY CALLIE WEI

calliewei.artstation.com | All images © Callie Wei

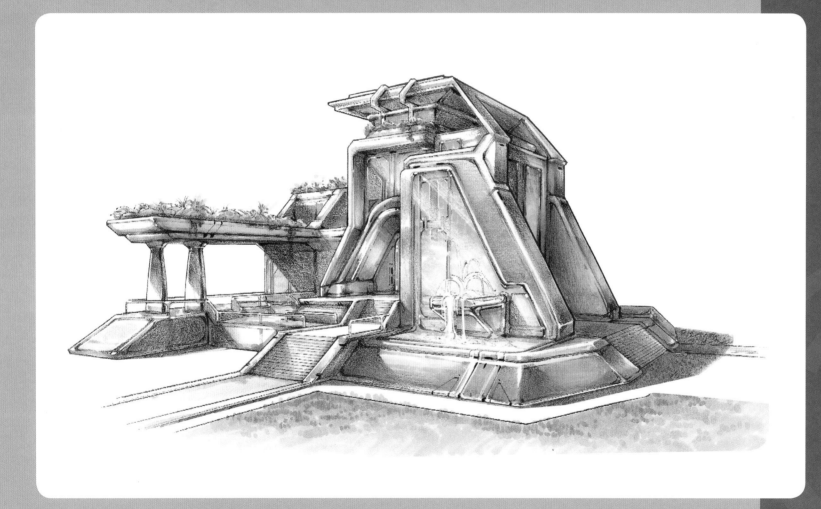

In this section, concept designer Callie Wei will break down the process for creating a sleek, glazed luxury dwelling. Marker pens will help to easily create the building's smooth, shining surfaces, while black and white colored pencils add texture to the shadows and highlights.

TOOLBOX

- Markers: light, medium, and dark in each color you wish to use (e.g. Copic 2, 4, and 6)
- Staedtler Pigment Liner (0.3 mm fineliner)
- Sharpie Fine & Ultra Fine Twin Tip marker
- White gel pen
- Black and white Prismacolor pencils
- Ruler
- Marker paper

RESEARCH

When starting to design any building, you need to make sure that you clearly decide two things: shape language and aesthetic treatment. Shape language refers to the basic shapes and silhouette, and the aesthetic treatment refers to the small detailed shapes within that silhouette. This formula is a good general guideline to help you create a cohesive design. To design this futuristic luxury home, I decide to combine the shape language of Islamic architecture with the sci-fi aesthetic of NASA drop pods.

Rocket engine In this study of a rocket engine, see how the round forms transition to give it a sleek sci-fi look. The cut lines go around the forms in a flattering way that is not too visually "noisy."

NASA drop pod In this study of a drop pod, pay close attention to the paneling detail on the rounded forms, as well as where the holes are placed. These holes are a small negative shape that will help to create visual interest.

Landing pad If you want to include a helicopter pad in your design to make the building seem more grand, keep in mind the support beams and walkways to add believability.

Islamic pillars Islamic architecture is easily recognizable for its unique pillars. I study the proportions and how the main shapes connect to each other.

Architecture analysis By breaking down the main windows, doors, and large shapes that make Islamic architecture look immediately recognizable, you can easily build upon those ideas to create a design that is still grounded in reality.

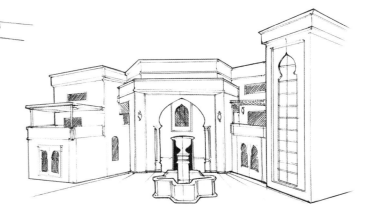

FLAT THUMBNAILS

When you are trying to ideate a design, you should approach it as clearly and simply as possible. One method is to sketch flat, front-facing buildings quickly with a light gray marker, so you don't get overwhelmed with the technical drawing aspect and can focus purely on silhouette and design. In this stage I want to explore different proportions and shape languages inspired by my previous study sketches.

Notice how I try out some thumbnails with a boxy Islamic-inspired silhouette, some that are more angular, and others that are rounded and taper upwards like a rocket, like the engines I explored in my research.

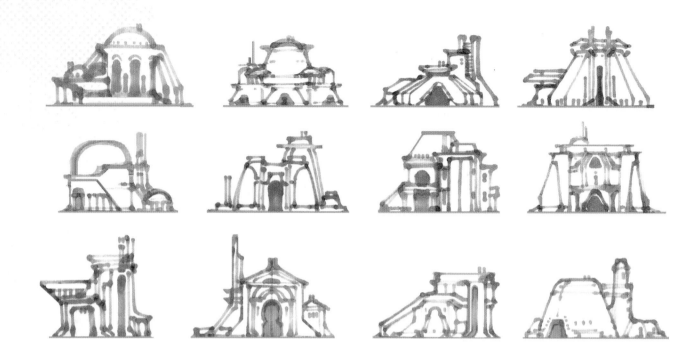

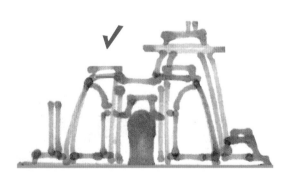

Balanced structure This thumbnail has a good balance of large, medium, and small shapes. The shapes are cohesive with one another, and there is potential for many different variations.

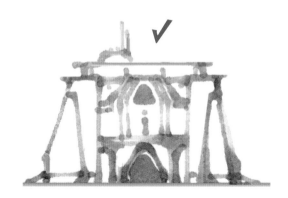

Bold inner shapes This thumbnail has strong inner shapes, allowing for possible multiple floors and a grand, luxurious entrance which is what I am looking for in this design.

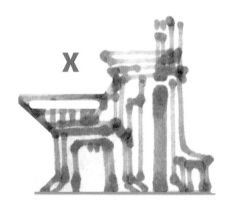

Unclear function This thumbnail does not work because it does not immediately tell you what the subject is. It could be any kind of building, which is a problem. It needs to be recognizable as a luxury home upon first read.

PERSPECTIVE THUMBNAILS

Since this design is a luxury home, a three-point perspective shot looking up at the building will make it feel larger and more immersive. However, it is still useful to explore other angles to show more information about the building, especially if it may include details such as a helicopter pad or something significant on the roof.

Using the previous thumbnails as a very loose guideline, I explore pushing and pulling the forms. I must prevent the building from looking like a simple cube, as that is not visually stimulating. Use a pen or pencil to achieve a finer level of detail in this round of sketches.

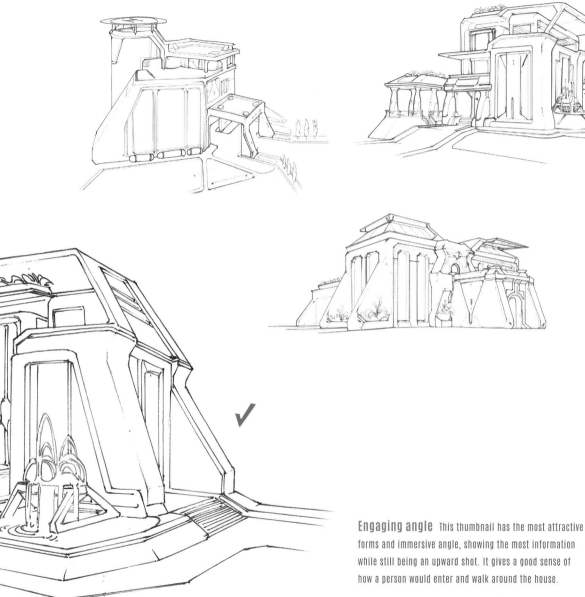

Engaging angle This thumbnail has the most attractive forms and immersive angle, showing the most information while still being an upward shot. It gives a good sense of how a person would enter and walk around the house.

BASIC SHAPES

To refine the thumbnail, it is very important to have a perspective grid to work on top of. This streamlines the process, allowing me to focus on solving important design issues instead of technical perspective issues. Since the chosen thumbnail has the exact angle I want, I now need to break down the shapes into their simplest forms. Although the thumbnail includes angles and bevels, it is important to look past them and see the overall large shapes first, then cut and add more boxes to modify the form.

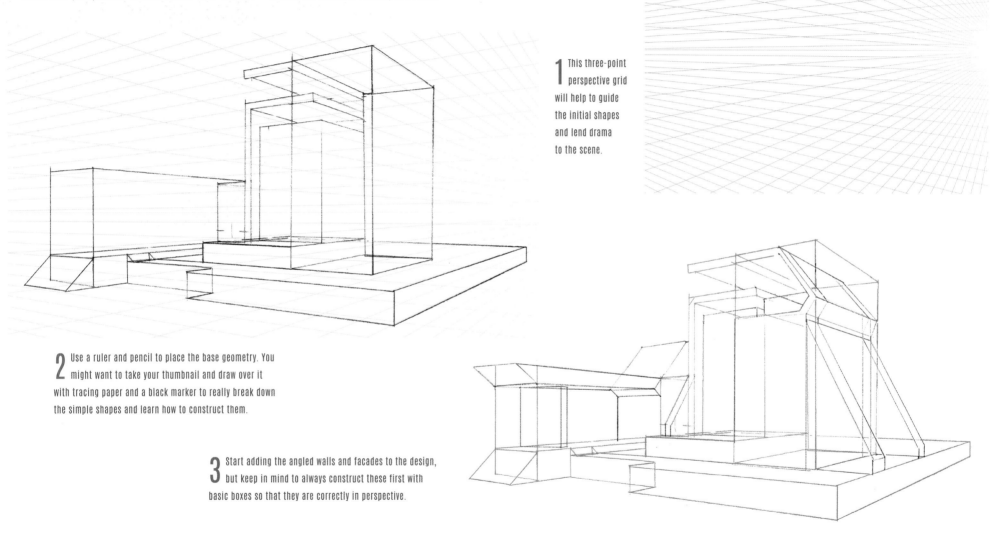

1 This three-point perspective grid will help to guide the initial shapes and lend drama to the scene.

2 Use a ruler and pencil to place the base geometry. You might want to take your thumbnail and draw over it with tracing paper and a black marker to really break down the simple shapes and learn how to construct them.

3 Start adding the angled walls and facades to the design, but keep in mind to always construct these first with basic boxes so that they are correctly in perspective.

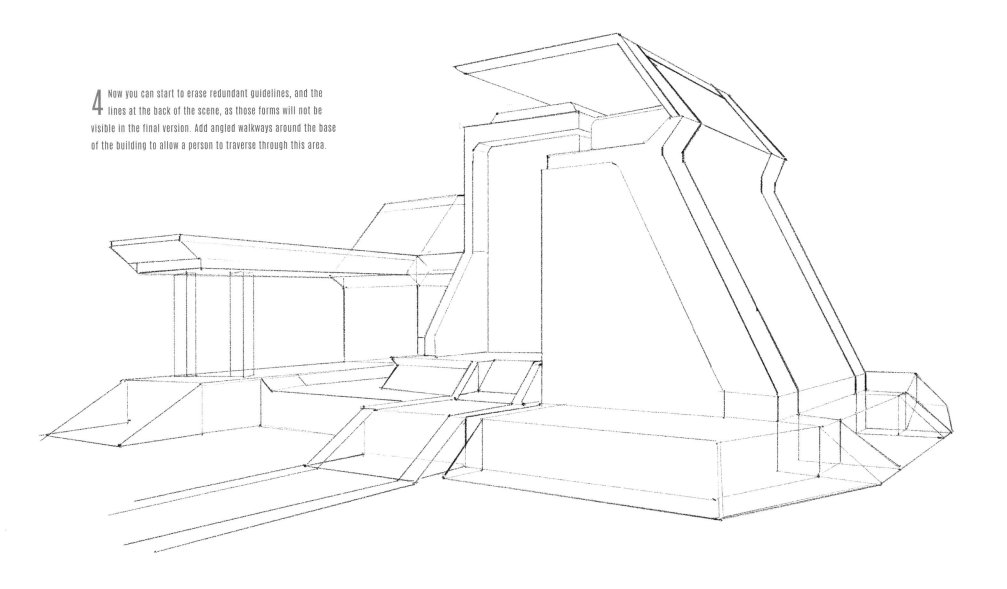

4 Now you can start to erase redundant guidelines, and the lines at the back of the scene, as those forms will not be visible in the final version. Add angled walkways around the base of the building to allow a person to traverse through this area.

DETAILS

Try to only add the sci-fi details you found in your studies, and not add random details entirely from your imagination. The reason for this is because our visual library is often too scattered to feel cohesive, and we don't want to undermine our own research. By setting up these design limitations for yourself, relying only on the initial reference you decided on, you will drastically increase the believability of your design. I have chosen to add a helicopter pad, a rooftop garden, a fountain, and large glass windows. All of these are chosen to help sell the idea of the futuristic luxury home, as you often see similar assets on existing mansions today.

You can begin setting down the final outlines in black pen now, or continue working in pencil and simply scan, print, and color over a duplicate later.

5 Start detailing from the focal point, which in this case is the entrance, enhancing the edges with bevels and borders. Play with Islamic wall motifs in a sci-fi fashion by connecting the lines just as you analyzed in the rocket engine and drop pod studies.

6 Here you need to nail down the main focal areas: the main entrance and fountain. Do this by adding a more detailed frame to the door, and adding an angled block for the fountain before detailing it with water. To help sell how a person would enter and walk around this area, add handrails and stairs. This will also help to convey scale.

7 Now that you have the general idea down, here you are adding more small details such as the rooftop garden, supporting beams for the subtle helipad, and cut lines that help your eye flow back to the focal point (main entrance). See how the cut lines and decorative details are light and simply drawn here, so they don't distract from the main outlines and angles of the architecture.

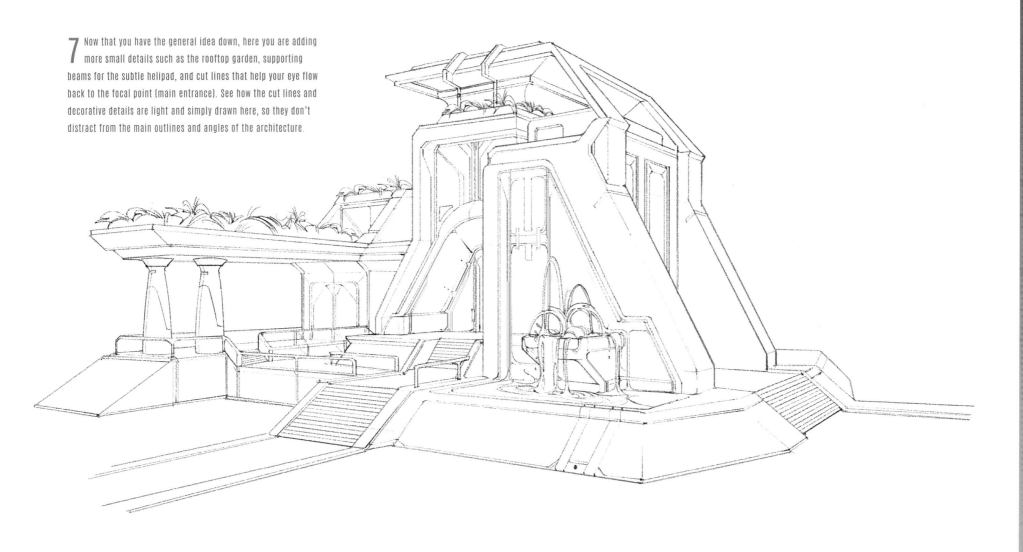

FINAL LINE DRAWING

To recap, the process to achieve a finished line drawing is to start with the basic shapes; cut out and add to the shapes; clean up this base; then add detail to the focal point before radiating detail outwards.

The details should be most complex around the focal area (in this case, the doorway) and looser in the less important areas of your piece, to draw the viewer's eye firmly to the most important or relatable element of the design. Evaluate your lineweights at this point to make sure they have this balance, like the final drawing pictured right.

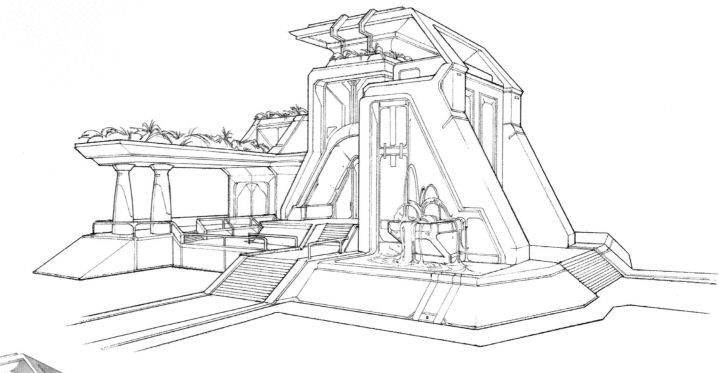

8 At this point you should have a final detailed line drawing, ready for coloring. The main outlines are bolder to ensure they stand out. There is space in the foreground for a lawn which will be conveyed with color rather than lines.

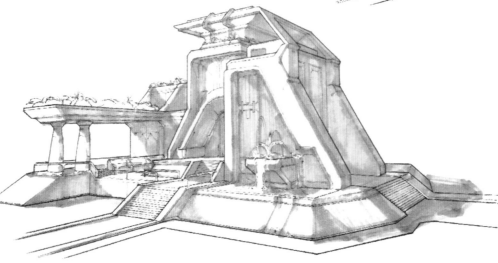

9 On a very loose duplicate of your final line drawing, use a light gray Copic marker to create a quick lighting pass, indicating where the light and shadow will be.

MATERIALS: CHROME & GLASS

Chrome

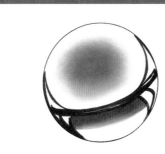

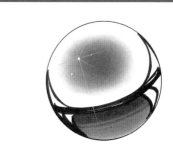

A Use an ellipse guide to draw out a circle with the Staedtler pigment liner. Determine your light direction and then use the fine tip of the Sharpie to draw curving lines perpendicular to your light direction; this is the core shadow of the sphere.

B Chrome is simply a reflection of the environment onto a form. To imitate the look of a desert and a clear blue sky, take a brownish-red Copic marker and apply to the bottom side of the Sharpie core shadow. Now take a very light blue Prismacolor pencil to the center of the upper sphere and carefully color in a smooth gradient radiating outwards.

C Immediately blend the brownish-red color down with a gold-orange Copic marker until it fills the bottom half of the sphere. Take a ruler and a white Prismacolor pencil to draw a dramatic star in the sky. Now take a white gel pen and dot the center of the star and one or two on the other flecks.

Glass

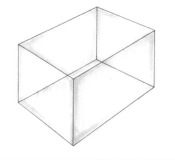

A Glass is a transparent and reflective material. Start by using a ruler and a Staedtler pigment liner to draw a simple box in a front-facing three-quarter perspective. Take your lightest blue Copic marker and trace the box's lines with the broad side of the marker. Now fill the empty sides with the same blue color, working with confident strokes in the same direction. Leave a couple of angled white marks so that the surface feels reflective.

B Using the second, medium-blue Copic marker, emphasize the lines right next to the box's edges to give the illusion of thickness and a rounding form inside the glass cube. Make sure to keep the white highlights clean.

C Lastly, use the last and darkest blue Copic marker to emphasize the lines right by the box's edges once more to really punch them out. Push this further using your Staedtler pen, drawing thin black lines in the vertices. Finally, use your white gel pen to dab white dots on the edges to create a convincing glassy shine.

RENDERING PROCESS

The tools I will use for rendering this design include: Copic markers, a 0.3 mm Staedtler Pigment Liner, a Sharpie Fine + Ultra Fine Twin Tip marker, white gel pen, black and white Prismacolor pencils, a ruler, and marker paper. When choosing Copics, I select three markers for each hue that I plan to use (values 2, 4, and 6 specifically) in order to create light, medium, and dark shades in each color.

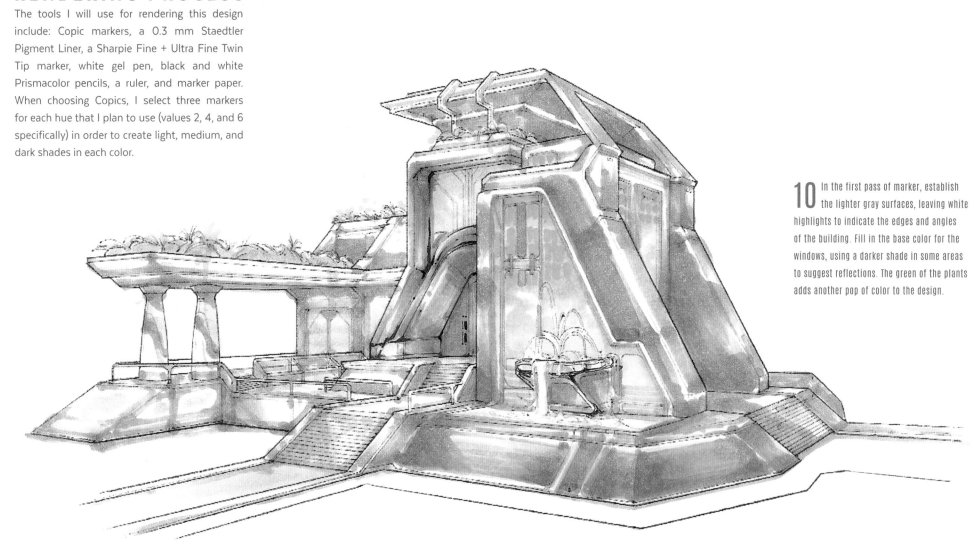

10 In the first pass of marker, establish the lighter gray surfaces, leaving white highlights to indicate the edges and angles of the building. Fill in the base color for the windows, using a darker shade in some areas to suggest reflections. The green of the plants adds another pop of color to the design.

11 Darken the gray with a second pass of marker to make the highlights pop even more vividly; now the angular futuristic design is even clearer. At this point you can lightly apply some extra green in the foreground as a base for the lawn.

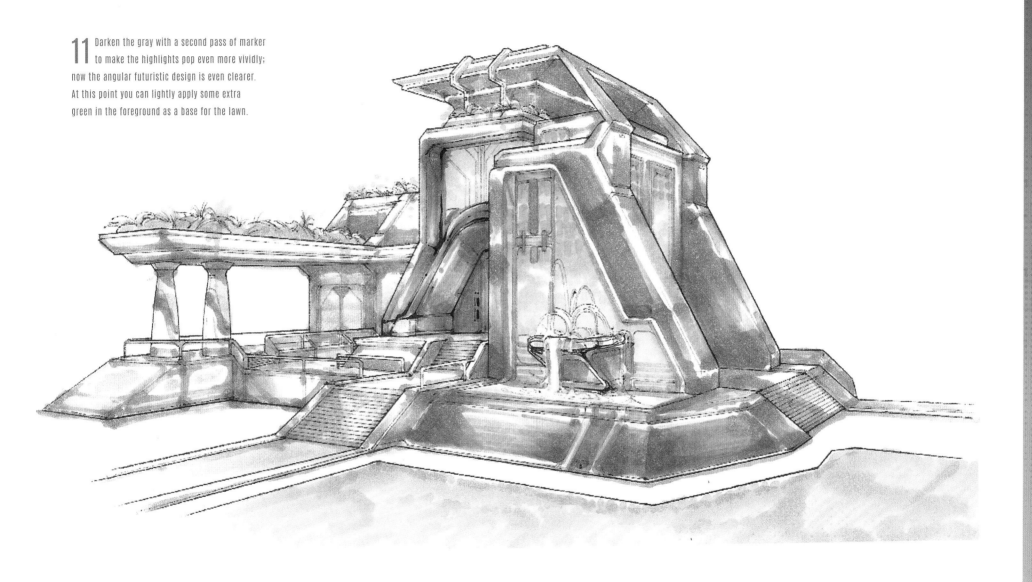

12 Flesh out the shaded areas and cast shadows with black pencil to give a new dimension of texture to the design, complementing the smoothness of the markers. Apply dabs of darker green to create more detail in the grass and plants, and strokes of white pencil to give the glass windows a mirror shine.

▶ As a finishing touch, you may wish to add flecks of color to the plants to suggest flowers.

◀ The design still needs some detail, so I will use black fineliner pen and white gel pen to bring the crisp lines of the design back out, sharpening the window frames, and adding extra details and panels to the final version.

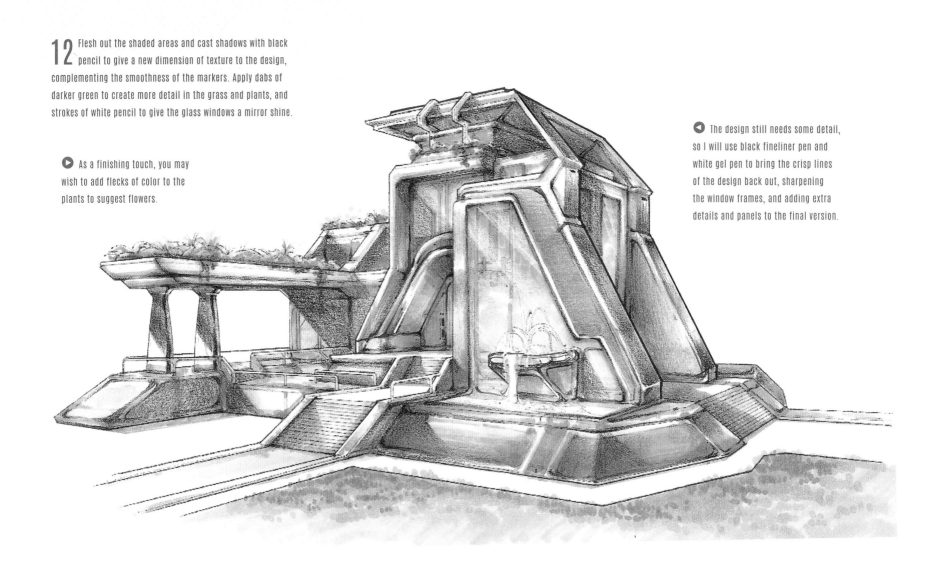

CONCLUSION

The initial design objective was to achieve a sleek, futuristic luxury home with a helipad, fountain, and garden using Islamic architecture and NASA drop pods as the basis for my design language. I'm satisfied with the result as it stays true to the original reference and fits all the required details without overwhelming the piece. Islamic architecture is well known for its motifs, squared-off roofs and repeating lines, and NASA drop pods are quite angular, with a short drop-off at the very bottom, and I believe the finished design successfully marries both these inspirations in a balanced way.

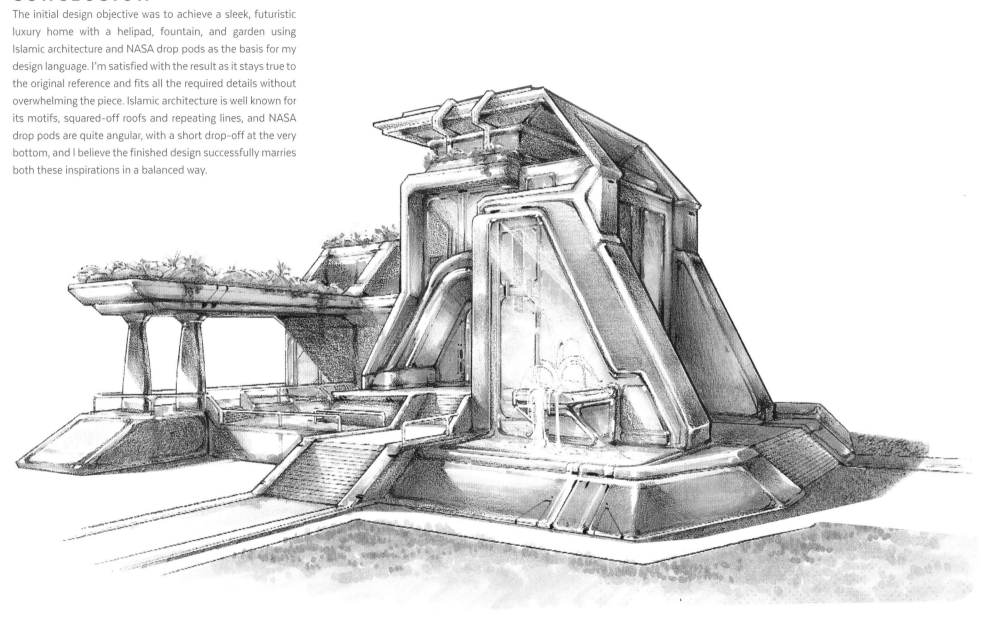

DOMESTIC HELPER ROBOT

BY ANG CHEN

angchendesign.com | All images © Ang Chen

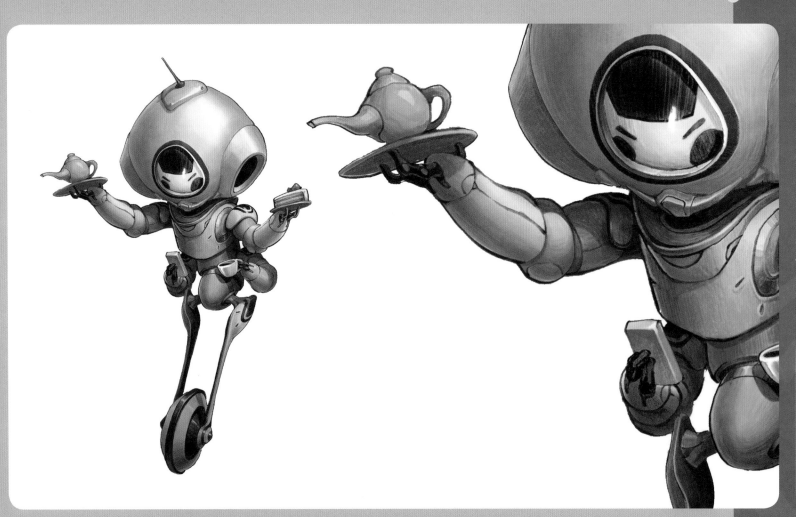

In this tutorial, entertainment designer Ang Chen breaks down the design behind this domestic companion robot. This busy bot will feature a humanoid face which would make it relatable and appealing to its human owners. Multiple limbs will make it efficient for carrying out several chores. Soft graphite pencils, erasers, and blending tools will be used to create a sketchy but smooth finish on the robot's clean, glossy surface.

TOOLBOX

- Soft graphite pencils
- Black colored pencil
- Blending tools
- Erasers
- Opaque white medium, e.g. paint pen (optional)

RESEARCH

As I will be designing a friendly personal-helper robot, I want to study the joints that already exist in real-world counterparts such as the ASIMO robot (the well-known humanoid robot designed by Honda). I want the design to have smooth, hidden joints to maintain a cute, sympathetic feel; this robot should not look threatening or too industrial for a household environment.

My studies tend to be quick, messy, and imperfect. I use this stage to wrap my head around a certain form or an idea, so I try not to spend time making these sketches look "good." Avoid worrying about presentation and technique during this stage, and focus purely on the substance of the sketches.

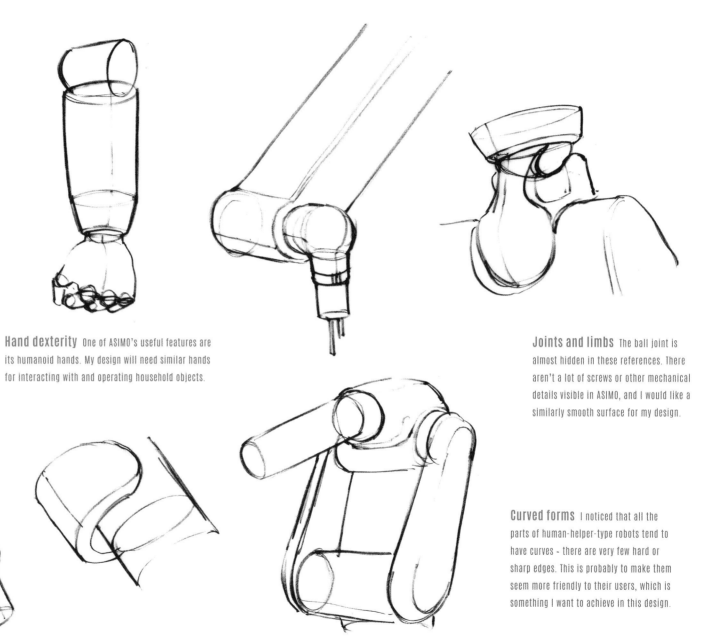

Hand dexterity One of ASIMO's useful features are its humanoid hands. My design will need similar hands for interacting with and operating household objects.

Joints and limbs The ball joint is almost hidden in these references. There aren't a lot of screws or other mechanical details visible in ASIMO, and I would like a similarly smooth surface for my design.

Curved forms I noticed that all the parts of human-helper-type robots tend to have curves - there are very few hard or sharp edges. This is probably to make them seem more friendly to their users, which is something I want to achieve in this design.

FLAT THUMBNAILS

Use a pencil to sketch thumbnails exploring a range of directions for the design, such as different variations of its modes of transportation, multiple arms, and so on. I try to explore many different silhouettes and overall shapes for the thumbnails, informed by the ones I saw in my research. Some of the ideas shown here are very humanoid, or even pet-like, while others draw inspiration from household objects and appliances to convey the robot's domestic role. Eventually I settle on two thumbnails that I like the most, either of which could work for a cute, child-like robot or a larger-sized assistant.

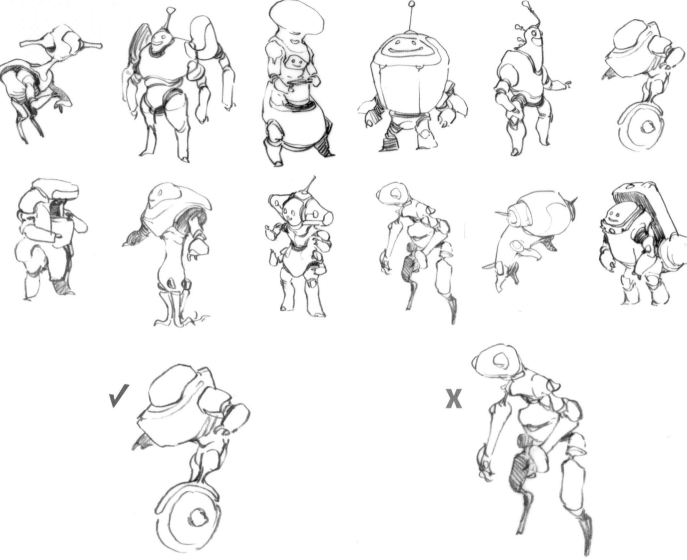

Unique shape I like the unique head shape in this thumbnail, as well as the utility and visual impact of the multiple arms. The thin antenna adds a contrasting detail that makes the whole design feel more complete.

Single wheel The single wheel in this design is a striking feature that adds a sense of fun and whimsy to this robot, and could help to make the design endearing.

Hunched posture This is one of the weaker thumbnails. The hunched-over posture and shape of some of the limbs make it look predatory and a little threatening. It could be an alien creature or a military robot - it doesn't look friendly and "domestic" enough.

PERSPECTIVE THUMBNAILS

These are thumbnails exploring further options based on the two I selected in the previous stage. Here I experiment with more interesting head shapes, and try combining my favorite elements from the two initial ideas: a head with distinctive "ear" sections, multiple arms for utility, and rounded features like a wheel or deep "collar" section around the head. I also experiment with different objects and accessories for the robot to interact with, looking for something that will lend a lot of personality to the design and give the best idea of its role.

In the final drawing, I plan to show the robot in the middle of performing an action, in simple one-point perspective and a three-quarter view, so I play around with different poses at this angle. These thumbnails are larger and more detailed than the ones in the previous stage, giving me a better idea of what the final design could look like, but are still not heavily refined or shaded.

Iconic silhouette This is the thumbnail I have chosen to take forward. I like the wheel as a way for the robot to move around, and I want to show the multiple arms each holding an item. The robot could be a personal butler or a waiter. Even though the head is not as complex as some of the other options, a simple circle or oval creates a more iconic silhouette and stays more similar to the original ASIMO inspiration. Borrowing an antenna shown in some of the other thumbnails will add a finishing touch to this rounded head.

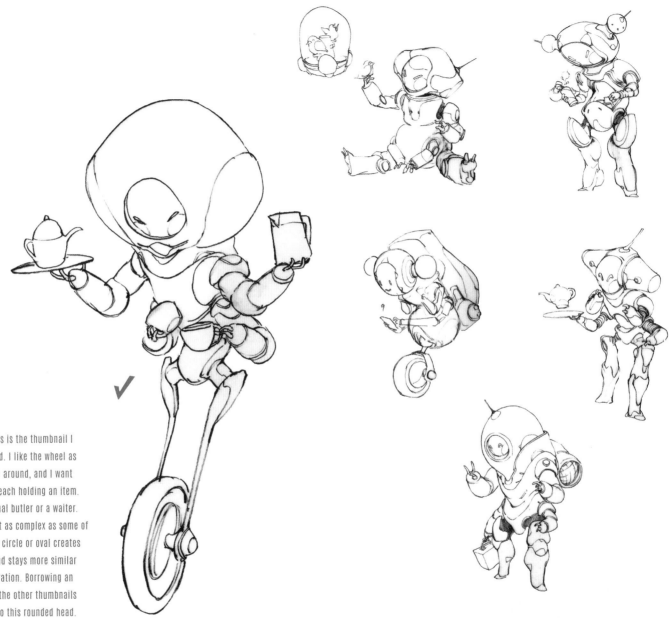

BASIC SHAPES

Before starting to block out the design, I sketch some general perspective lines. Because this robot doesn't have perfectly horizontal stacking segments and is mostly made of cylinders and spheres, I only use a few lines that could be drawn from a far-off horizon point, creating a subtle one-point perspective effect. The spacing of these guidelines will help to maintain the proportions for each segment of the robot's body.

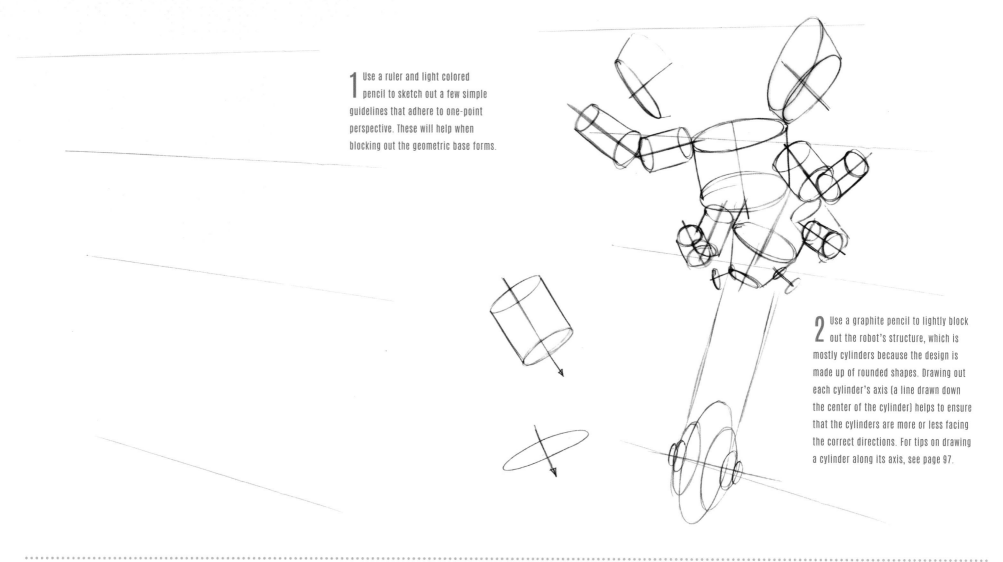

1 Use a ruler and light colored pencil to sketch out a few simple guidelines that adhere to one-point perspective. These will help when blocking out the geometric base forms.

2 Use a graphite pencil to lightly block out the robot's structure, which is mostly cylinders because the design is made up of rounded shapes. Drawing out each cylinder's axis (a line drawn down the center of the cylinder) helps to ensure that the cylinders are more or less facing the correct directions. For tips on drawing a cylinder along its axis, see page 97.

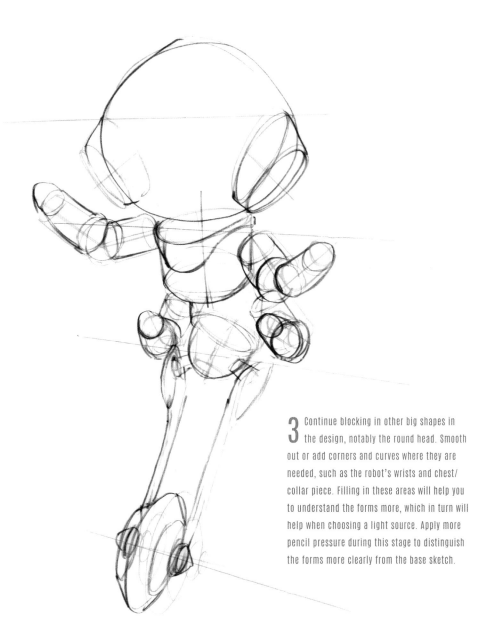

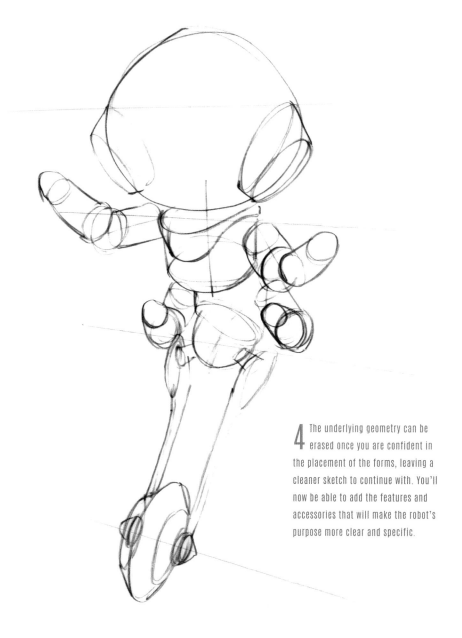

3 Continue blocking in other big shapes in the design, notably the round head. Smooth out or add corners and curves where they are needed, such as the robot's wrists and chest/ collar piece. Filling in these areas will help you to understand the forms more, which in turn will help when choosing a light source. Apply more pencil pressure during this stage to distinguish the forms more clearly from the base sketch.

4 The underlying geometry can be erased once you are confident in the placement of the forms, leaving a cleaner sketch to continue with. You'll now be able to add the features and accessories that will make the robot's purpose more clear and specific.

DETAILS

In these steps I continue to add surface details and chamfers, applying dimension and width to each piece that needs it, so that the robot doesn't look flat. These are mechanical details that provide a level of realism, as the robot parts shown in my research had thick, rounded plates and segments. The research also showed features that were relatively smooth, with very few visible screws, so I want to keep this design clean too.

5 Add a small "window" for the robot's face, following the curved sphere of the head to help create a sense of dimension. Some humanoid facial features will be visible here later.

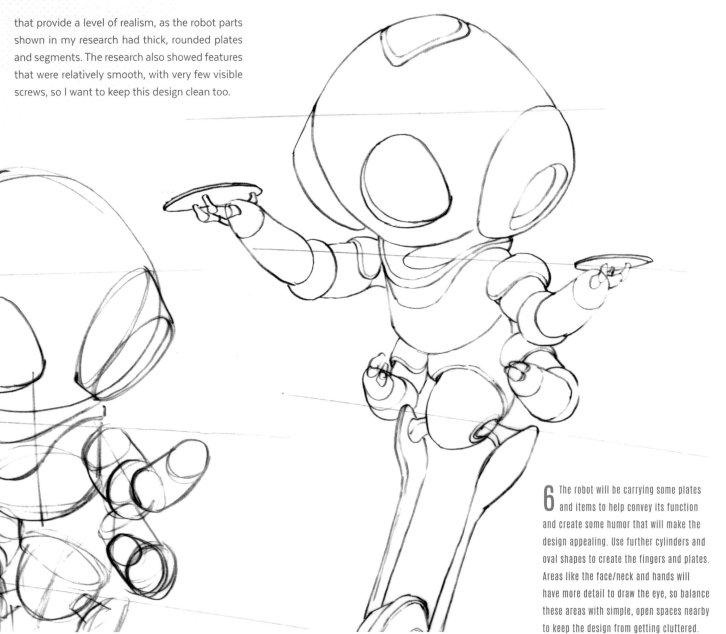

6 The robot will be carrying some plates and items to help convey its function and create some humor that will make the design appealing. Use further cylinders and oval shapes to create the fingers and plates. Areas like the face/neck and hands will have more detail to draw the eye, so balance these areas with simple, open spaces nearby to keep the design from getting cluttered.

7 Now focus on the finer details which are to show where different segments, parts, and joints start and end, such as cut lines on the body and round joints in the fingers. Some details can be for decorative purposes or as a suggestion of potential functions, like the lines I add to the collar/chest piece, which make it look more interesting and mobile. Note how the face and collar are detailed, while the rest of the head is not, so there's no confusion for the viewer about where to look.

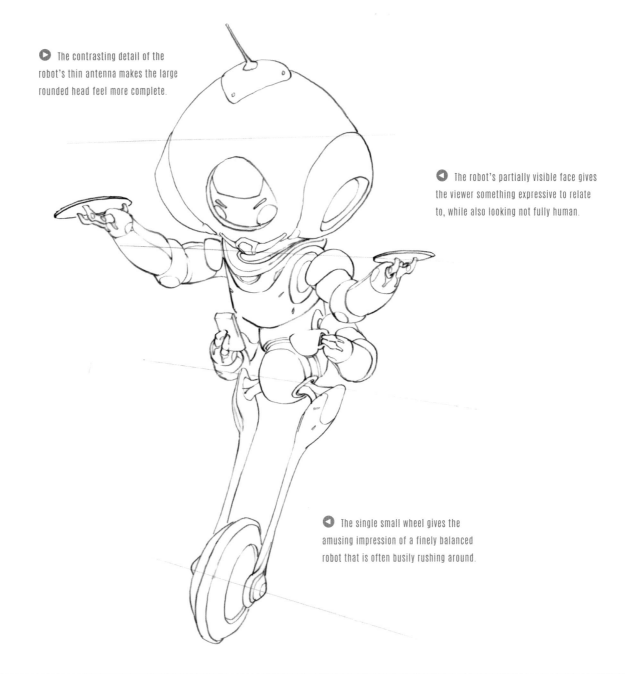

▶ The contrasting detail of the robot's thin antenna makes the large rounded head feel more complete.

◀ The robot's partially visible face gives the viewer something expressive to relate to, while also looking not fully human.

◀ The single small wheel gives the amusing impression of a finely balanced robot that is often busily rushing around.

MINIMAL DETAILS

Add a few screws here and there to suggest a manufactured surface, but keep these to a minimum to maintain a very smooth, clean appearance with no exposed machinery.

FINAL LINE DRAWING

This is the final line drawing with all the details included. I plan on leaving the lines relatively intact for the rendering stage, rather than erasing them or covering them over - this makes rendering and showing form much easier and quicker, because the lines help to define the forms, and will keep a sketchy hand-drawn appeal in the final image.

It's a good idea to scan your drawing and clean up any dirt and smudges, printing a copy on your chosen paper, rather than shading on your only hard copy for the final.

▶ You can erase the colored pencil guidelines at this point, or scan the image and lighten them in order to print a clean copy of the lines.

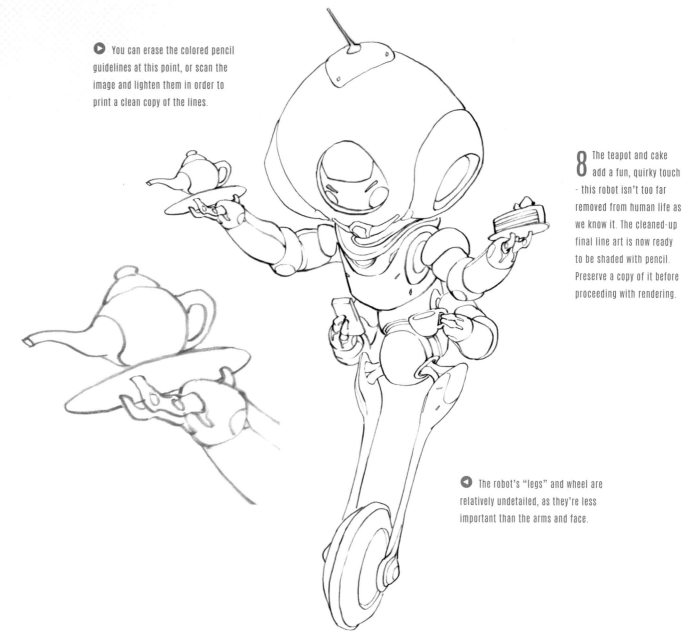

8 The teapot and cake add a fun, quirky touch - this robot isn't too far removed from human life as we know it. The cleaned-up final line art is now ready to be shaded with pencil. Preserve a copy of it before proceeding with rendering.

◀ The robot's "legs" and wheel are relatively undetailed, as they're less important than the arms and face.

ADDING A FACE
When creating a design that's meant to be sympathetic to a human audience, even a non-organic one such as a robot, a recognizable face is an asset that will instantly draw the viewer's attention. This robot's facial features and slightly harassed expression - even if they're somewhat hidden behind a glass window - add a lot of personality to this design.

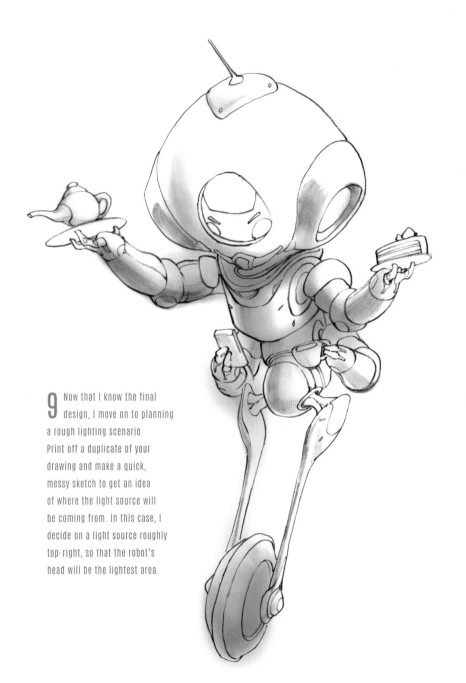

The top-right light source will light the side of the head that's facing the viewer most brightly, which is ideal for a clear final presentation. This scenario will create shadows on the left-facing sides of the robot's "ears," as well as deep shadows on its collar and chest, as those areas will be shielded from the light by its head and arms. However, the robot's surface is made from a light, polished material, so bear in mind how this will bounce some light back up onto nearby shadowed surfaces.

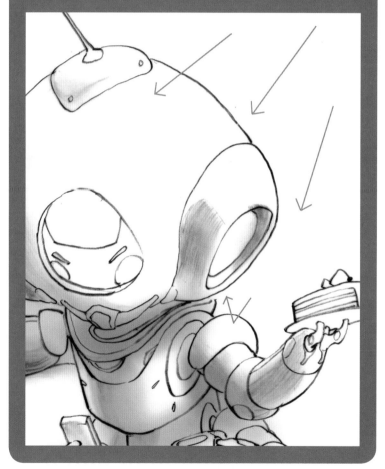

9 Now that I know the final design, I move on to planning a rough lighting scenario. Print off a duplicate of your drawing and make a quick, messy sketch to get an idea of where the light source will be coming from. In this case, I decide on a light source roughly top-right, so that the robot's head will be the lightest area.

Dark glass

A A dark glass texture will be useful for shading the robot's facial features, which will be visible through the round ASIMO-like window in its head. Start out with a rough line drawing of the shape you will be rendering, using a pencil for this light base sketch.

B Shade the cylinder with a dark value such as a soft pencil or black pencil. Very dark glass doesn't have a lot of value variation, but add just enough to suggest the curved form. You can see here how the gradient of darkness around the cylinder's body gives definite curvature to the glass surface.

C There should be a sharp contrast between the highlight and the general light that reflects off the dark glass, so erase out a brighter highlight on the top edge of the chamfered cylinder. The whiter the highlight, the harder and more polished that edge will look.

Light plastic

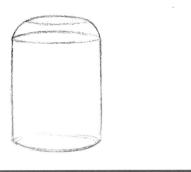

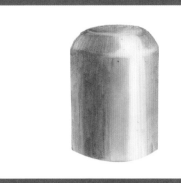

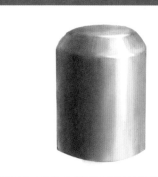

A The majority of the robot's surface will be made from a light gray, glossy plastic material. Again, start by using a pencil to sketch out a rounded cylinder as a base, as this shape offers a useful variety of curves and edges to practice on.

B Start by shading in the form shadow and planning out where the highlights will fall. It is always helpful to look at a real-life reference, so while I am shading, I try to match the values closely to real plastic. This material has more variation in value than the glass, but not as much as steel or metal. The highlight down the side of the cylinder is much more distinct than in the dark material above.

C Smudging and blending helps to create the impression of a smooth, clean surface, and can be achieved with a soft pencil and blending sticks or with gray markers. The robot needs to have a polished luster to it, so the gradients here are heavily blended so that individual strokes are less visible. For the brightest edges, erasing or using an opaque white medium helps to keep the highlights distinct.

RENDERING PROCESS

The final drawing will be rendered with soft graphite pencil and blending sticks to create smooth smudging. For darker areas, such as the shadowed collar area or black decorative patterns, switching to a black colored pencil will give those areas stronger distinction.

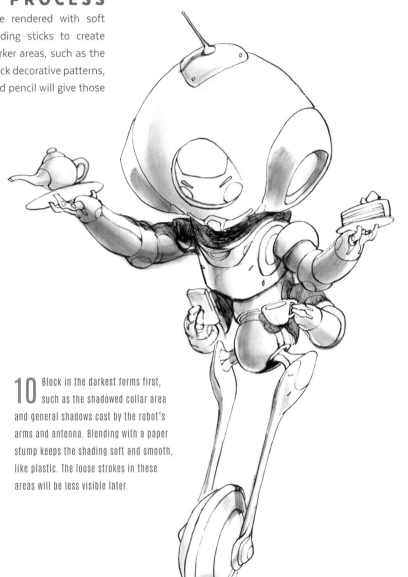

10 Block in the darkest forms first, such as the shadowed collar area and general shadows cast by the robot's arms and antenna. Blending with a paper stump keeps the shading soft and smooth, like plastic. The loose strokes in these areas will be less visible later.

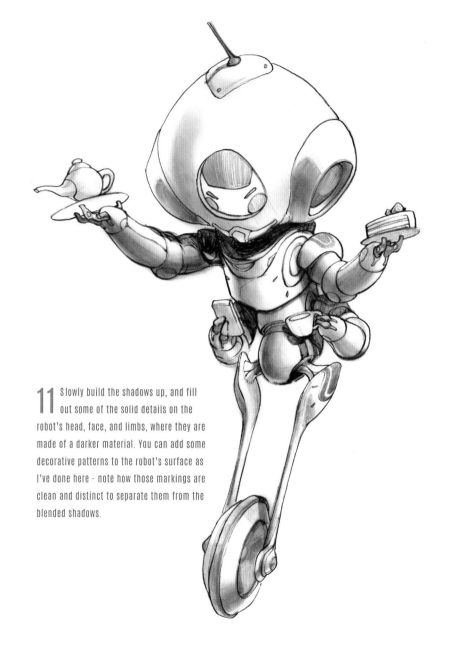

11 Slowly build the shadows up, and fill out some of the solid details on the robot's head, face, and limbs, where they are made of a darker material. You can add some decorative patterns to the robot's surface as I've done here - note how those markings are clean and distinct to separate them from the blended shadows.

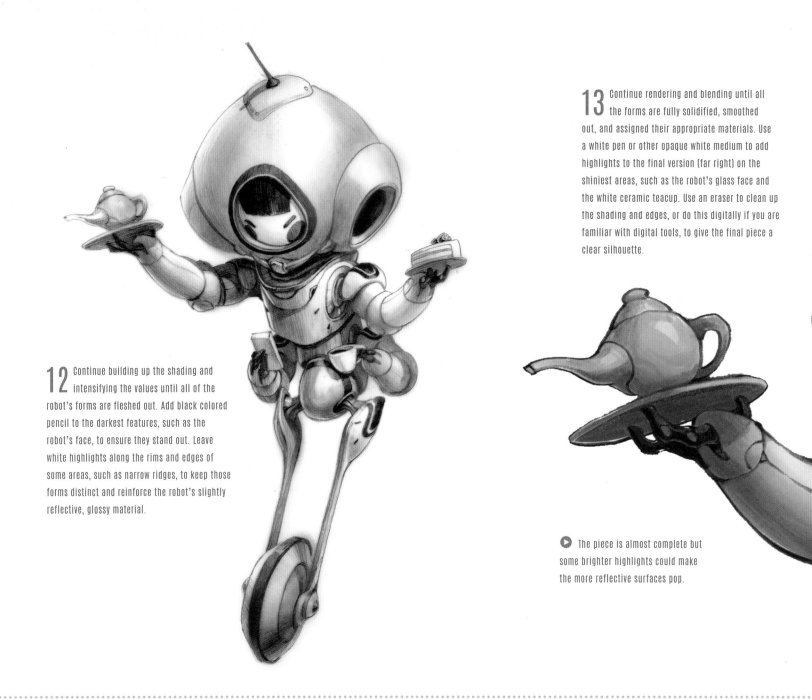

13 Continue rendering and blending until all the forms are fully solidified, smoothed out, and assigned their appropriate materials. Use a white pen or other opaque white medium to add highlights to the final version (far right) on the shiniest areas, such as the robot's glass face and the white ceramic teacup. Use an eraser to clean up the shading and edges, or do this digitally if you are familiar with digital tools, to give the final piece a clear silhouette.

12 Continue building up the shading and intensifying the values until all of the robot's forms are fleshed out. Add black colored pencil to the darkest features, such as the robot's face, to ensure they stand out. Leave white highlights along the rims and edges of some areas, such as narrow ridges, to keep those forms distinct and reinforce the robot's slightly reflective, glossy material.

The piece is almost complete but some brighter highlights could make the more reflective surfaces pop.

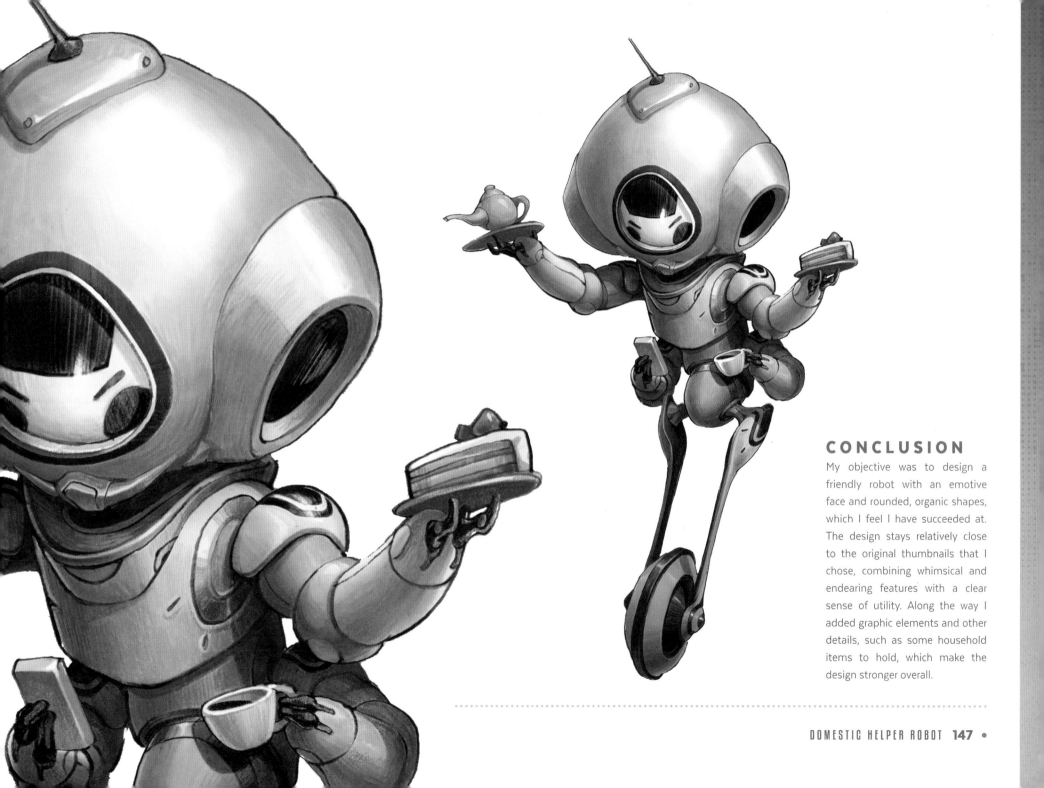

CONCLUSION

My objective was to design a friendly robot with an emotive face and rounded, organic shapes, which I feel I have succeeded at. The design stays relatively close to the original thumbnails that I chose, combining whimsical and endearing features with a clear sense of utility. Along the way I added graphic elements and other details, such as some household items to hold, which make the design stronger overall.

ABANDONED SPACESHIP INTERIOR

BY QIANJIAO MA

q-draws.com | All images © Qianjiao Ma

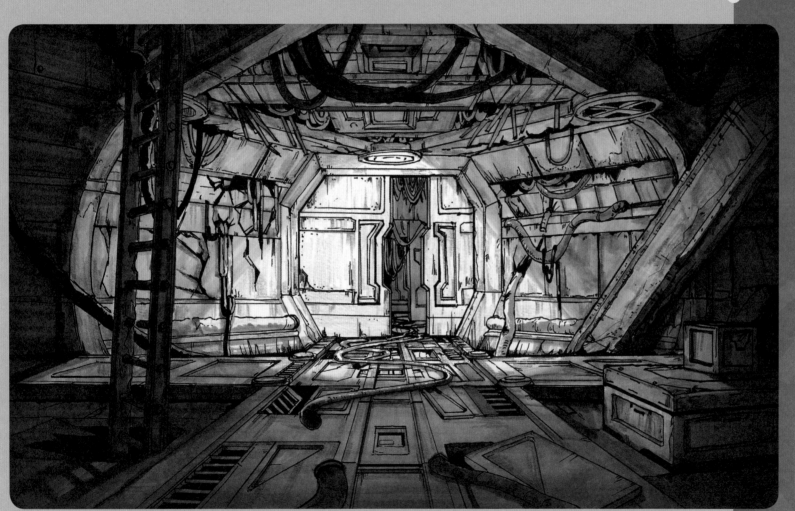

In this tutorial, concept artist and illustrator Qianjiao Ma will be creating an interior scene set on a derelict spacecraft. Black pens and gray markers will help to create deep, atmospheric shadows, and colored pencils will add a rusty hue and texture to the final piece. Three-point perspective will give the viewer an immersive view of their abandoned surroundings.

TOOLBOX

- Pencil
- Black brush pen
- Black rollerball gel pen (around 0.3 mm and 0.7 mm)
- White and red-brown colored pencils
- White gouache (or other opaque white)
- Charcoal powder (or pastel)

RESEARCH

To design the inside of an abandoned spaceship, we'll start by using research to get a broad understanding of what such an environment might entail. Researching and studying existing things that can relate to the subject is a fundamental step. Old factories can evoke the feeling of a derelict spaceship, for example; heavy machinery contains motifs like intertwining pipes and rusted panels that can be studied to better envision your designs.

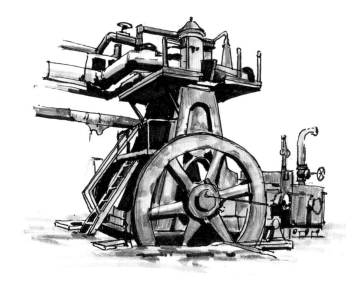

Factory machinery For these industrial ruins, try to get a feel for how the different elements of the structure connect, how segments from the larger pieces branch out into smaller motifs. Note the broken floor - a good marker for a derelict environment.

Heavy equipment This particular scene perfectly exemplifies the shape language of heavy industrial equipment, which we can borrow for our designs. Note how it features large, medium, and small aspects with the wheel, tower, and pipes respectively.

Shape contrast This equipment shows a particularly interesting juxtaposition of shapes, namely the thin pipeline and bulky body of machinery. We can utilize this kind of visual interest to our advantage.

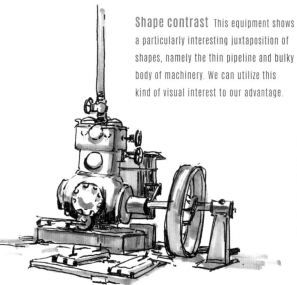

Greenery Depending on the spaceship's environment, nature's greenery may invite itself into the scene, as shown in this study. This contrast between organic and hard-surface can serve as a great storytelling and visual design element.

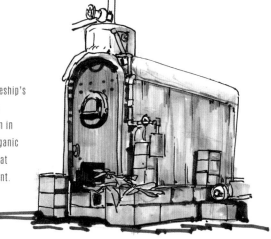

Rust textures While we should have restraint in digging too soon into details, this close-up shot shows some interesting features and rust textures that we can incorporate.

FLAT THUMBNAILS

In this first stage, I create flat thumbnails for the spaceship entrance, ignoring perspective in order to focus purely on design solutions. Here I'm mainly concerned with aspects such as shape language, proportions, and simple-versus-complex graphic design juxtapositions. A strong design should successfully balance these elements in order to engage the viewer.

A Pentel Brush Pen offers a variety of lineweights that can add depth to these flat designs. Working with this tool can also involve the occasional happy accident, which is welcome in these early design stages.

✓

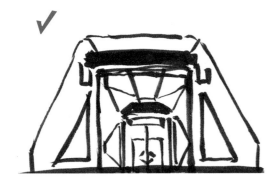

Contrasting complexity The design emphasis of this thumbnail is its shape exploration. The juxtaposition of the square door and triangular frames, and their contrasting complexity, offers good ideas to carry on with.

✓

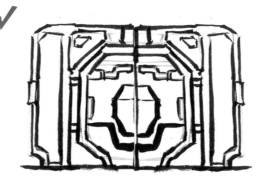

Triangular motifs The repetition of triangular motifs for this entryway is balanced, and the gradation of simple to complex, from the outside to inside, are interesting takeaways from this thumbnail.

X

Unbalanced shapes In this thumbnail, too much focus is placed in the least important areas. Unlike the previous thumbnail, it is not balanced in its repetition of shapes, which obscures the clarity of the subject.

PERSPECTIVE THUMBNAILS

It is encouraged that you explore with different types of camera angles at this stage of thumbnailing, including an establishing shot that gives an overview of the whole scene's scale, eye-level, medium, and long shots. Different perspectives are valuable as well.

In this second round of thumbnails, I am emphasizing camera placement and shot composition over design; whatever view serves the feeling of the design is best. Pencil is an ideal medium at this stage, because it is much more forgiving for the purpose, and can allow for shading for quick values.

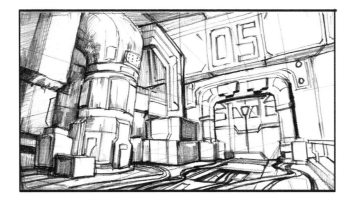

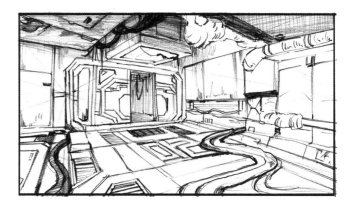

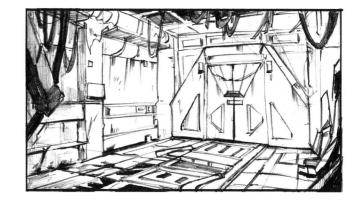

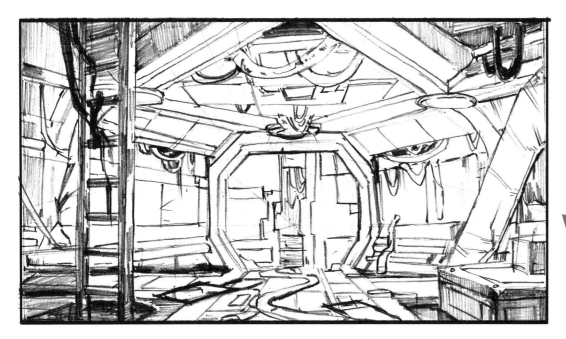

Evocative composition I feel strongest about this thumbnail because the composition evokes the feeling of moving through this derelict interior, creeping past these foreground elements of decrepit, abandoned hardware. The entryway design combines some of the strongest elements from my thumbnails.

BASIC SHAPES

It is always best to simplify your design into straightforward geometric shapes at the beginning, which will house the plethora of detail that follows. You can break this environment down simply into a series of cubes and cylinders, sitting in this space, segmented into these major components: the ceiling plane, left and right wall planes, the ground plane, and the entrance plane. Alluding to our factory studies, we'll establish the major shapes first, and then add smaller details onto that base.

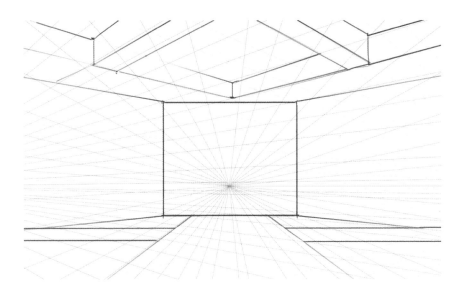

1 This three-point perspective grid will help to lay out the scene, with the entryway being the central focus.

2 Use a pencil and ruler to place the largest shapes of this environment first: the boxy planes on the wall, the ceiling shapes, and the path to the entrance.

3 Add on the medium shapes here, which include the ladder and foreground boxes. Think of the ladder as a long box, rather than two pillars and a series of rungs; keep it simple.

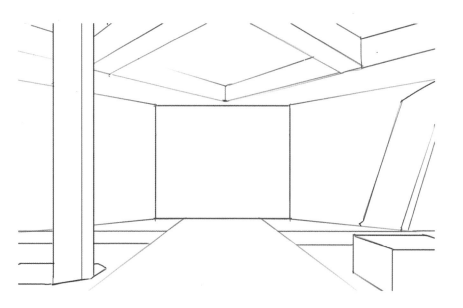

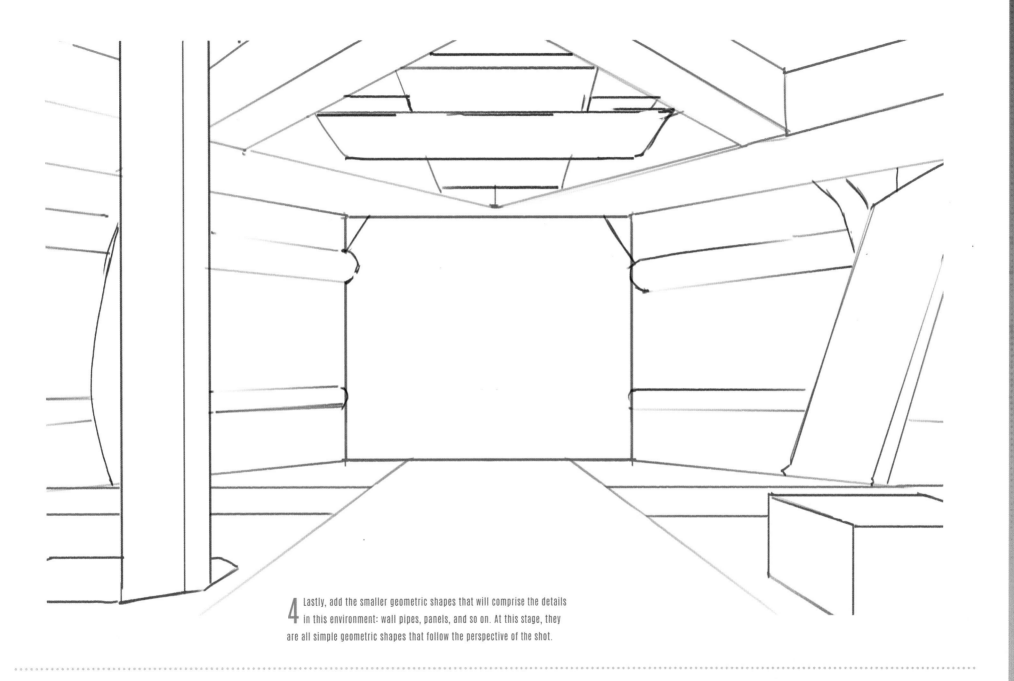

4 Lastly, add the smaller geometric shapes that will comprise the details in this environment: wall pipes, panels, and so on. At this stage, they are all simple geometric shapes that follow the perspective of the shot.

DETAILS

In order to sell this as a derelict spaceship interior, *decrepit* is a key word to keep in mind. Details such as fallen pipes and broken-through surfaces indicate neglect and age that tell the story. We can organize placement of these details around focal points, like the entrance we designed, to add another layer of storytelling. Sometimes placing an emphasis on particular objects – in this case, the entrance – can be an indication of where the answer lies to the question, "How did this environment come to be?"

DON'T FORGET YOUR RESEARCH

At this point in the drawing process, some time will probably have passed since you last looked at your research and references! You should keep your research close at hand, so that you don't lose sight of your original goals, and can continue making informed, believable decisions about which details to add. If you haven't checked your references for a while, now is a key time to refresh your memory.

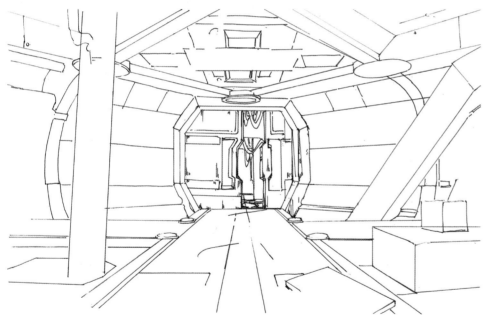

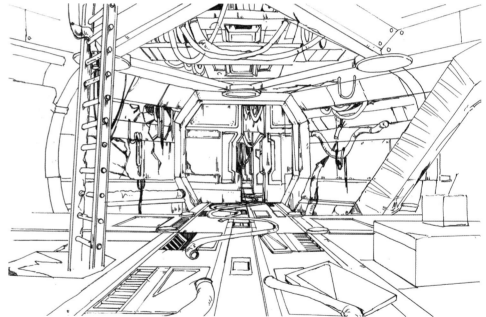

5 Use fineliner pen to begin detailing the geometric shapes that were laid out previously. Always work from the biggest areas first (in this case, the floor and ceiling, and the focal point of the entrance) and then move on to the smaller parts and surrounding areas.

6 After the ceiling, move on to detailing the left and right walls, adding more rust to the surfaces and details upon the falling pipes. You can shade in the darkest crevices and floor hatches with almost solid black.

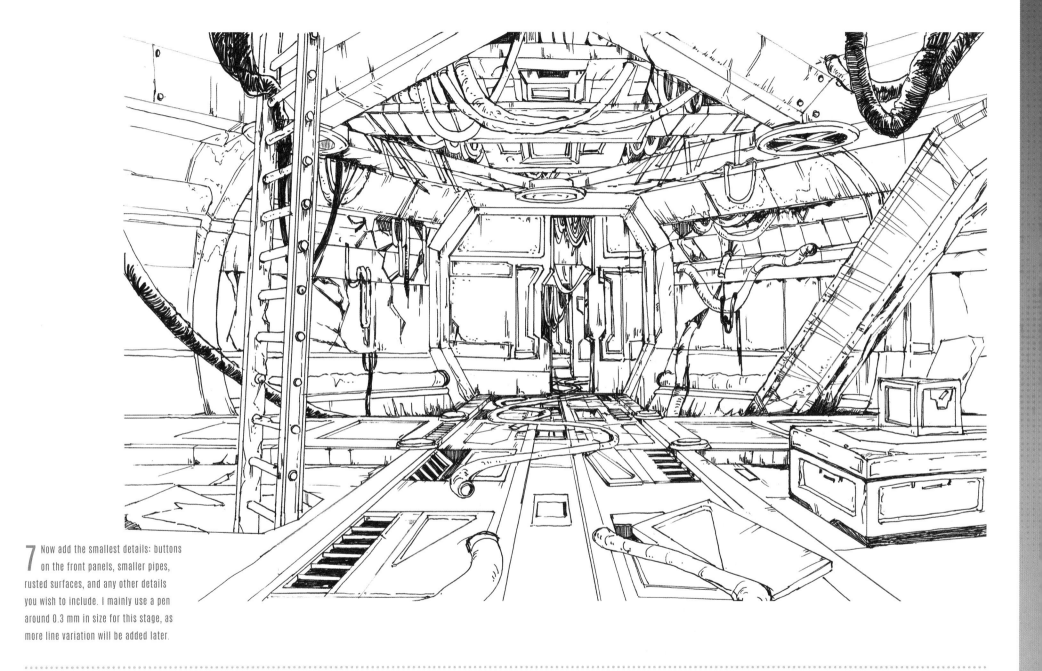

7 Now add the smallest details: buttons on the front panels, smaller pipes, rusted surfaces, and any other details you wish to include. I mainly use a pen around 0.3 mm in size for this stage, as more line variation will be added later.

FINAL LINE DRAWING

Once the design stage is complete, we can move on to the final line drawing, preparing the cleanest outline possible to accommodate the final rendering. I prefer to use Canson Marker Paper, but most other heavier papers that are meant to receive ink should work. This particular paper is somewhat transparent, relative to standard printer paper, which enables me to put the finished design sketch underneath and trace it, though you can use a lightbox if this isn't possible. I use black rollerball gel pens for this final inking stage: a Pilot G-2 0.38 for details, and a Pilot G-2 0.7 for general lines.

8 Trace the final scene onto marker paper to prepare it for rendering.

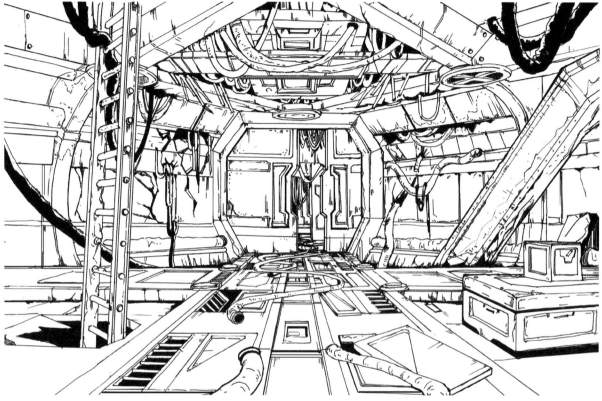

9 I plan out my lighting with gray markers on a duplicate of the drawing. This is an enclosed interior environment, so there are only artificial lights to be had. Always try to design your lighting around the focal points, such as the entrance here.

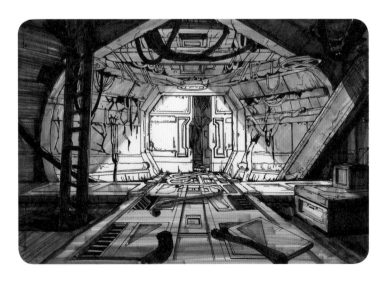

Aluminum

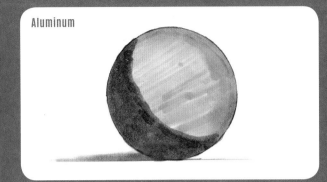

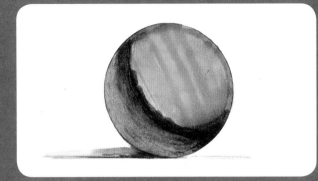

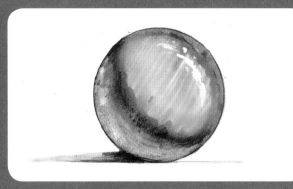

A The basic color for this aluminum material is a lighter gray. Use a light Copic Neutral Gray as the local color for the aluminum sphere. The light source is coming from the top-right, which gives us the placement of the light and shadow that create the form of the sphere.

B Add a reflection on the shadow side using a white colored pencil. Slowly build up the reflection on the sphere. Use gray and black colored pencils to add darker tones to the core shadow. No need to shade the surface to be immaculate; the imperfection will give it a metallic texture.

C Always save the highlight for the end. The light source is coming from the right, so the highlight will be directly on the top curve of the sphere. It is very hard to get pure white on top of marker tone, so use an opaque white medium such as gouache to paint in the highlight.

Glowing light

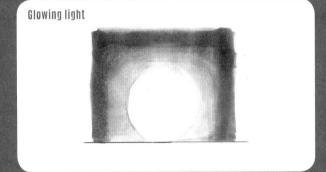

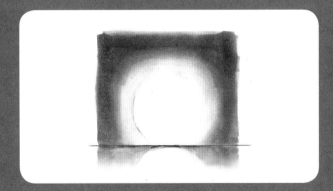

A For glowing light, a dark background is needed first, in order to show the light. Paint the background in Copic Neutral Gray N3 or N4 to get a darker tone. The value should be lighter when it gets close to the light, but do not render the sphere. That is our light source, so keep it white throughout the rendering process.

B Here we are rendering the surface "table" to show a glowing reflection. Since we need to keep the light source white, we'll render its surroundings instead to emphasize its brightness. The background will be dark and the surface bright; it will have a reflection of the light and gradually change to dark. Use a lighter marker color and pencil to render the surface.

C To finish the background, I use charcoal powder mixed with baby powder to get a gray mixture with a smooth consistency. I cut a piece of paper to protect the white sphere, then use Webril Handi-pads (or any plain cotton pads) to apply the powder on top. Swipe with the pad create an airbrushed look, and revisit the background with marker or more powder to make the gradient as subtle as possible.

RENDERING PROCESS

Now we can proceed to rendering the final scene, following the lighting scenario we mocked up previously. This process will require a range of neutral gray markers, a red-brown colored pencil for rust, an opaque white medium for the highlights, and the same black fineliner pens to refine the line drawing and shadows where necessary.

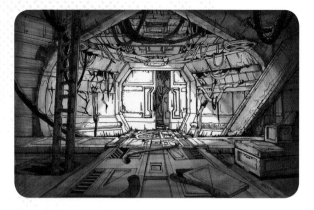

GRAY MARKERS

Gray markers are often available in sets of grays, usually warm gray (slightly more brown), cool gray (slightly more blue), and neutral or "true" gray hues. Any of these sets are suitable for creating a grayscale concept, but it's worth bearing in mind the slightly different moods they can create, especially when combined with other tools and tones of paper.

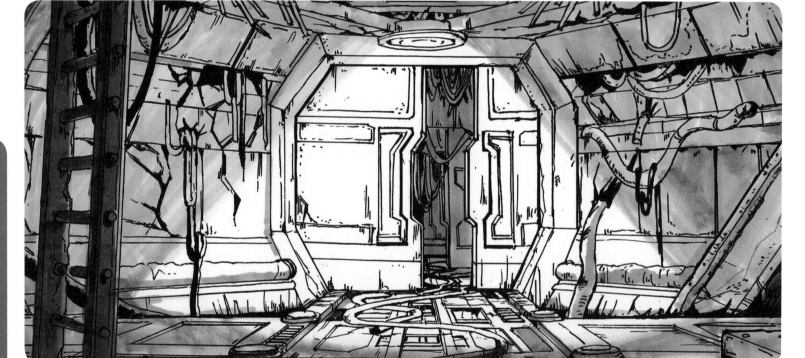

10 Use a range of gray markers to fill out the first pass of shading, following the rough value study we made earlier. Make sure that the paper is left white around the focal point of the light and entrance.

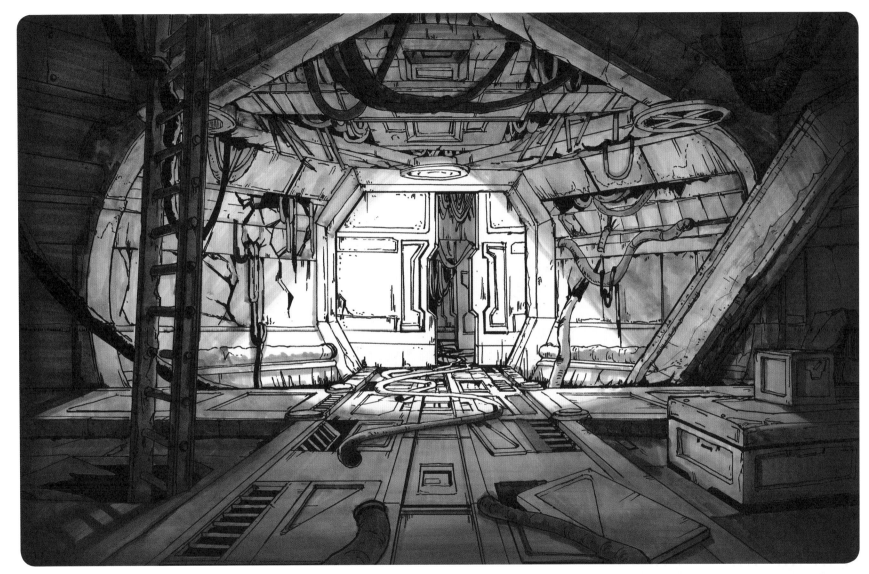

11 Build up another marker pass to make the shadows deeper and smoother, creating darker silhouettes. Adding the shadows cast by objects, such as the ladder and crates, makes the lighting more believable and atmospheric. Note how the sides of objects facing towards the viewer are darker, as they are facing away from the light source.

12 Add streaks of red-brown colored pencil to immediately create the appearance of weathering, as if surfaces have peeled away or rusted in the damp. The pencil also adds an extra dimension of color to an otherwise monochrome scene. I go over the whole scene to refine the shading and fill out any small recesses and edges that still require shadow. The aluminum piping currently lacks texture, but as a very last touch, I will add small highlights to them with white gouache or pen.

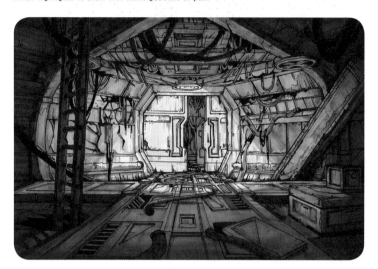

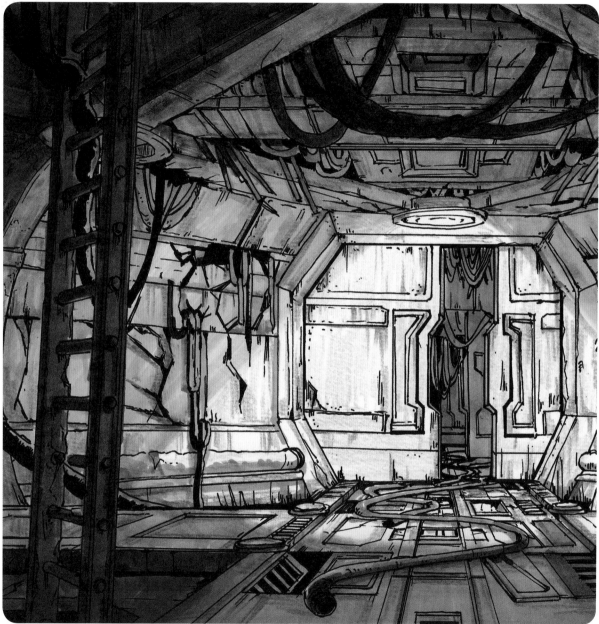

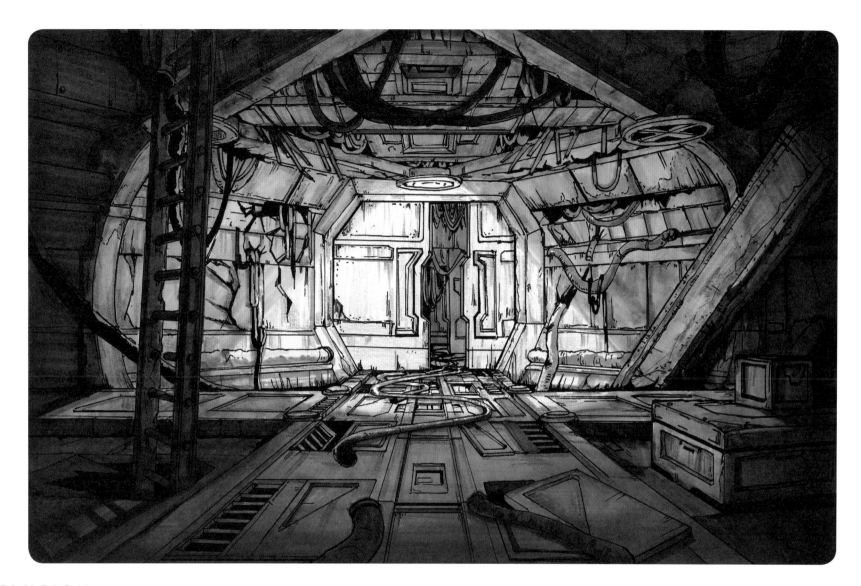

CONCLUSION

That concludes this tutorial process. In summation, we started out with a research phase involving industrial ruins to get an idea of a derelict environment. After that, we utilized a flat thumbnailing process to focus on the design, followed by a camera shot pass to capture the mood of such an environment. We used a structured, organized process to keep the essence of the details we discovered in our research phase, amplifying them with storytelling elements, and keeping in mind the lessons on geometric shapes and material rendering. This enabled us to accomplish an atmospheric, derelict spaceship scene that successfully fulfils the criteria set in our original brief.

QUICK STUDIES

In this chapter, six artists will share how they develop and draw a variety of smaller sci-fi concepts. These quick-fire case studies are short and focused on pencil sketching rather than full-color rendering, to help you generate your own ideas for objects and accessories with which to populate your sci-fi worlds. These projects will also offer an insight into how different artists approach the concept development process in different ways, which may give you further ideas to experiment with as you discover your own process.

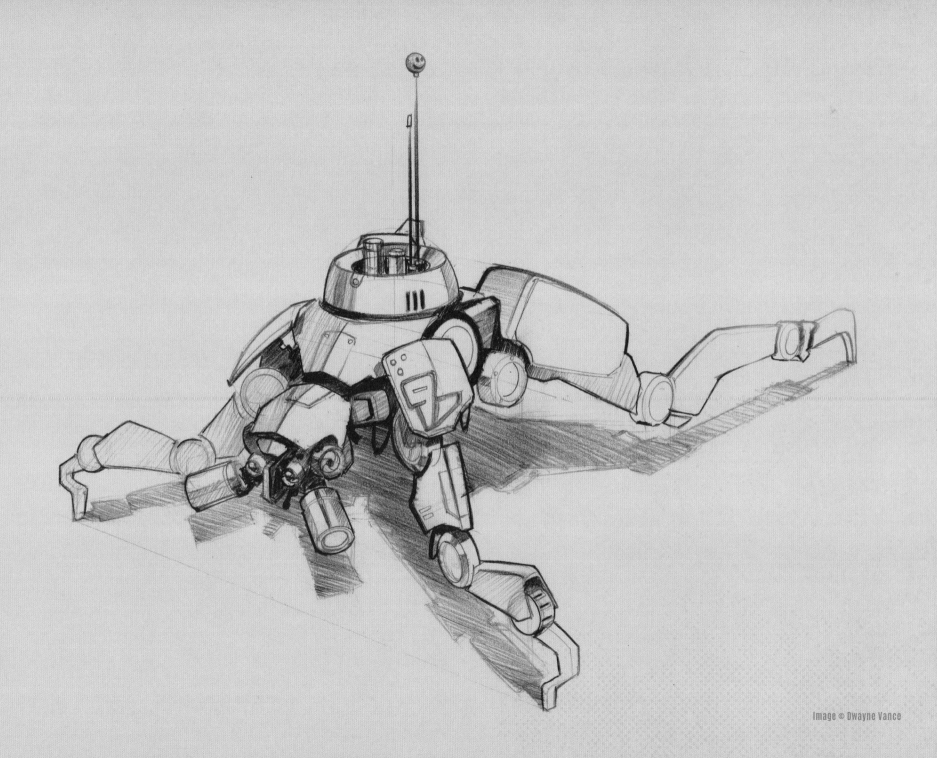

▶ QUADRUPED ROBOT

BY DWAYNE VANCE

behance.net/FutureElements | All images © Dwayne Vance

My brief for this design is to create a quadrupedal robot that might be used for recon or espionage. My initial thoughts are for it to be bug-like and able to travel across any type of terrain.

❶ QUICK SKETCHES

I start by drawing loose shapes, looking at spiders and beetles for inspiration. I keep these pencil sketches loose, not focusing on details. I think specifically about the legs and how animated they could be as the robot crawls across terrain.

❷ DEVELOPMENT SKETCH

I decide to develop the top-right thumbnail, as its shapes have the most interesting feel. I want the design to have a spider-like appearance, but not *just* look like a spider, and the arachnoid eyes and legs on this design achieve that.

❸ ROUGH LINE ART

I start to block in more shapes that will be the robot's armor and the mechanical elements underneath - communication devices and other gadgets that the robot would use for espionage.

❹ CLEAN LINE ART

I use the sketch as a basis to create a cleaner line drawing for the final piece, using heavier pencil strokes. This version has more refined mechanics and some decorative details added to it.

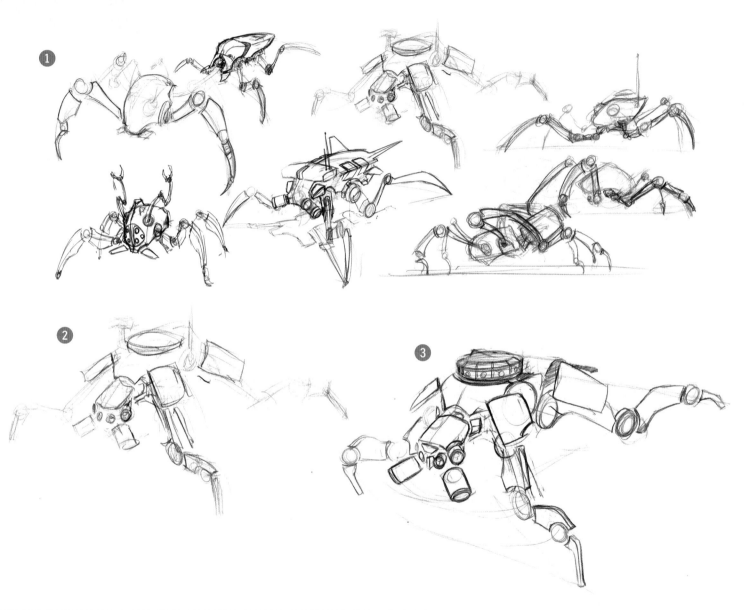

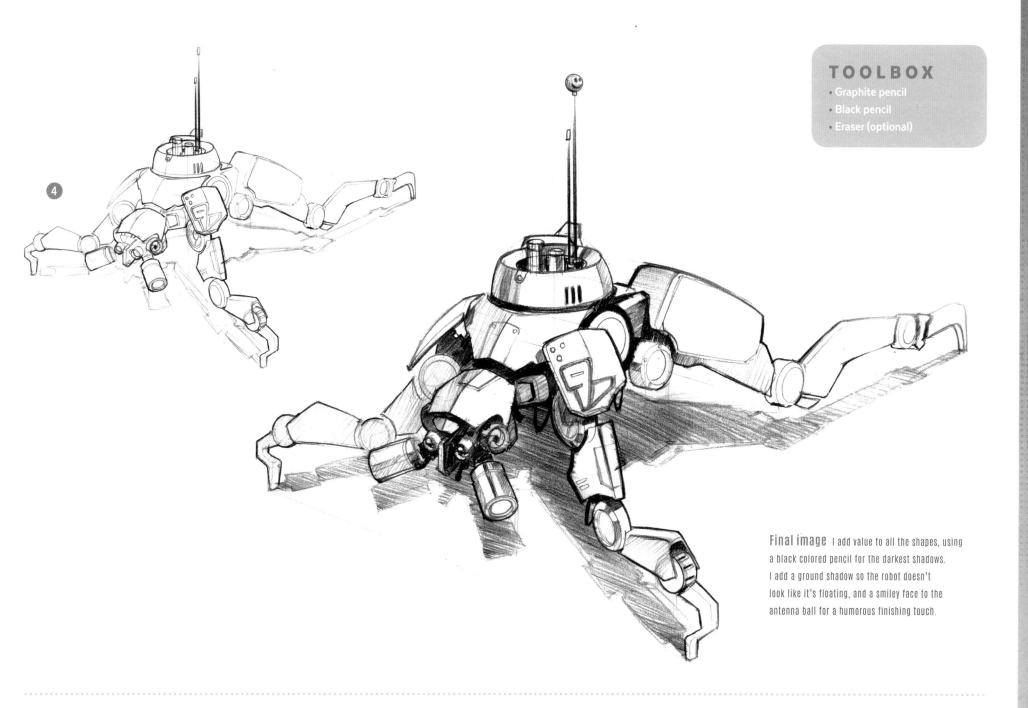

TOOLBOX
- Graphite pencil
- Black pencil
- Eraser (optional)

Final image I add value to all the shapes, using
a black colored pencil for the darkest shadows.
I add a ground shadow so the robot doesn't
look like it's floating, and a smiley face to the
antenna ball for a humorous finishing touch.

▶ BREATHING APPARATUS

BY JAN BURAGAY
tsugomori.artstation.com | All images © Jan Buragay

For this project, I will be sketching a fully enclosed helmet design that allows an alien wearer to breathe safely in toxic conditions. My medium of choice will be graphite pencils, including water-soluble graphite to achieve an ink wash effect. For inspiration, I look to vintage gas masks as a starting point, and incorporate "insectoid" shapes to add an unconventional, alien twist to this popular subject.

❶ THUMBNAILS
For any design work, I always start by loosely sketching thumbnails around an inch or two in size, taking into account my specific pool of inspirations and design constraints. This helps me to quickly find the shapes that I want to use for the final design.

❷ ROUGH SKETCH
After deciding on the far-right thumbnail, I proceed to draw a larger rough sketch of the design. In this stage I define shapes for the details. I can still draw loosely during this step, but I find that a certain degree of decisiveness when sketching the important details helps in drawing the final image.

❸ LINES
After roughly sketching the final design, I proceed to finalize the helmet and add more definition by drawing the line art. For this step, a clean line is key, as this will form the basis of the final drawing.

❹ SHADING
I apply volume to the shapes and details with shading. This step is very loose once again, as that is my style when using this medium. For this particular work, I use water-soluble graphite to build up the shading of the helmet. This must be done gradually, from the lightest to the darkest value, in order to achieve a balanced image. Applying water with a brush creates a dramatic, inky effect for the finished design.

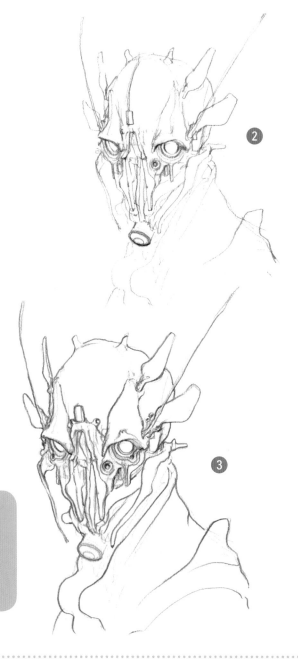

TOOLBOX
- Graphite pencil
- Water-soluble graphite pencil
- Water and a brush

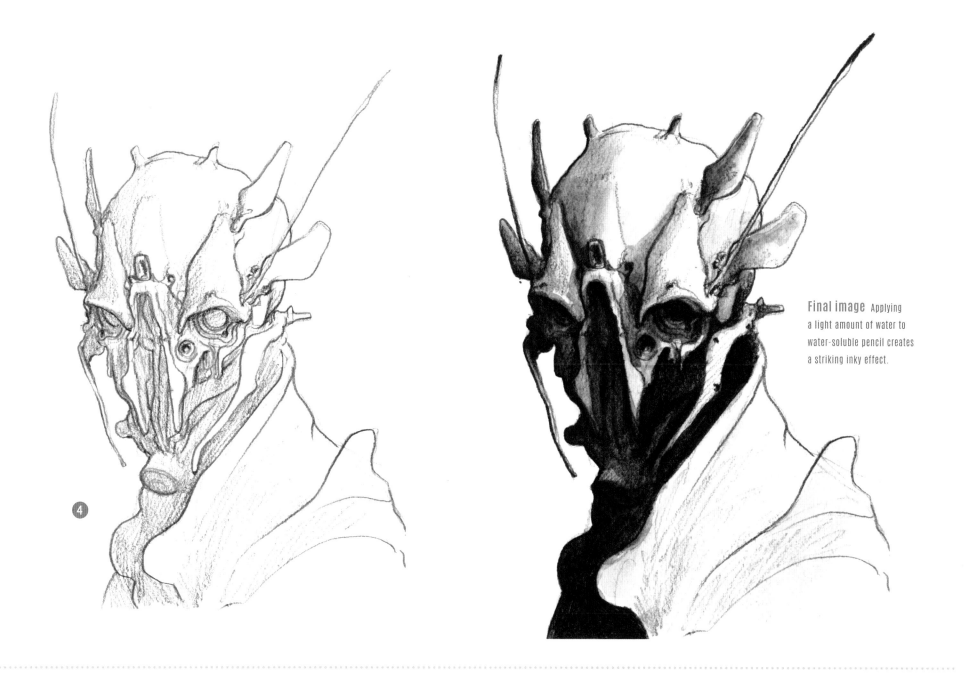

Final image Applying a light amount of water to water-soluble pencil creates a striking inky effect.

④

▶ MYSTERIOUS OBELISK

BY WAYNE HAAG

ankaris.com | All images © Wayne Haag

In this project I will design an ancient alien obelisk. Nothing says "ancient alien" more than some mysterious hovering object that appears to confound humankind's attempts at understanding it. I'll be using graphite pencils and a paper blending stump for all of the work.

❶ SILHOUETTES

Silhouettes are easy to create regardless of the tool you use. Start with what you know and branch out from there. I begin with a standard human obelisk as a reminder of the shape and size, but for fun, I want to explore some shapes reminiscent of H.R. Giger's designs. Taken in isolation, they might not appear as obelisks, so I must be careful that my designs are quickly identifiable. The object must *read* as an obelisk, but the forms could range from blocky to organic.

❷ REFINING THE DESIGN

My choice of design is dependent upon the readability of the idea. To that end, I'm going to stick with something recognizable as an obelisk. Designing surface features such as pictograms, as well as refinement of the shape, is next. Here I focus in on a section of the base and lower portion. This won't be my final composition, but exploring a concept from multiple viewpoints helps to flesh out my ideas.

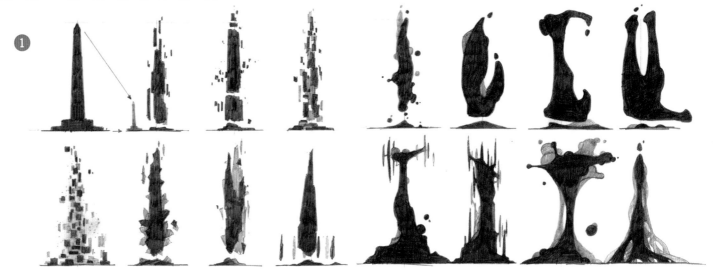

❶

❷

❸

❸ COMPOSING THE SCENE

Composition of the scene is what we otherwise call our "point of view." It's as if we see the scene through a camera. I will keep the elements to a minimum: the ground plane, the mound upon which the obelisk sits, the obelisk itself, and the background hills.

4

TOOLBOX
• Graphite pencil
• Blending stump

④ LIGHTING

Here are two thumbnails showing different lighting situations. I want the scene to have quick readability in its shapes, like it did in the first step. Top, front, side, or rear lighting are options I can choose from, but choosing *light against dark* or *dark against light* are two quick, effective ways to show off the object within our scene.

Final image The finished drawing is based on the first sketch above, but greater depth and texture are added.

SUBMERSIBLE CRAFT

BY JEFF ZUGALE
jeffzugale.artstation.com | All images © Jeff Zugale

Diving into the ocean's depths is a daunting endeavor, requiring intensive training, certificates, and licenses. But what if it were as simple as getting in your car to take a sightseeing trip? Using graphite pencils on paper, let's take a look into how to design and draw an improbable mode of transport: the personal submarine.

❶ QUICK SKETCHES
Using an HB lead in a 0.7 mm mechanical pencil, I fill a page with rapid sketches, no more than five minutes' work each. Depending on the project, I may spend a whole day powering out as many ideas as will fit, exploring every shape, form, and function I can imagine.

❷ BLUE LINE SKETCH
I want a very accurate final drawing, so I take time to do a fairly rigorous layout sketch on 9″ × 12″ with Mars non-photo blue lead in a Staedtler lead holder. It is very important to scale the submarine in a believable way to the person operating it.

❸ PENCIL LINE ART
Switching back to the HB mechanical pencil, I draw over the blue lines, both freehand and with rulers and ellipse templates. The result is still a little rough, so I tape a sheet of vellum over the drawing and retrace it for the cleanest possible look.

❹ SHADING
Starting at 4H and working mostly with the side of the pencil, I shade from light to dark through 2H, H, HB, 2B, 4B, and 6B Staedtler art pencils. The bottom of the image needs more darkening, which I add with a black Prismacolor pencil. For the final, I overlay white Prismacolor, chalk pastel, and gouache after spraying the drawing with workable fixative.

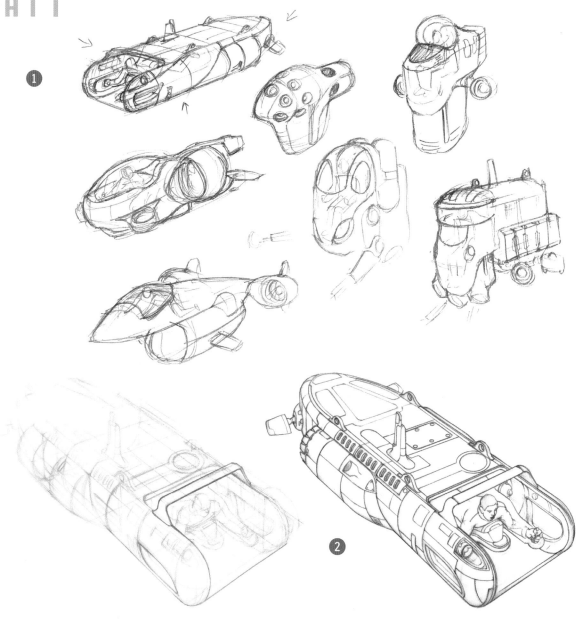

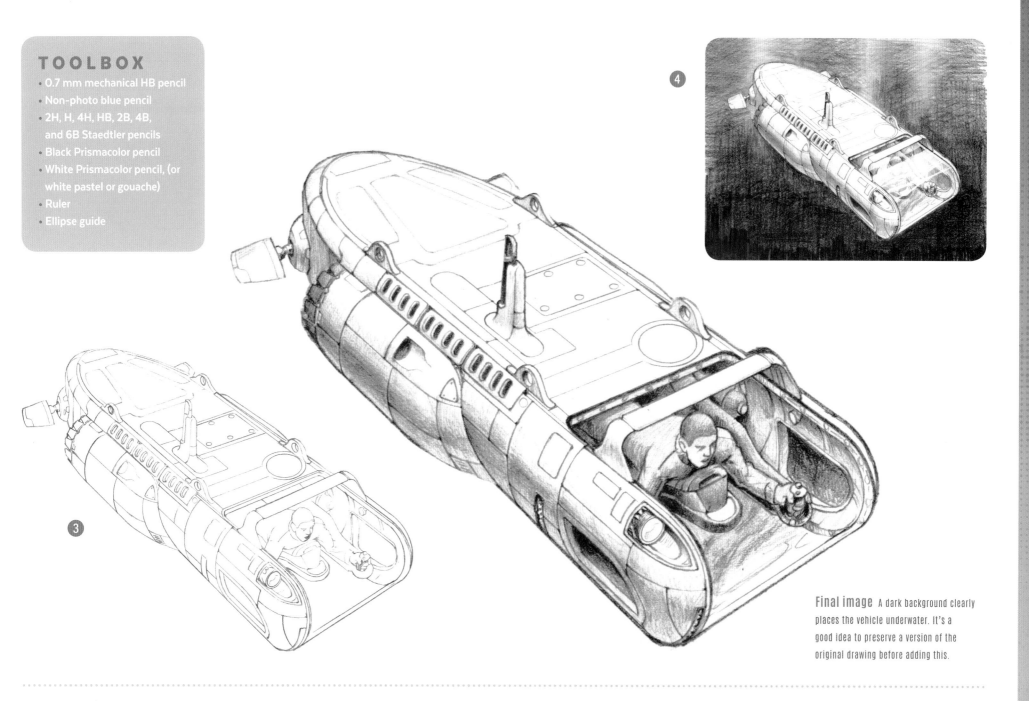

Final image A dark background clearly places the vehicle underwater. It's a good idea to preserve a version of the original drawing before adding this.

FLOATING ROCK FORMATION

BY RICCARDO PAGNI

riccardopagniart.blogspot.com | All images © Riccardo Pagni

In this project I will show the process of creating a floating alien rock formation. I would like to go crazy with the shapes as much as I can, yet keep an overall sense of balance, as you might see in a real rock formation.

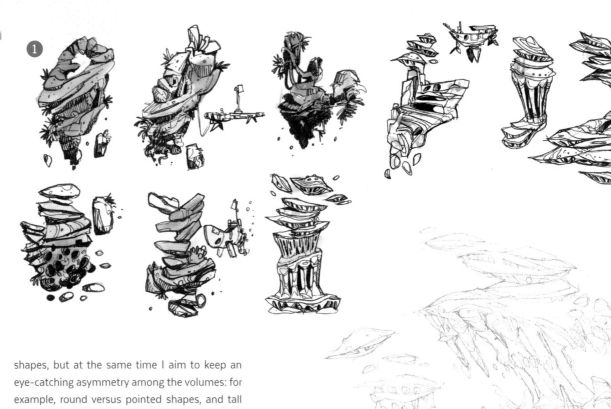

❶ THUMBNAILS

Exploration is always the most important step. While studying different compositions, the important thing is to maintain consistency. To do that, I aim to use a maximum of three different kinds of rock, in order to avoid mixing too many unrelated textures and shapes. I try to give each thumbnail a simple silhouette, too, as this makes the designs more effective. Including elements such as plants, smaller rocks, or vehicles might help to suggest scale.

❷ ROUGH DRAWING

I choose the weird cave-like rock idea because it has the most "alien" feeling, though I borrow some elements from the other thumbnails, such as the floating rocks and the ship as a scaling reference. I start drawing it roughly with pencil, at a larger size.

❸ CLEANING UP

As I start cleaning up and shading the drawing, I concentrate on balancing the different textures together. I try not to mix too many different shapes, but at the same time I aim to keep an eye-catching asymmetry among the volumes: for example, round versus pointed shapes, and tall versus flattened shapes.

❹ SHADING

This last part is always the most relaxing, as all the design work is already complete. Now I just pay attention to adding the right amount of detail. A good way to avoid overworking a drawing is to deliberately keep some areas with fewer details than you might normally add, creating a balance of filled and empty spaces.

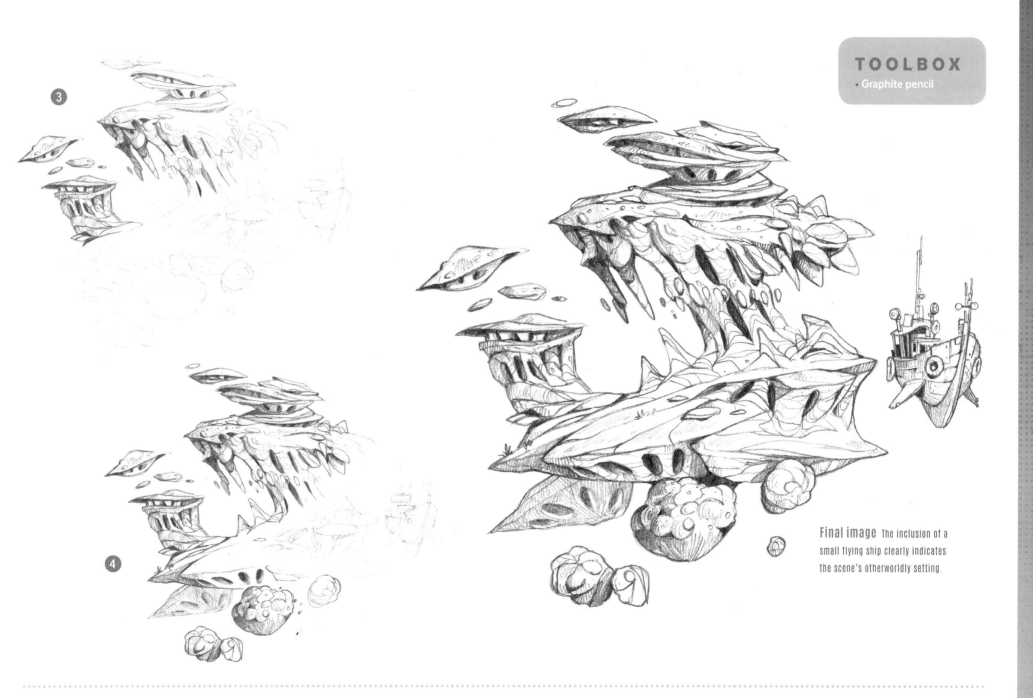

Final image The inclusion of a small flying ship clearly indicates the scene's otherworldly setting.

▶ BIPEDAL MECH

BY DWAYNE VANCE
www.behance.net/FutureElements | All images © Dwayne Vance

In this project I'll be creating a bipedal mech that might be used for reconnaissance. My plans are for the mech to be lightly armored and nimble, and to have some communications equipment that help to show its purpose.

❶ QUICK SKETCHES
I start with some loose pencil sketches to explore different shapes and get a good feel for what the mech might look like. These are not really focused on details, but on the overall shapes and stance. When I start drawing robots, I try to think of them as animated characters rather than mechanical objects; I want them to feel as if they have movement.

❷ DEVELOPMENT SKETCH
I decide on the thumbnail that I feel has the best stance and proportions for a recon-style robot: a design with thin legs that give it a fast appearance, contrasted with rounder elements.

❸ ROUGH LINE ART
I start to fill in the shapes more and add some details. Since this robot needs to look fast and nimble, its legs could almost have the appearance of ostrich legs with running shoes on. A funny concept, but I feel that it works for this design!

❹ CLEAN LINE ART
I take my rough sketch and use it as an underlay to create a clean line drawing. As I do this, I change a few of the details on the torso area, as I feel that some of the shapes could be more interesting. Now I am ready to add the final shadows and definition to give the robot form; I will use a simple lighting scheme with the light source coming from the above.

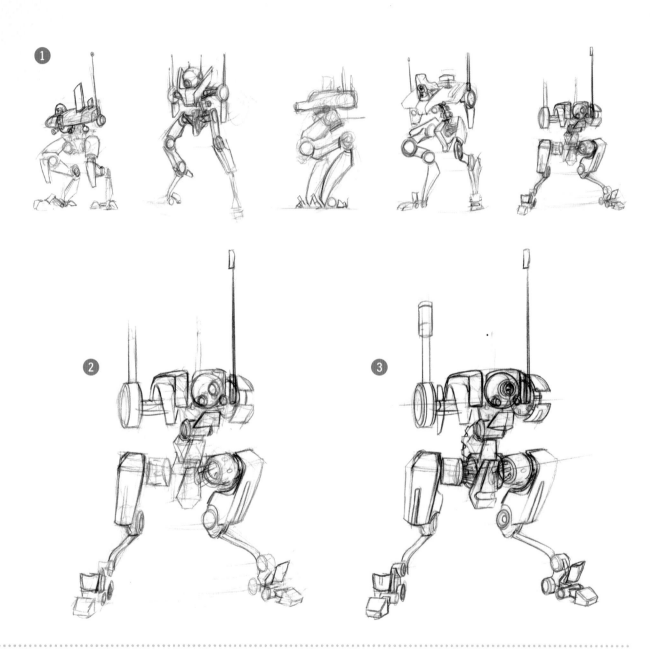

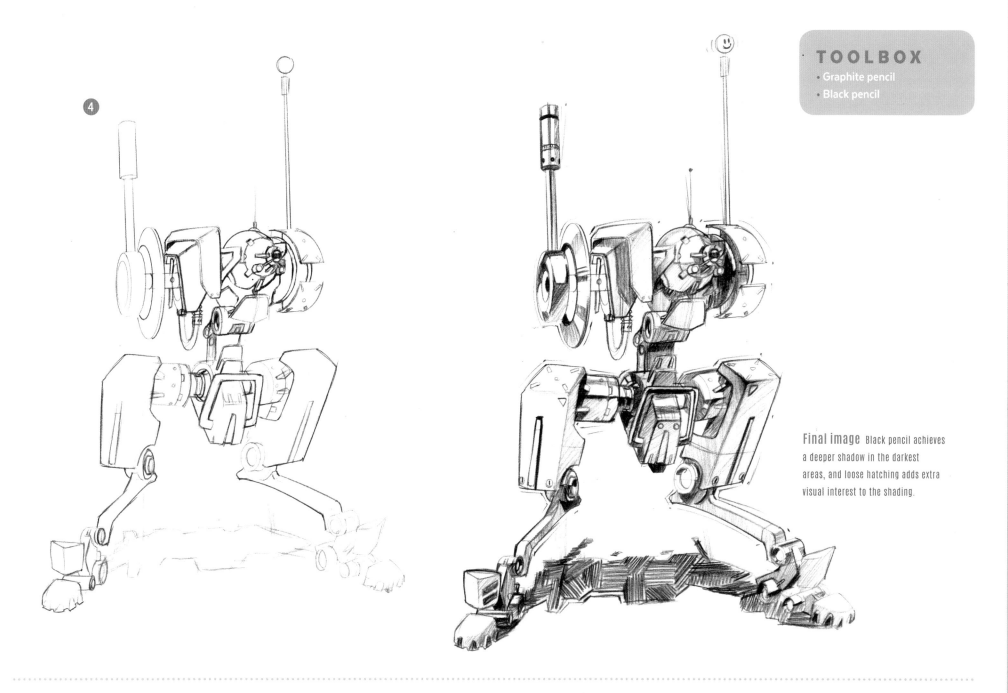

4

Final image Black pencil achieves a deeper shadow in the darkest areas, and loose hatching adds extra visual interest to the shading.

► CONTROL PANEL

BY ERIK DILLINGER

www.instagram.com/edillin | All images © Erik Dillinger

In this project, I am going to create a control panel with buttons, switches, and some exposed cables. I want to explore a unique set of mechanical controls that feel like they were custom-fitted for the operator. I like the idea that they would feel really connected to what they're controlling, so I want to stay away from touch-screen or virtual inputs - if the character is operating something like a vehicle, I think it makes more sense to have active and tangible interaction.

❶ EXPLORATION

I start getting ideas by playfully doodling different types of controls and arrangements, not worrying too much about realism. I like to not limit my thinking with practicality at this stage, focusing on play and invention, considering what kinds of objects could make things happen when moved or turned.

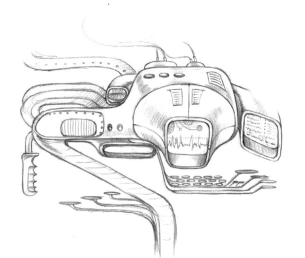
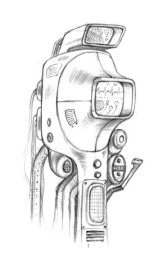

❷ DEFINING THE DESIGN

I start to narrow down the ideas that work well, and begin to make sense of what does what, and how the left and right hands of the operator might interact with the controls. I also incorporate a couple of viewports or monitors, as a navigator might have on a ship.

❸ ROUGH SKETCH

I decide on something like a battleship navigator's station, with an angled support which suggests that it can swing in from the side. I add handles and a headrest so that the operator could carefully look through a kind of periscope, and also quickly move away to view the monitors.

❹ LAYOUT AND REFINING

Having my rough sketch from step 3 for reference, I begin laying out the final drawing. I work very lightly in pencil, making sure I find the essence of the shapes, angles, and proportions. Once I have the whole design sketched out, I work progressively darker with sharper details until I reach the final.

❸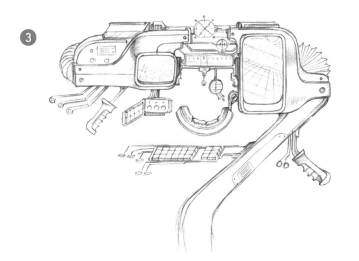

❹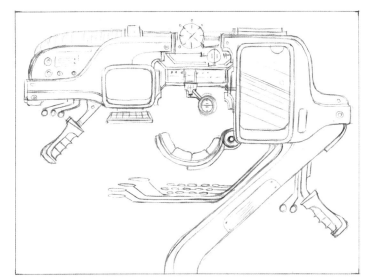

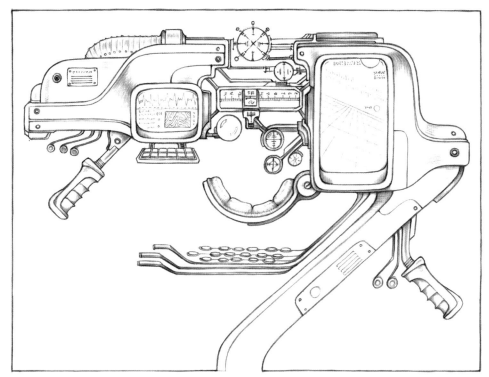

Final image Areas of shading on the corners give the controls' material a metallic finish. A border adds an appealing touch to the final presentation.

▶ HOVERBIKE

BY JEFF ZUGALE

jeffzugale.artstation.com | All images © Jeff Zugale

Don't we all want a hoverbike? I am a motorcyclist, and a hoverbike would definitely help me to get around the traffic in Los Angeles. Will my design recall a streetfighter sport bike, a big-twin chopper, a touring machine, or perhaps even a scooter? Let's find out...

❶ QUICK SKETCHES

My first step is always to scribble out several different ideas very quickly, usually in a side view. I can see them clearly and pick one that I think will work best - or in this case, be the most fun! My go-to drawing tool for this stage is a 0.7 mm mechanical HB pencil.

❷ DEVELOPMENT SKETCH

After choosing the strongest ideas from my thumbnails, I sketch a larger three-quarter view to work out the form. I want to exaggerate the "biker on a big, *loud* Harley" trope to something really outrageous. For human-operated objects, I generally add in a person to make sure the design feels viable.

❸ ROUGH LINE ART

Time to go larger; this step fills a LTR or A4 page. I lay the groundwork for the final art using 2H and 4H Staedtler pencils. Ruler-assisted center and perspective lines and strategic ellipse guides do wonders for accuracy at this stage.

❹ CLEAN LINE ART

There are no shortcuts here. It's a lengthy process combining freehand drawing with a ruler, sweeps, and ellipse guides. I draw with the HB mechanical pencil first, then with 2B, 4B, and 6B Staedtler pencils to reinforce lines where needed. The completed line art can be photocopied, scanned for a digital finish, or rendered on paper.

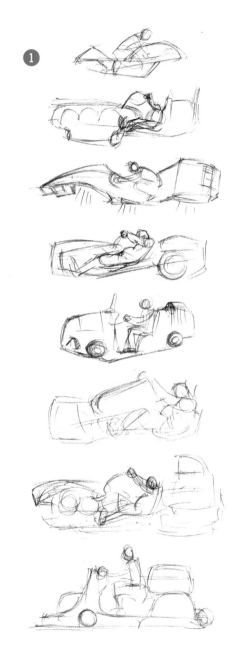

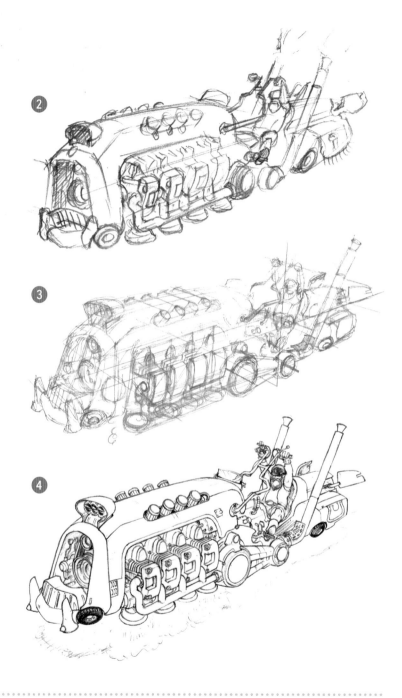

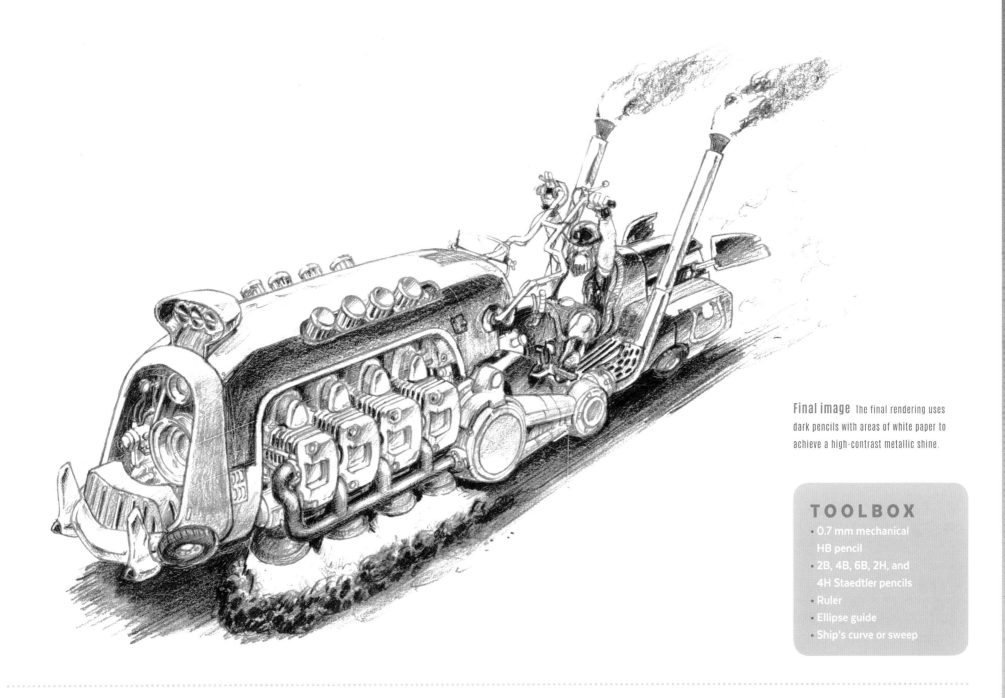

Final image The final rendering uses dark pencils with areas of white paper to achieve a high-contrast metallic shine.

TOOLBOX

· 0.7 mm mechanical
 HB pencil
· 2B, 4B, 6B, 2H, and
 4H Staedtler pencils
· Ruler
· Ellipse guide
· Ship's curve or sweep

▶ MUTANT PLANT

BY RICCARDO PAGNI

riccardopagniart.blogspot.com | All images © Riccardo Pagni

In this tutorial I will explain how I approach the creation of a mutant plant: a Triffid-like being that might lurk on an alien planet. My main references are real-life plants, but I would like to mix them with inspiration from the insect and animal world, in order to achieve a weird, almost creature-like feeling.

❶ THUMBNAIL

Exploration is the first and most important step. Allow yourself to experiment with shapes of any sort and don't be afraid to go with something strange. Above all, try to give the subject a strong "personality." Drawing a rough, random shape first is a good way to achieve some extra unpredictability. I use a pen for this stage, though you can use a pencil.

❷ ROUGH DRAWING

I start translating my ideas to a larger rough drawing. I mix elements from multiple thumbnail explorations, ending up with a new shape that combines the details I liked the most. The result is a twisted, predatory-looking plant with almost mantis-like branches, and random fungal growths. Although this drawing is only light and rough, I try to keep the design as clean as possible.

❸ PENCIL LINE ART

I start to shade and refine the drawing. In this phase I pay attention to the main volumes and shadows, solving how the shapes overlap. I start from the focal point (the plant's "face"), concentrating the most details and contrast in that area, before moving on to the rest of the drawing.

❹ SHADING

At this point all the important elements are set, and I keep on refining the drawing by darkening the shadows and adding more details. I pay particular attention to varying the lineweight, making the lines thicker in the shadowed areas. This adds dynamism and volume to the overall drawing.

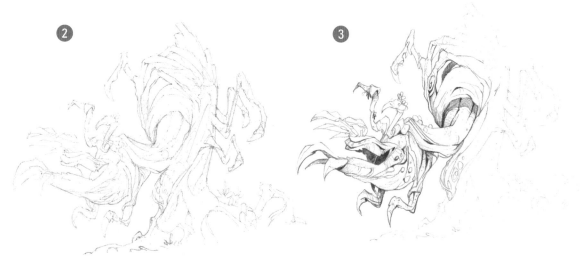

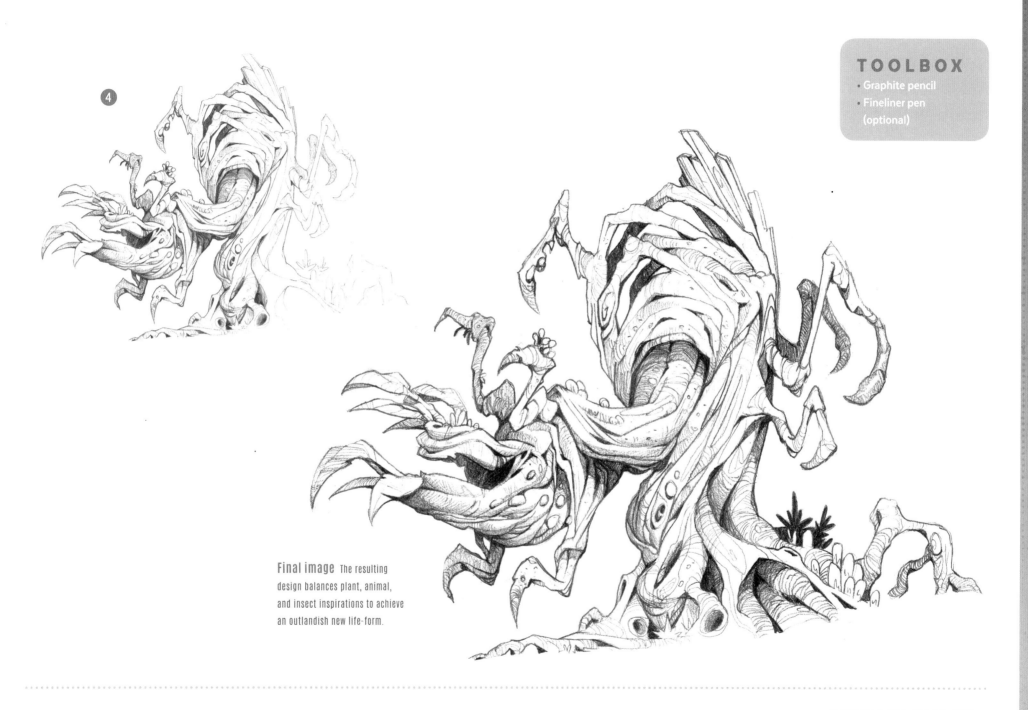

④

TOOLBOX
- Graphite pencil
- Fineliner pen (optional)

Final image The resulting design balances plant, animal, and insect inspirations to achieve an outlandish new life-form.

▶ FUTURISTIC RIFLE

BY WAYNE HAAG

ankaris.com | All images © Wayne Haag

In this project I will design a sci-fi rifle, which could be a laser or projectile weapon. The first thing I'll do is familiarize myself with the basic anatomy of a rifle. If you're new to the subject, keep it simple and don't try to reinvent the wheel – stick with what works.

❶ RESEARCH

I start with a simple sketch of a modern rifle and its proportions. There are three main parts: the stock, action, and barrel (which takes up around 50% of the overall length). This step is a warm-up to get myself acquainted with the subject.

❷ SILHOUETTES

I begin to sketch ideas in pencil. My silhouette designs start out as recognizable contemporary firearms, but progressively become more futuristic, with smooth, stylized shapes that are more fanciful. The silhouettes could be projectile weapons, or represent electrical rail gun configurations or sci-fi laser guns.

❸ INTERIOR SHAPES

Now I design the interior shapes, patterns, and secondary materials. Shape language is important here, so I make sure that the interior shapes match the exterior design. I complete two variations, based on the two bottom-right silhouettes, but you could make more.

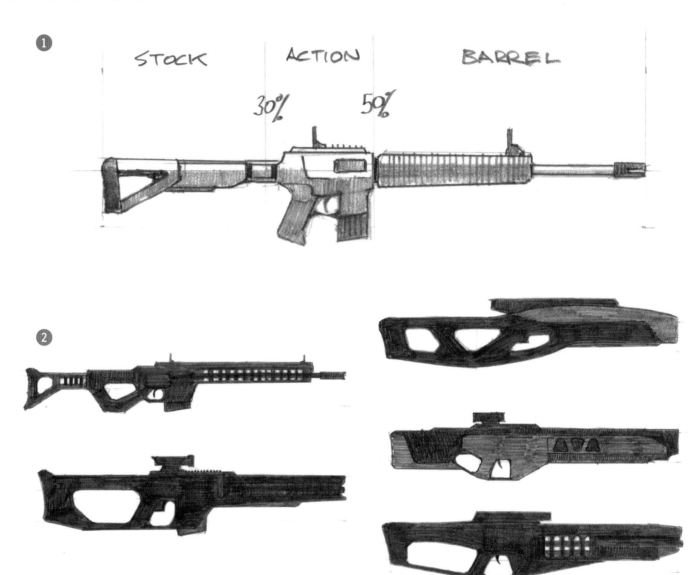

❶ STOCK ACTION BARREL 30% 50%

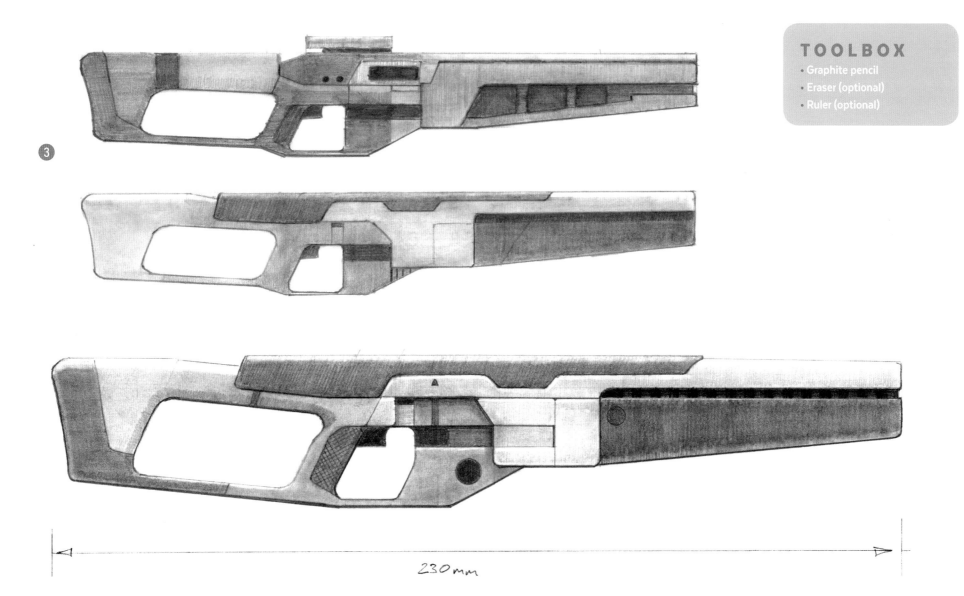

③

230mm

Final image I decide to take the second concept forward for the final design, refine the shading with more contrast, and make a few minor design changes and additions - such as extra grooves and textures - to create interest.

▶ SPECIMEN TANK

BY ERIK DILLINGER
www.instagram.com/edillin | All images © Erik Dillinger

For this project, I'll be creating a specimen tank containing an ambiguous creature. I will begin with lots of exploration, developing one idea, before proceeding to a rough layout, a hint of perspective, and final drawing.

❶ EXPLORATION

This idea – a life form that has been captured – offers a fragment of story that provides plenty for the imagination. I ask myself, "What makes this creature something to study or confine? Is it otherworldly, deformed, dangerous, endangered? What about the tank was designed just for this creature?"

I begin by making lots of loose exploratory sketches, trying many different shapes of tanks and characters. I consider cute and creepy beasts with tentacles, gloomy bat-like monsters, a three-headed mutant, and so on. I also explore tanks with different functions: preservation, keeping something in stasis, or even harvesting from the specimen.

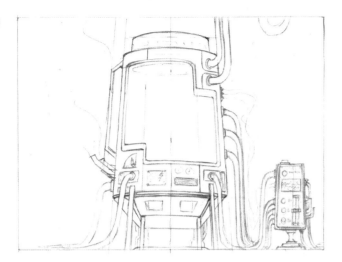

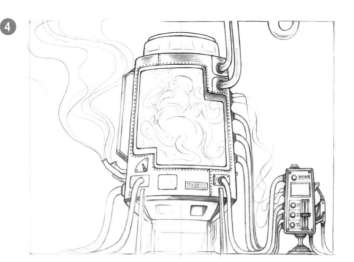

❷ ROUGH COMPOSITIONS

I choose a tentacled creature, kept alive as a source for something valuable – perhaps its blood or vital fluids. I know the tank has to show this in some way. I make several rough drawings with different versions of these elements, tubes and monitors, and creatures – some like lost puppies, others looking more vicious.

❸ LAYOUT

I start the final drawing with a light sketch to find the proportions, freehand perspective lines, and ellipses that will give a sense of looking up into the tank. For this I tend to hold the pencil loosely, searching out curves and straight lines. I don't make my lines too dark until I am sure about the shapes.

❹ REFINING

I rough in the specimen and add what looks like a gas pump that dispenses whatever's being harvested from the creature. I clean up some of my loose lines and commit to the composition, applying darker lines where needed, and defining areas that were vague.

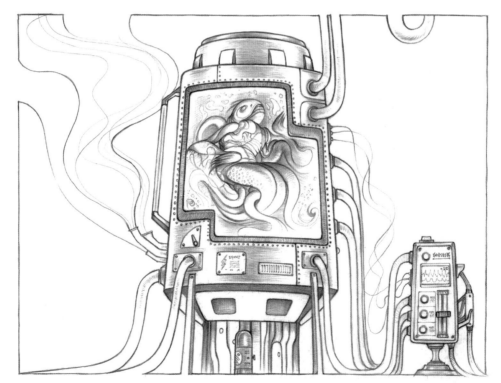

Final image Deeper shadows, volume, and additional textures complete the design.

ADVANCED PROJECTS

This final chapter presents two different projects that offer insights into more complex work processes. The first introduces using toned paper to bring a new layer of visual depth to your images, and the challenges inherent to that medium; the second steps off the paper page and onto the digital canvas, exploring how digital art software can free up your creative process. These projects will give you some more challenging elements and ideas to explore, which have the potential to expand your artistic skillset and enrich your future concepts.

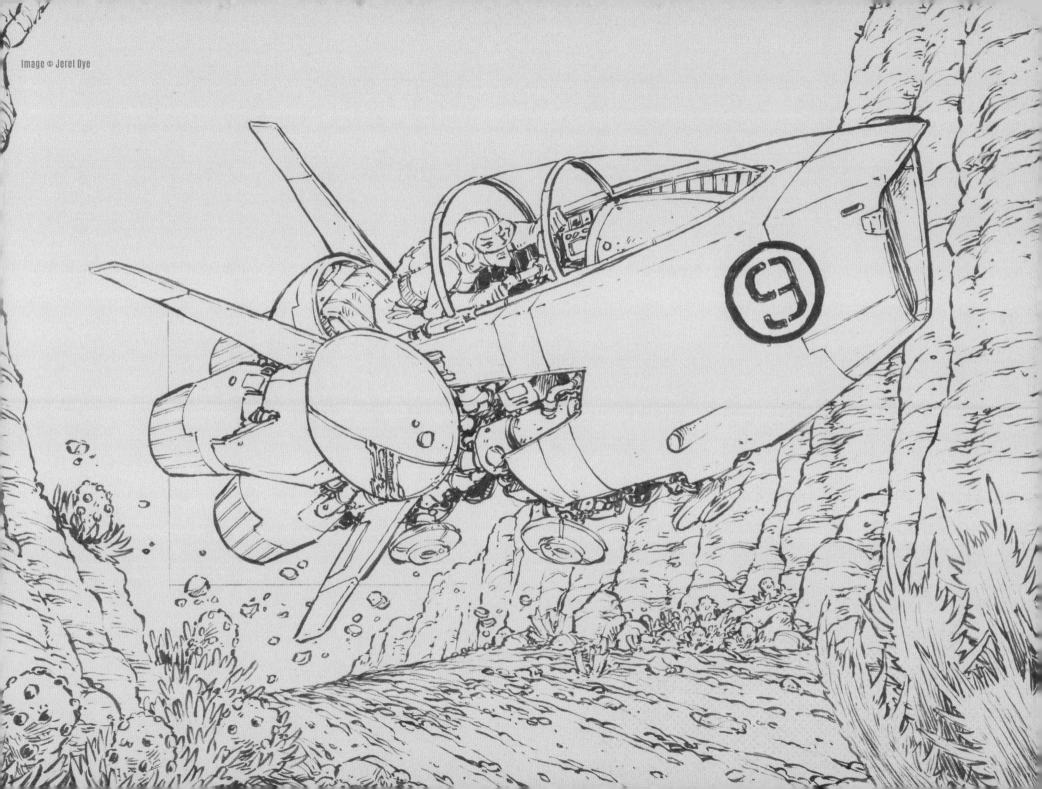

SPEEDER VEHICLE SCENE

ADVANCED PROJECT: USING TONED PAPER

BY JEREL DYE

jereldye.com | All images © Jerel Dye

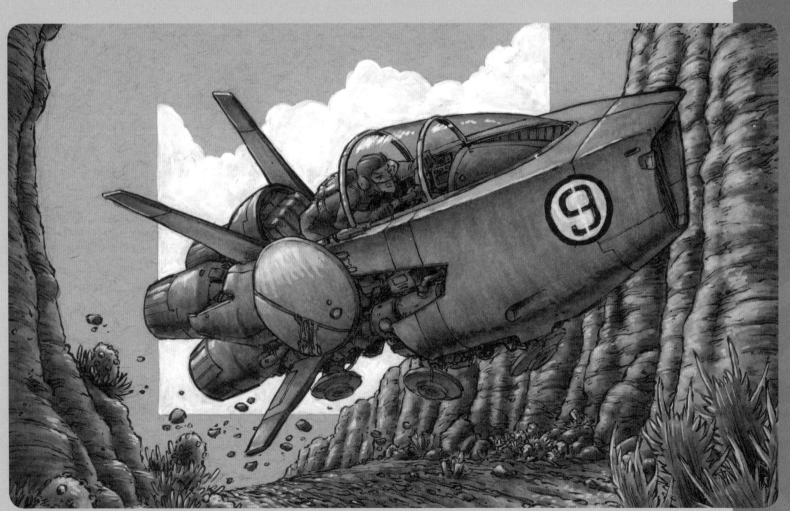

Working on plain white paper is a familiar process to many artists, but what about when toned paper is involved? Toned or colored paper opens up a new range of challenges, as well as exciting opportunities for your images and range of media. In this tutorial, illustrator Jerel Dye shares the process behind this toned-paper scene, which includes the extra challenge of an organic landscape backdrop.

TOOLBOX

- Toned paper (tan is used here)
- Black brush pens with waterproof ink
- Graphite pencil
- Kneaded and plastic erasers
- Copic markers
- White gouache
- A fine paintbrush and water

WORKING WITH TONED PAPER

I've been working with toned tan paper for sci-fi concept art and illustrations for many years now. I've always been attracted to the warmth and tactile quality of the paper, and pairing that with futuristic drawings seemed like an interesting idea. The color of the paper has a pleasing way of bringing marker tones together and unifying the palette; of course, it is essential to bring the lighter opaque tone of white gouache paint to the drawings as well. That is what the toned paper is designed for: working with lights and darks, with the paper tone sitting in the middle.

Pencils and erasers
I will use a 4H 0.5 mm mechanical pencil for the initial sketch and a softer 2B 0.3 mm lead for the finishing, as well as plastic and putty erasers.

Toned paper This is Strathmore Toned Tan sketch paper, 9" × 12" (slightly larger than A4 size). It also comes in different sizes and in a gray variety.

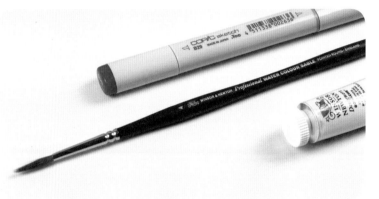

Coloring tools For color, I'll use Copic markers, white Winsor & Newton's Designers Gouache, and a sable brush (with water for diluting the paint where needed). The Copic markers are the best out there, in my experience: the ink blends well, the tips are resilient, and refills cuts down on the cost.

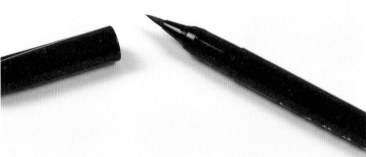

Brush pens There are many decent pen brands and types, but I like Zebra for their razor-sharp lines and waterproof ink. Try to find a couple of sizes, such as Zebra Fude brush pens in medium and super-fine thicknesses.

THUMBNAILS

It is important to plan your images carefully when working with marker and a toned paper. Marker can be a tricky medium, and combining it with tan paper means that mistakes are difficult to correct. You need to know exactly what colors you are working with and how those colors are going to interact. You should also nail down your design and the overall composition before starting on the final piece; drawing and redrawing on the page can damage the paper, which will show when you start coloring.

Vehicle design After deciding on where to go with the composition, begin working out the details of the setting and fully designing the vehicle with ink.

Thumbnail scenes
A range of very loose ideas start the process. I subconsciously come back around to the same general composition multiple times here.

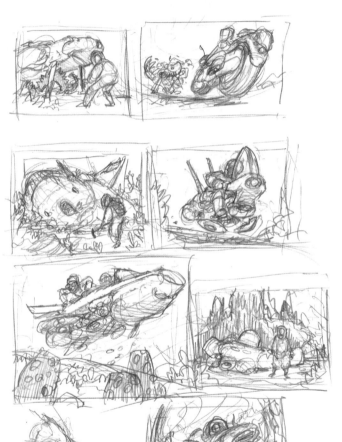

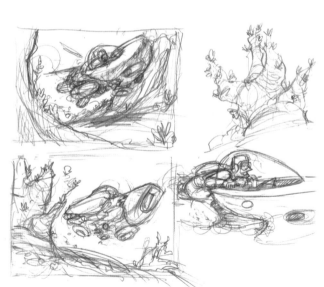

TRIAL COLOR PALETTE
Making a small full-color sketch helps to work out ideas for the final scene. For example, after this, I decide that the vehicle needs to be cooler in tone in order to pop out more against those red rocks.

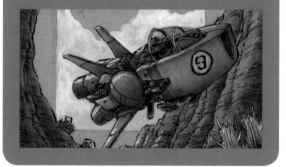

LINES

Every good marker illustration starts with a good under-drawing. In addition to getting the composition right, the underdrawing should help you and the viewer to understand the volume, space, texture, and silhouette. These elements should all be explored and committed to during this beginning drawing phase. It's the foundation upon which those elements will be built during the coloring process. Look for ways to reinforce shape and texture by drawing across the forms. Riveted seams or stripes of paint are great for reinforcing shapes in vehicles and robots.

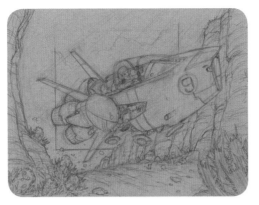

Clear composition
Make sure that the smooth texture of the vehicle stands out and looks interesting against the texture of the craggy rock walls, the rocky scree underneath, and the spiky foliage.

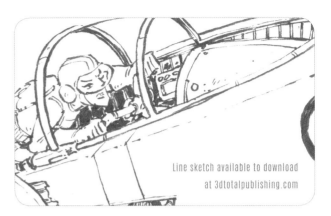

Line sketch available to download at 3dtotalpublishing.com

BEFORE MOVING ON TO INK
Use a kneaded eraser to lighten your pencil drawing before starting to ink it. Press firmly onto the page and then lift. Repeat the process across the whole image, especially in places where the graphite is heavy. This will ensure that your ink has a better chance of penetrating the paper, and it makes your ink marks easier to distinguish from your pencil drawing.

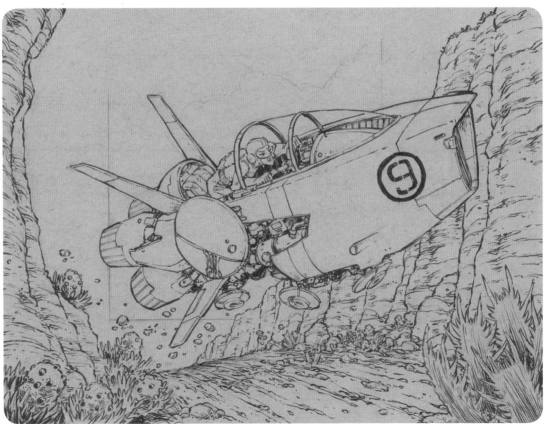

Inking process The inking process is one of my favorites. It can be absolutely Zen-like - all the hard decision-making of the penciling has been done, and now you get to spend some time really enjoying what you are creating.

UNDERPAINTING

I always begin the coloring process with a marker "underpainting." This is an important step to help unify the colors, and can really help to set the mood of the piece. You can do this simply, with a single color, or with a narrow color range like I am doing here. Using a highlight, midtone, and shadow, I am able to fully realize how the light will work. These colors will be largely obliterated by later layering, but this base layer will accentuate and tint those tones in an appealing way.

DYNAMIC HUES

Shifting the hue slightly when going from dark to light is a great way to add interest to your colors. For this piece I want to add some heat to my shadows, so I start with a deep red violet marker before moving into lighter purple hues. You should always try your ideas out on other paper before putting the colors down in your piece.

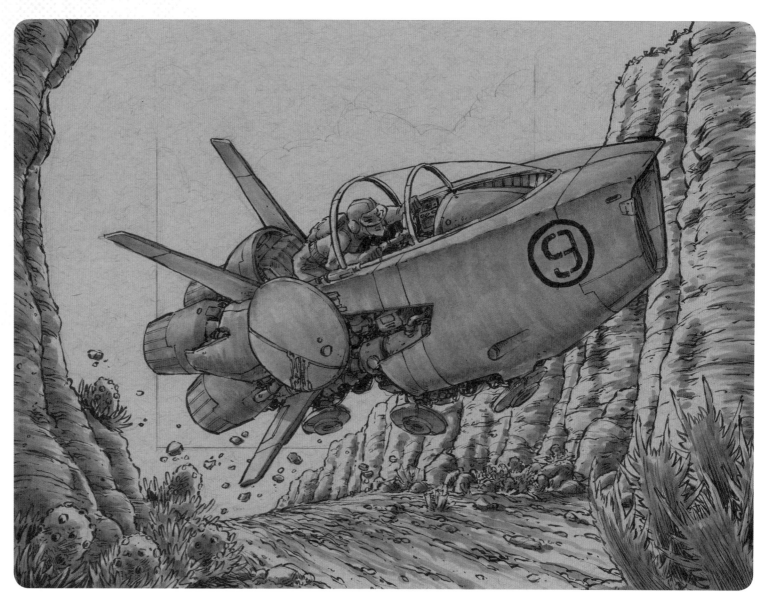

Marker base Apply a layer that establishes the light, shadow, and base color.

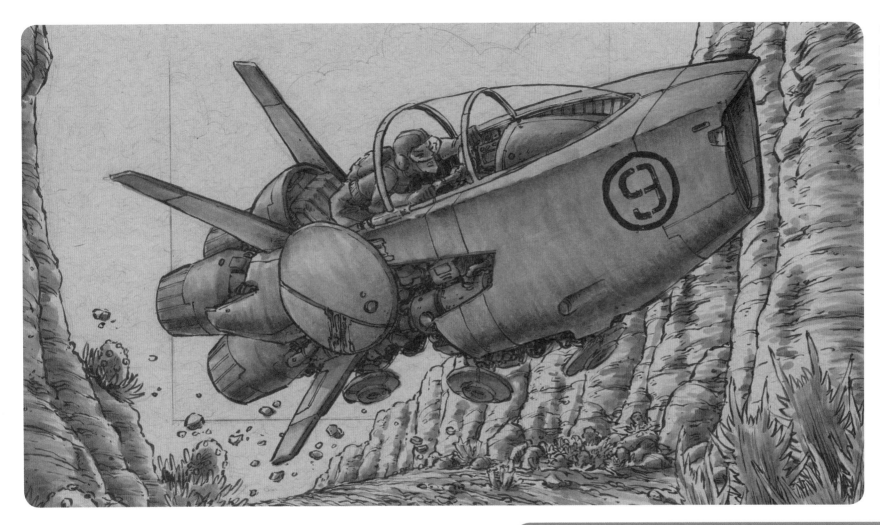

COLORING THE VEHICLE

Getting this vehicle's colors in place first is very important. The vehicle is the main feature of the illustration, so it's essential to make sure that the background is going to work with its colors here, and not the other way around. These colors are fairly straightforward, staying in the blue-green marker range for the bulk of the vehicle. On the yellow accents I use a slightly warmer brown for the shadows. I use a warm, somewhat dark gray marker for the hints of engine and mechanisms inside. Finally there are a few small lights that I hit with a bright red.

TWEAKING MARKER TONES

If you find the colors aren't working exactly to your liking, you can shift their temperature slightly by using pale tones across the whole area. A little color theory can go a long way! Here I feel that my yellows are a little too green and sickly, so I overlay them with a pale salmon pink. You may need to go back in with a darker marker and reinforce your shadows a little after doing this.

COLORING THE ROCKS

The tone and texture of the red rocks are next. This color needs to work well with the teal and yellow of the vehicle, as well as with the organic tone of the paper. As I mentioned previously, the cool palette of the vehicle needs to stand out against the warmer rocks. I start with some basic browns and pinks to create the overall form, but then use a wide variety of other browns, reds, and yellows to add complexity. It's important that my marks are loose to reinforce the craggy quality of the rocks, but also that the shading flows with the overall form of the surfaces.

CREATE FORM WITH SHADING

When filling in large areas, be sure that your marker is moving with the form of the subject in some way. You can use the streaky tendency of the marker to your advantage, adding to the overall sense of volume in your forms, but scribbling or streaking in a thoughtless direction can actually flatten out your shapes.

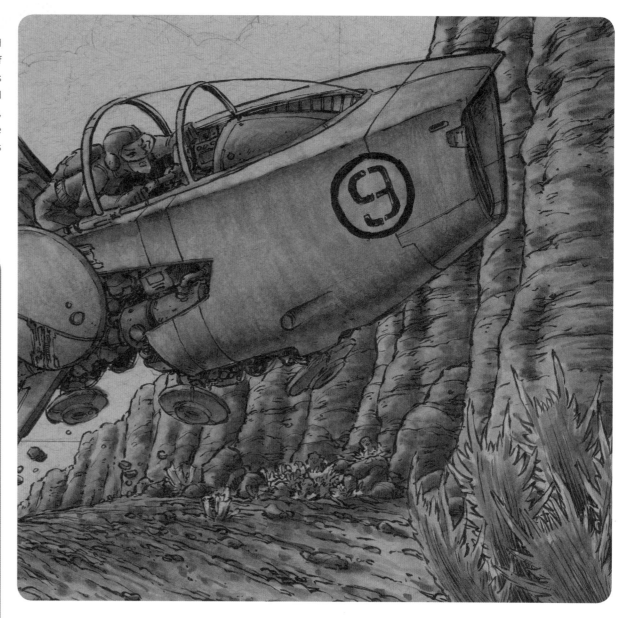

Rocky background Color in the reddish rocks and ground, making sure the flow of marker strokes follows the shape of the environment.

FINISHING THE ENVIRONMENT

Adding the green and yellow flora is the final detail for the marker-coloring stage. I want this green to be more neutral than the blue-green of the vehicle, and to work with the surrounding red rocks, and to still feel harmonious. To achieve this, I bring in a little of the deep blue-green from the vehicle and blend it into in the darker areas of the flora. Now is also the time to make any additional color-blending and minor adjustments across the whole image, before I can then move on to the final highlight stage with gouache.

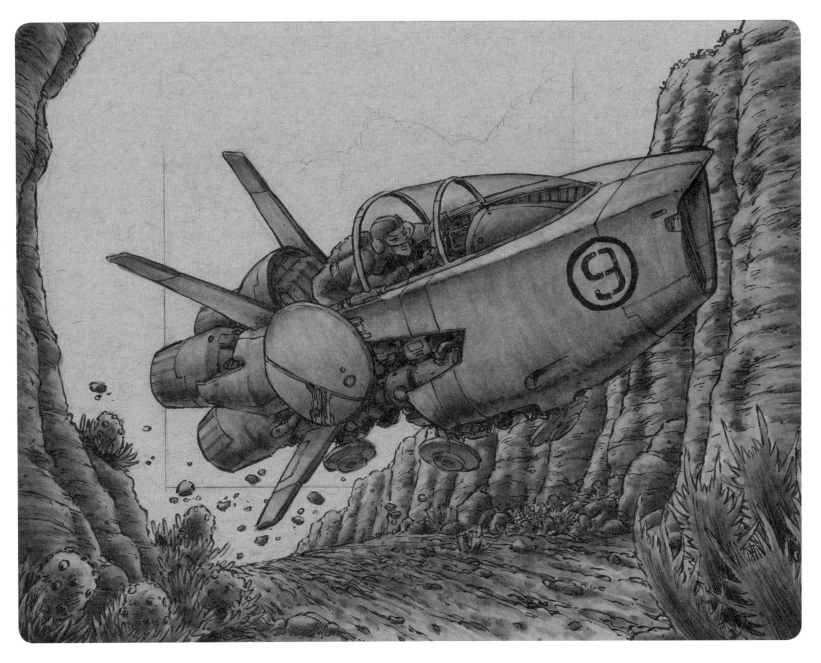

Adding greenery
Finish the plants to conclude the marker stage of the process.

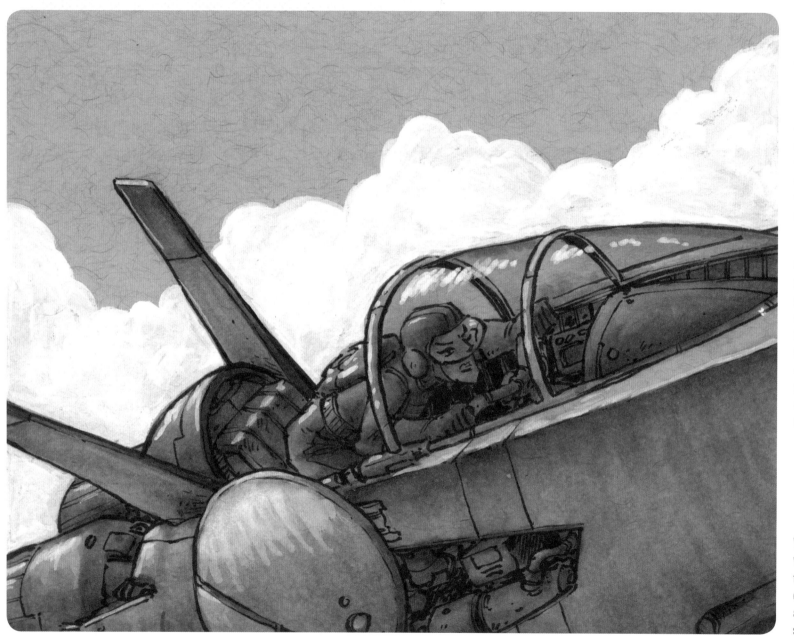

WHITE GOUACHE HIGHLIGHTS

Adding the final touches of white gouache always makes such a huge difference. Having the white to brighten the illustration and stand out next to all your other colors really makes them pop. Use a little water to thin the gouache for areas such as the clouds or the subtler highlights on the vehicle body, so they can be layered up more subtly with your brush.

CONCLUSION

In the final image, you can see how the geometric cloud backdrop makes the most of the toned paper, and helps to draw further attention to the silhouette of the vehicle. It's a very useful device that, with the right tools, can add a whole new layer of dynamism and presentation to your illustrations and concepts.

White highlights
White gouache is used to carefully add the cloud backdrop, as well as highlights to the ship and landscape.

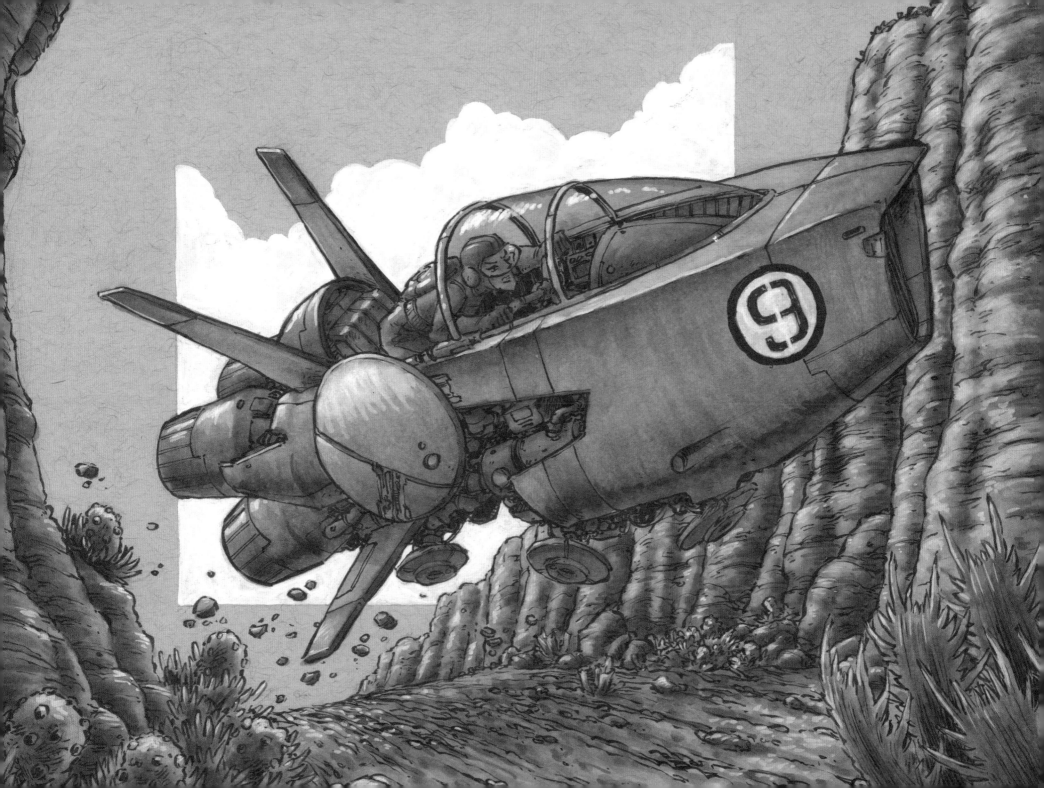

▶ ARMED PATROL ROBOT

ADVANCED PROJECT:
DIGITAL SKETCHING

BY MICHAL KUS

focalpointschool.com | All images © Michal Kus

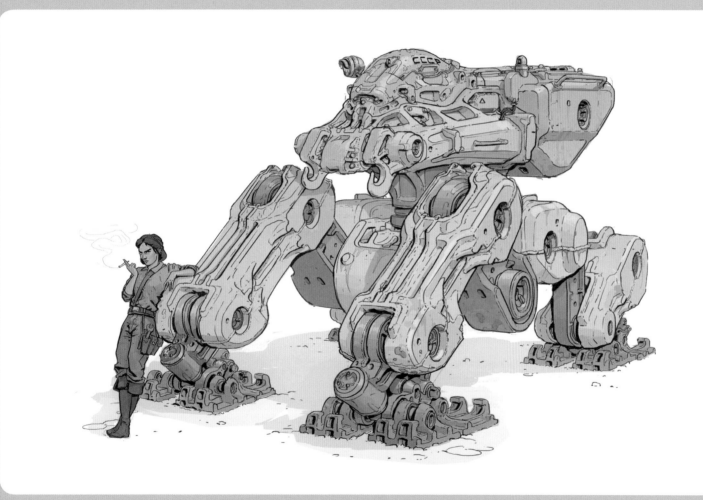

Digital hardware and software are more accessible than ever, and are perfectly fitting for an artist inclined towards the high-tech! While traditional drawing skills are an essential foundation, being able to think digitally will give you greater versatility in how you can create concepts and solve problems. But the freedom of the blank digital canvas and an infinite Undo button can present their own challenges to a beginner. In this section, concept artist and instructor Michal Kus will show how to create a concept using a simple digital work process.

TOOLBOX

- Adobe Photoshop (or another software with brushes and layers)
- Graphics tablet

INITIAL SKETCHES

In this tutorial I am going to design a Soviet-inspired patrol mech, with a simple sketching process which is suitable for artists who only know the basics of digital rendering. You will be able to follow this process with a graphics tablet and Adobe Photoshop, or any art software with basic brush and layer capabilities. Digital layers offer freedom that traditional media does not, enabling you to build up an image in overlaid parts; for example, with lines on one layer, flat colors on another layer, and shading on another. Each layer remains independently editable; you can easily change a layer's color or transparency, or discard it altogether.

Before we spend any time on a complex image with a fine finish, it is very important to carry out proper research. To avoid randomness and increase the richness and believability of a design, it's a good idea to give yourself restrictions from the start. What kind of world and time is this design from? What level of technology does it have? This design will be part of my project *Project: 1952,* which is set in an alternative world in which World War II is still waging, with some sci-fi technological advancements that still keep the design languages of the 1940s.

My initial sketches are a warm-up, not concerned with clean lines or presentation, just using a plain hard brush on a large canvas. I advise beginners to research how mechanical joints look, and roughly how they function, to embed their design in reality. For this project, I'm inspired by digging machines and Boston Dynamics robotics.

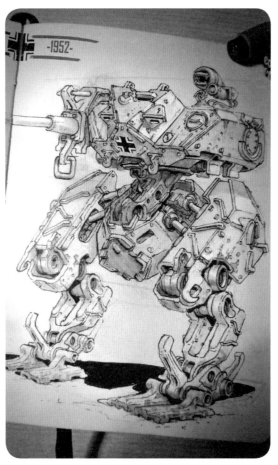

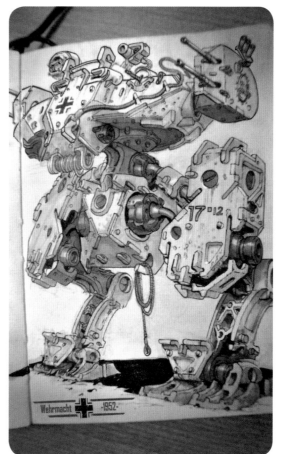

Rough ideas Sketching on one large canvas gives a useful overview of your visual notes, and helps you to not to care too much about each and every sketch. Here my main goal is to capture the overall shape of the design, influenced by the rough, rounded shapes that I know from Soviet equipment. The legs are the most prominent part of this design, so I pay attention to exploring how the legs could move.

Previous examples These are two examples of previous concepts from this project. These have a focus on German-inspired, state-of-the-art engineering and superior quality. However, the new design will be influenced by Soviet technology's focus on strong, mass-produced equipment that's easy to use and build. The new mech must clearly represent a different group and design language, while looking like it belongs to the same world.

SILHOUETTES

After warming up to the theme with some sketches, start making some silhouette thumbnails with a hard, opaque brush. Profile views ensure that you stay focused only on the main shape, and making it strong and distinctive. You can suggest some finer detail, but each sketch should not take much longer than five minutes; do not tax your brain with details that aren't important until later. Not thinking about perspective, surface materials, and clean drawing allows you to be totally free in your explorations.

I like the general feeling of most of the thumbnails from the top two rows, and will make sure to use some aspects of those. However, my strongest result is the third thumbnail. Though the Russians had relatively simple technology, I want this mech to be an example of their most exotic engineering; I think this thumbnail captures that feeling, while retaining a bulky, rounded, Soviet-inspired design language. The weakest thumbnail is the eighth; I tried to express a solid, bulky design, but the result looks too condensed and indistinct, with no visual separation between the body and legs.

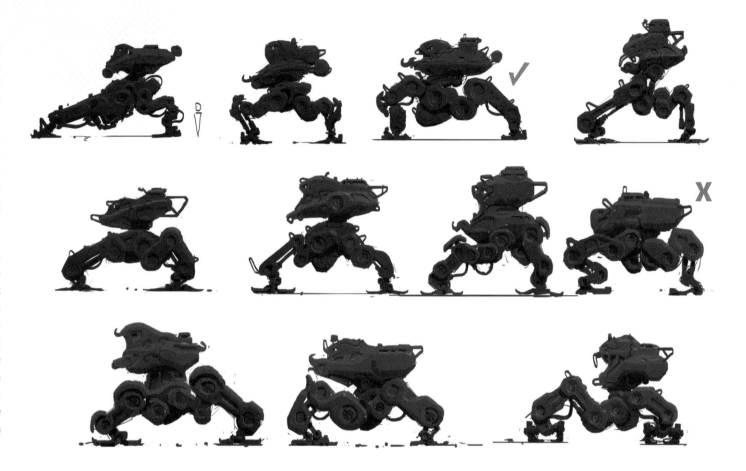

Bulky and powerful shapes There is a fine line between a bulky and effective shape, and one that is clunky and confusing! Digital brushes and layers make it easy to add opaque colors. You can use them to add extra details such as joints on top of silhouettes, as I have done here with different grays.

SKETCHES IN PERSPECTIVE

Now we can increase the design's complexity with a second round of thumbnails incorporating perspective. Take the basic forms from the previous round and immerse yourself in the designs, enriching them with more detail and complexity, while still thinking about function.

Don't overcomplicate things yet, but focus on solving design questions such as how the legs move, and what the top and front of the mechs look like. Here you can also see more clearly the level of technology I am using for this design: it is not a typical futuristic sci-fi robot, but one grounded in machinery and equipment from the 1940s to 1950s, almost like a tank or locomotive in appearance.

Though I will use elements from all the designs in my final concept, the top left thumbnail has the strongest overall feeling of a solid-looking mech that I will take forward: it is rounded, bulky in places, but at the same time introduces some complex-looking high-end mechanical details.

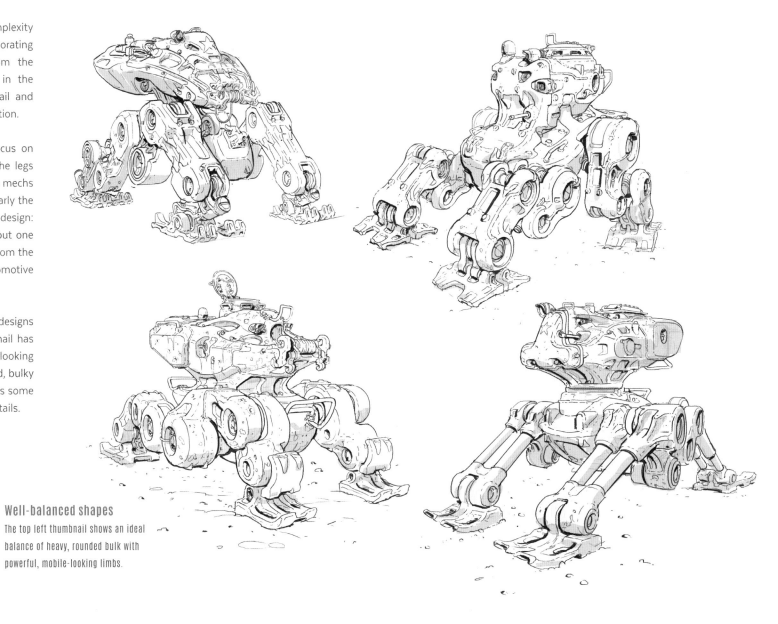

Well-balanced shapes
The top left thumbnail shows an ideal balance of heavy, rounded bulk with powerful, mobile-looking limbs.

BASIC SHAPES

Before going forward with detailing the final version, let's take a closer look at how the thumbnails on the opposite page, or even larger drawings, can be built up from basic geometry. For beginner and aspiring concept artists, understanding this stage is crucial.

Building blocks This is the most basic breakdown of the shapes, which will serve as a solid foundation to check that the design's forms make sense. This stage allows you to easily see the forms used, and to plan out the perspective. If you start adding complex bevels and details too soon, you can lose this sense of shape.

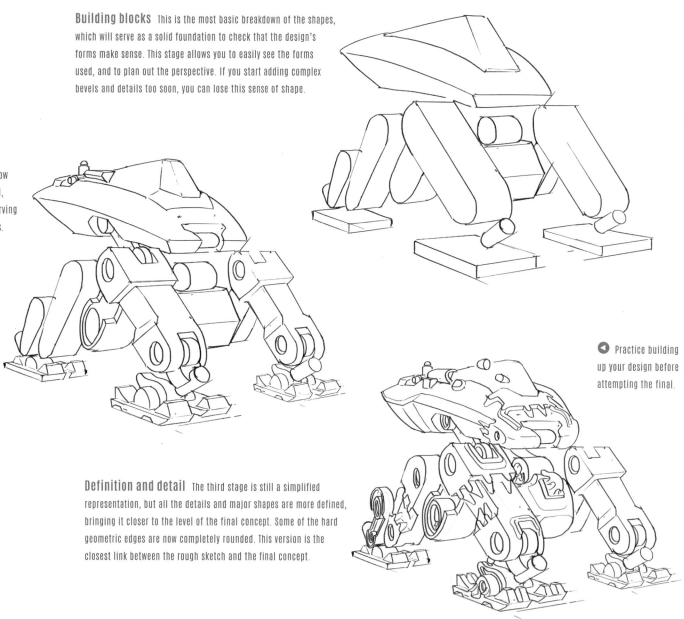

Modifying and refining This stage adds more complexity in all the main forms. You can still see how basic the design actually is - just a simple main hull, and a couple of blocks as legs - but I have begun carving out the shapes and adding some of the larger details.

RECONSIDERING WEAPONS

At this stage, I give the mech no weapons on purpose. Anything with a gun or some kind of weaponry can look "cool" by default, and I believe this diminishes your overall effort to make a design that stands out and is actually successful. Designing a mech without weapons lets you focus on the main shape and other features of the design. For example, a major feature of this design is its reconnaissance ability, which is what I primarily focus on. Later, I add a gun port on the side of the main hull, to suggest that the mech is upgradeable or has additional capabilities.

◀ Practice building up your design before attempting the final.

Definition and detail The third stage is still a simplified representation, but all the details and major shapes are more defined, bringing it closer to the level of the final concept. Some of the hard geometric edges are now completely rounded. This version is the closest link between the rough sketch and the final concept.

BASE SKETCH

To prepare for the final piece, start the drawing over again in a new document, in the form of a large, rough base sketch. This stage should not take much time, now that you're certain of the design and all the exploration and major decision-making has already been done.

CLEAN LINE ART

On a new layer, begin to "ink" the final drawing over your sketch with a hard brush. This requires patience, care, and knowing your design. Crafting tight lines and clarifying every shape takes time. It takes practice to forge the coordination between your brain and hand to put what you want onto the canvas. It's easy to get lazy or lose interest, because accurate line drawings don't allow you to "cheat" like you can with a more painterly digital scene, where you can cover things up with atmospheric fog or cool effects. You have to immerse yourself in the design and show equal passion and dedication to each part of it.

DEEPER THINKING

Remember that real-life shapes, both natural and artificial, have meaning and function. For example, the sharp, arrow-like shape of a fighter jet makes it as aerodynamic and maneuverable as possible. This thinking is key to making believable designs which, mixed with your own vision, result in high-quality, rich, original concepts.

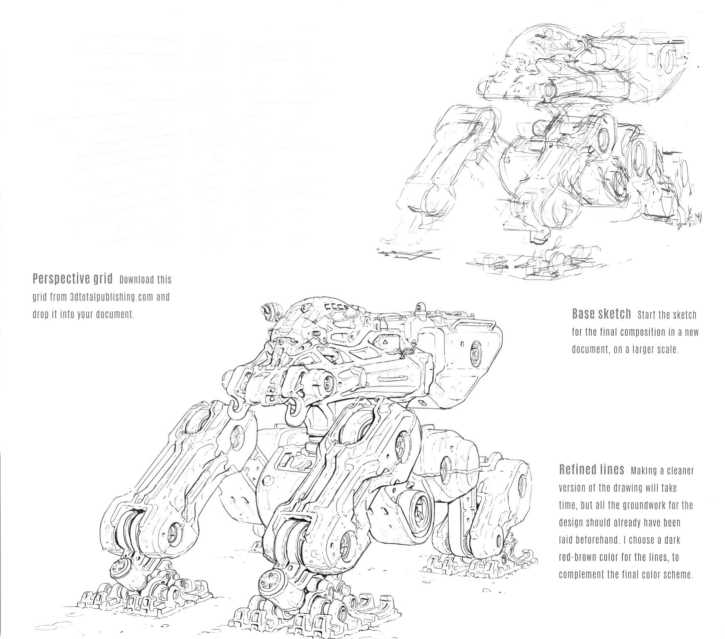

Perspective grid Download this grid from 3dtotalpublishing.com and drop it into your document.

Base sketch Start the sketch for the final composition in a new document, on a larger scale.

Refined lines Making a cleaner version of the drawing will take time, but all the groundwork for the design should already have been laid beforehand. I choose a dark red-brown color for the lines, to complement the final color scheme.

FINAL LINE DRAWING

Here I apply more varied lineweights to simulate depth in the design. Lineweight control is commonly used to make a drawing stand out more clearly and look less messy. It's a good way to suggest light and shadow without rendering something in depth, simply by applying thicker lines to shadowed areas. It also gives the drawing a strong, appealing visual style with some comic-art influences.

Working digitally also enables you to make corrections and changes on new layers, even at this late stage, such as the addition of an engineer that gives the mech a clearer sense of scale. This human character, relaxing with a cigarette after doing some maintenance work, adds a storytelling aspect which is always fun, even if the piece is design-oriented.

If this was a professional project, the concept at this stage could already be used for production, and be passed on to be modeled, rigged, and animated. It has enough clear visual information and communicates its idea confidently. However, we're going to focus further on the presentational aspects of the image: color and rendering.

TAKE A BREAK

It is always advisable to take a break – even for a whole day – before you make the final touches to a drawing. Your mind will be refreshed and you'll be able to see things with a new eye. Take a walk, go to the gym, walk your dog, or spend time with friends or family. Instead of being stubborn and trying to solve all of a project's problems in one go, take a break to enjoy life and you will return to your work with more joy. This profession can be taxing and stressful, even though people think you're just drawing cool robots!

🔽 Thinner lines here and there indicate weathered material: spots, streaks, and rust that will enrich the final design.

🔺 Sketch in a human figure to ground your design with a recognizable sense of scale.

Dynamic lines The finished line art has more varied lineweights, forming solid shadows in the deepest areas, which gives the drawing depth and makes it much clearer.

COLOR PALETTE AND MATERIALS

The mech will consists of two main materials. The primary material is the steel armor, which is cheap to produce, but sturdy; I imagine it being softer steel that will bend rather than break, which will be shown through many bumps and weathering effects. It would also be prone to rust, as cheaper steel tends to oxidize faster. This kind of general knowledge helps to enrich your design – I always encourage my students to show interest in a wide variety of subjects.

The second material is a high-quality steel, which can be forged with much more accuracy, and thus will be used for the moving and internal parts, with a darker color enhancing their already shadowed appearance.

I explore two different color palettes to differentiate these materials, with a range of values from light to dark, and practice building up the material textures using these colors in a separate document. You can use a solid, high-opacity brush of any shape for this.

PRIMARY COLORS

SECONDARY COLORS

Color palettes The design will feature a simple, mostly neutral palette which I explore in advance, testing out rendering on primitive shapes.

PRIMARY MATERIAL

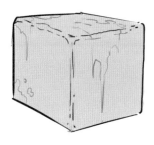 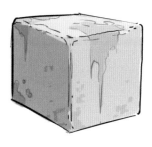 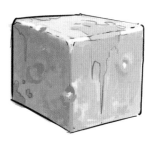

SECONDARY MATERIAL

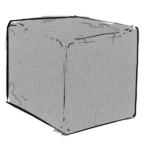

LOCAL COLOR

Unlike coloring with traditional media, where you are often constrained by how materials interact, digital painting offers a lot of freedom in how you can apply and edit colors. Keeping shadows and highlights on separate layers from the base color, for example, is good practice for this type of simple rendering, allowing you to adjust a layer's opacity (how transparent it is, and thus how strong its effect is) on the fly. Smoothing and blending with in-between colors can be done on another layer again, to preserve the original rough colors if you decide you want to return to them.

Let's begin with the "local color," which represents the base color of the material when it is not affected by strong lighting. Imagine the mech is lit by a neutral ambient light that shows the true colors of the materials; for a good representation of ambient light in reality, look at an object during an overcast afternoon, when the sunlight is scattered through the clouds and the whole sky emits a flat, neutral light. The local colors of the two steel materials are applied on a layer underneath the line drawing. I also add some very rough shading to some of the undersides and recessed areas of the design, using the darker values from the palettes I made for each color.

Base colors Block in the local color and very simple shadows underneath the line drawing, establishing the rough color and lighting for the whole design.

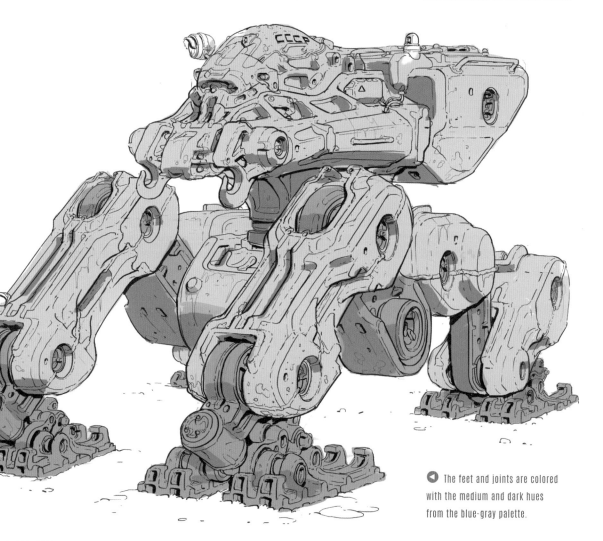

▶ The figure can be filled in last with simple colors. Focus on the mech for now.

◀ The feet and joints are colored with the medium and dark hues from the blue-gray palette.

BASE LIGHTING

On a new layer above the local color, we can apply the base lighting. This represents how the materials react to a stronger, direct light source, which in this case comes from the upper right of the scene. The upper part of the mech receives the most light, while the surfaces facing the lower left are in shadow. So far I have used only three values in each of my gray materials, and through these alone I've introduced a lot of definition.

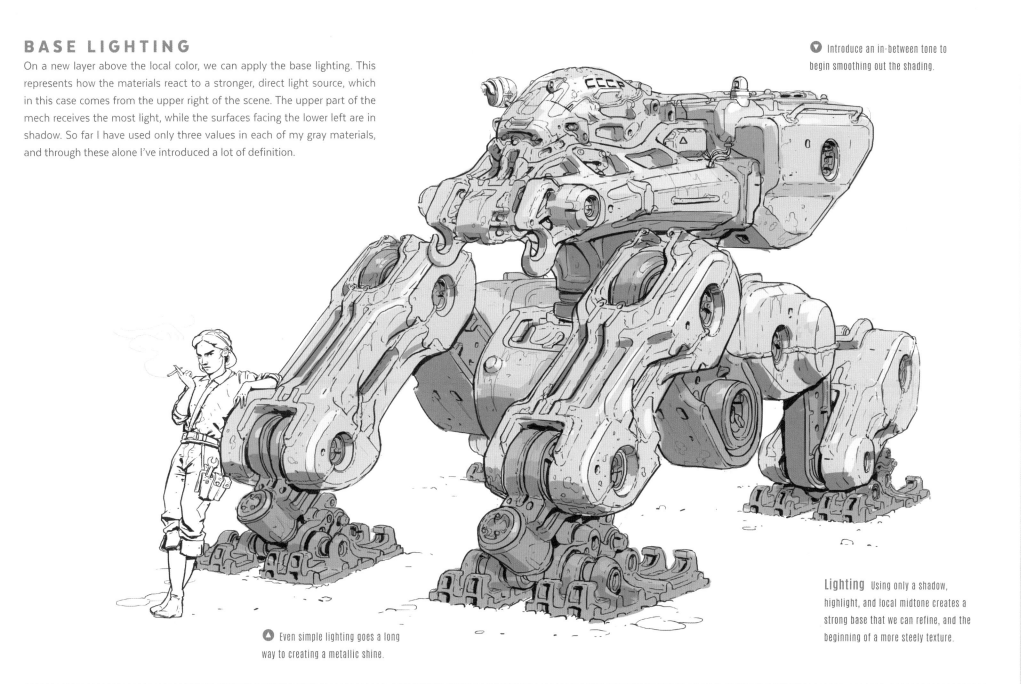

▼ Introduce an in-between tone to begin smoothing out the shading.

▲ Even simple lighting goes a long way to creating a metallic shine.

Lighting Using only a shadow, highlight, and local midtone creates a strong base that we can refine, and the beginning of a more steely texture.

REFINING THE COLORS

Now we can refine the shading to achieve a more complex representation of our design, using the intermediate values from our palette to create smoother blending. Light always finds a way into a scene, so I include secondary "bounced" lights even on the faces which are put into shadow, which adds subtle depth to the lighting.

The fine bevels on some parts of the design will catch a more defined specular highlight, which adds to the metallic look of the surfaces. I also introduce more distinction between the steel materials: I add more bumps and damage to the primary armor, while the secondary steel parts have more intense specular lighting and less weathering, so they appear more resilient.

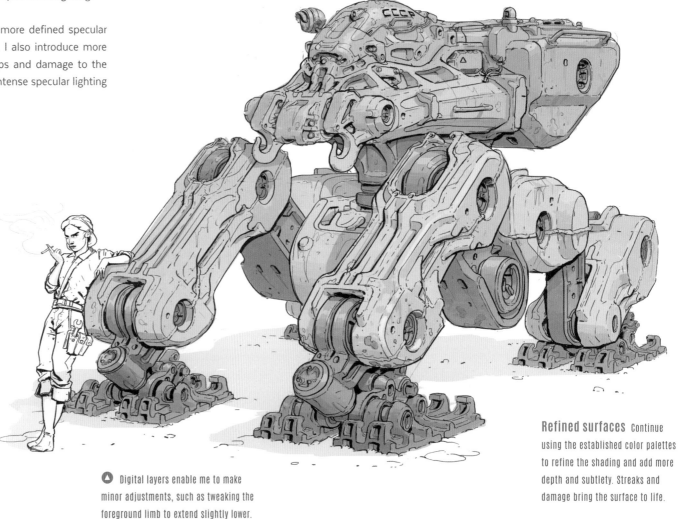

ALWAYS AIM TO IMPROVE

Concept art is a beautiful thing, and the amount of topics and themes that you can cover is limitless. It encourages you to be a constant observer and will always drag you back to the canvas to try new ideas. Do not stagnate, and aim to keep developing. Even though I find this design successful now, I know I will look back at it in the future and be eager to make a new, improved version. Remember, if you never fail, it means you are not progressing!

△ Digital layers enable me to make minor adjustments, such as tweaking the foreground limb to extend slightly lower.

Refined surfaces Continue using the established color palettes to refine the shading and add more depth and subtlety. Streaks and damage bring the surface to life.

CONCLUSION

The finished illustration successfully meets the criteria and restrictions that I established at the start, creating a mech design that fits into a specific setting, with a straightforward digital workflow. Being a World War II history nerd helped me to give this design a grounded look, and my ideas for an alternative setting and backstory give it a unique spin. The concept is accurate enough that it could be used for an industry production, while the final presentation would make this image suitable for marketing as well.

Digital tools offer some versatility and benefits, like more ways to solve problems and make revisions - but in many ways the same principles apply, and the processes are not that different, as demonstrated here. The same ideas apply to creating a strong line drawing, for example, as if you were drawing with ink on paper. Nonetheless, it's worth exploring how working partially or fully with digital software can save you time and materials, and enhance your design process.

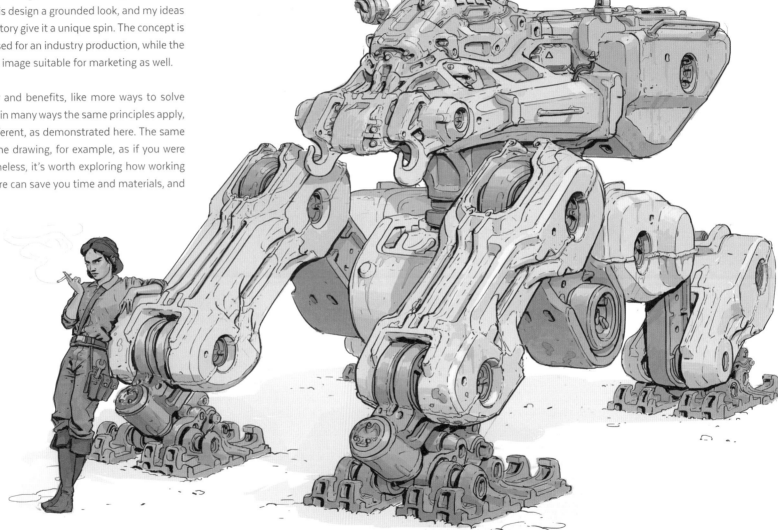

▶ The final touch is to add a new layer for coloring the engineer, for which I use similar colors and tones as the mech, so she doesn't distract from the main focus of this project.

CONTRIBUTORS

JAN BURAGAY
tsugomori.artstation.com

Jan Buragay is a freelance artist based in the Philippines. He is self-taught, with a passion for sci-fi and mechanical illustration.

ANG CHEN
angchendesign.com

Originally from the Bay Area, Ang Chen is a concept designer and illustrator currently living and working in Los Angeles, California. Ang attended ArtCenter College of Design, and enjoys reading and coffee.

ERIK DILLINGER
instagram.com/edillin

Erik Dillinger is a freelance artist experienced in graphic design, animation (including stop-motion), motion graphics, illustration, sculpture, model/set-building, stage work, and lighting.

JEREL DYE
jereldye.com

Jerel Dye has been creating sci-fi art and comics since 2009, and has produced self-published mini comics and stories for anthologies. His first graphic novel, *Pigs Might Fly*, was released in 2017. Jerel teaches courses in drawing, cartooning, and comics.

JOHN A. FRYE
fryewerk.com

John Frye has a degree in transportation design from ArtCenter College of Design and has worked at Honda R&D for more than 20 years. He teaches at Concept Design Academy in Pasadena, California.

WAYNE HAAG
ankaris.com

Wayne Haag's greatest passion is for sci-fi oil painting. He has contributed matte painting to *The Fifth Element*, *Red Corner*, and *The Lord of the Rings* series, and created concept art for films such as *The Wolverine*, *Maze Runner*, and *Alien: Covenant*.

MILEN IVANOV
milenskyy.artstation.com

Milen Ivanov is a concept designer based in Sofia, Bulgaria, specializing in creating sci-fi vehicles in both 2D and 3D.

GUIDO KUIP
guidokuip.artstation.com

Guido Kuip is a self-employed concept artist and illustrator living in a small town in Nova Scotia together with his better half and their two rescue parrots.

MICHAL KUS

focalpointschool.com

Michal Kus is a concept artist with a passion for hardware and vehicle design, and has worked for many companies including EA Games, Disney, Marvel, and Platige Image. He tutors at CGMA, Focal Point School, and workshops throughout Europe.

QIANJIAO MA

q-draws.com

Qianjiao Ma is a Los Angeles-based concept artist, background painter, and designer, working in the themed entertainment and animation industries. Her clients include Warner Bros., Rough Draft Studios, Shadow Machine, Thinkwell Group.

RICCARDO PAGNI

riccardopagniart.blogspot.com | riccardo_pagni.artstation.com

Riccardo Pagni is an illustrator and concept artist, currently living in Dublin and working in the animation industry.

ROB TURPIN

thisnorthernboy.blog

Rob Turpin is an illustrator and designer from Yorkshire, and has been living and working in London for the last 20 years. Mainly working in science fiction and fantasy, Rob has a love of spaceships, robots, and the color orange.

DWAYNE VANCE

instagram.com/dwaynevance | behance.net/FutureElements

Dwayne Vance has been a designer for over 20 years, and has worked for several major companies and brands, including DC Comics and Disney. Dwayne has his own brand called *Masters of Chicken Scratch*, offering books, art prints, and drawing tools.

CALLIE WEI

calliewei.artstation.com

Callie Wei is a Los Angeles-based concept artist working in the games, film, and television industries.

LORIN WOOD

lwoodesign.com | nuthinbutmech.blogspot.com

Lorin Wood has been a concept designer for film, television, video games, and product design for the past 20 years, and is currently pursuing a new career in academia. He is the creator of the *Nuthin' But Mech* blog and accompanying book series.

JEFF ZUGALE

jeffzugale.artstation.com | starshipwright.com

Jeff Zugale is a concept designer and illustrator, comprising four distinct types of nerd and at least six kinds of geek – so of course he works in video games. He loves drawing spaceships and makes his own sci-fi art, books, and toys under the title *Starshipwright*.

GLOSSARY

For quick reference, here is a list explaining some expressions and technical terms used throughout the book.

BLOCKING IN / OUT

Blocking a drawing or design in or out refers to the general process of laying its basic foundations, or loosely placing elements that you will refine later.

BOOLEAN PROCESS

A Boolean process or Boolean operation is a function commonly found in 3D modeling, and involves the addition or subtraction of geometric shapes to or from each other.

CAST SHADOW

This shadow is created by one shape overlapping or blocking the light from another. It is darker and sharper than a "form shadow", which occurs when a surface is simply facing away from the light.

CHAMFERING

Chamfering is the process of trimming down a right-angled edge to make a slope.

CONCEPT ART / DESIGN

Concept art is a type of art used to develop and demonstrate a subject or idea, usually for final use in a media product such as a film or video game. Concept artists often specialize in different subject matter, such as characters or environments, and may work with traditional, 2D, or 3D tools to convey their ideas.

ELEVATION

In architectural drawing, an elevation refers to a flat view of a design, usually the sides and front of a building.

ELLIPSE

In the context of this book, an ellipse is an oval, like a circle that is flattened or in perspective.

EYEBALLING

Eyeballing refers to the process of working something out "by eye," without needing to plan or measure it first.

HAPPY ACCIDENT

This is something that was a mistake or that you didn't intend, which turns out to be useful or a good idea. Concept design is full of these!

HARD-SURFACE

In concept design, this refers to a subject that is human-made and usually metal. A "hard-surface" design can refer to a vehicle, robot, or other industrial object that is not organic.

HORIZON LINE

The horizontal guideline that acts as the horizon or eye-level line in a perspective grid. When making a grid, one or more vanishing points are placed on the horizon line to create further perspective guidelines.

HOT SPOT

In lighting and photography, a hot spot often refers to an area on an image or surface where the highlight is extremely bright.

ISOMETRIC

Isometric perspective, or isometric projection, refers to the depiction of three-dimensional subjects in a flattened view that does not represent natural perspective.

ITERATION

Concept design is an iterative process, meaning multiple versions and revisions of an idea are made until the final version is reached. This process (and a result of this process) is called iteration.

LENS

This refers to the viewpoint or point of view from which a subject is depicted. Even if you are not literally working with a camera, it helps to imagine your scene as if viewed through one.

LINEWEIGHT

In drawing, the weight of a line refers to its thickness or heaviness. You can achieve a variety of lineweights by applying lighter or heavier pressure to your pen or pencil, or by using tools with different thicknesses.

LOCAL COLOR

An object's local color is its flat base color, unaffected by strong light or shadows.

MECH

In sci-fi, a mech is a large robot. This term is sometimes used interchangeably with "mecha," which more specifically refers to a giant robot with a human pilot, commonly found in Japanese pop culture.

MIDTONE

Midtones are the range of middle values in an image, in between the shadows and highlights. In a grayscale drawing, the midtone could be captured with light and medium gray markers.

ORGANIC

In concept design, an organic subject refers to one that is natural or fleshy, as opposed to hard-surface. This could refer to people, creatures, or plants and natural environmental elements.

PERSPECTIVE GRID

A grid or guidelines used as a visual aid for drawing a scene with perspective, typically including a horizon line and vanishing points.

PLANES / PLANAR

In geometry, a plane is a flat two-dimensional surface that can be used to construct a three-dimensional shape. "Planar" refers to the quality of these surfaces, or sometimes a visual style that emphasizes this geometric quality.

PRIMITIVES

Primitive shapes are the simplest forms of geometry – such as cubes, spheres, pyramids, and cylinders – from which more complex geometry can be built. This term is commonly found in digital 3D modeling.

READ

Artists mentioning a "visual read" or "at first read" are referring to an image's clarity – if it flows well and can be clearly interpreted. It's important in concept design for an image to read well.

REALISM

Realism, across art in general, refers to the practice of depicting a subject in a way that is accurate and true to life.

RENDERING

In drawing and painting, rendering is the process of adding color, texture, and shading to an image.

SHAPE LANGUAGE (OR DESIGN LANGUAGE)

In concept art, shape language refers to the quality of the forms that are used to create a design and communicate its nature to the viewer. For example, a vehicle with a square, blocky shape language will come across very differently from a vehicle with curved shapes.

SILHOUETTE

A silhouette is the solid dark shape made by an unlit object.

VALUES

In art, value refers to how dark or light a color is. You can create areas of high contrast in an image by using values with a large difference between them, and areas of low contrast by using similar values within a similar range.

VANISHING POINT

In perspective drawing, a vanishing point is a point on the horizon towards which the scene recedes. More complex perspectives, such as three-point perspective, feature multiple vanishing points.

VERTEX/VERTICES

In geometry, a vertex refers to where two lines meet to form a point, angle, or corner.

VOLUME

The volume of a drawing refers to its sense of form and depth. You can add volume to a design by using shading to give it light and shadow.

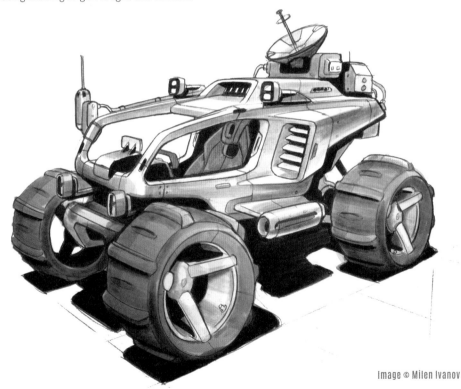

Image © Milen Ivanov

beginner's guide to
sketching:
characters, creatures & concepts

Embark on a sketching journey with the inspirational *Beginner's Guide to Sketching: Characters, Creatures & Concepts*.

From gesture drawing and finding simple shapes to mastering line quality and shading, *Beginner's Guide to Sketching: Characters, Creatures & Concepts* is a fantastic companion that will teach you to sketch confidently while helping you improve the way you design. Your journey will begin with a look at drawing materials and techniques, before moving on to essential warm-up exercises to help you become familiar with the fundamentals. Four master projects by seasoned professional artists will then take you from concept to final illustration, walking you step by step through poses, designs, and costumes before culminating in a final scene. Featured artists include Justin Gerard, Brun Croes, and Sylwia Bomba.

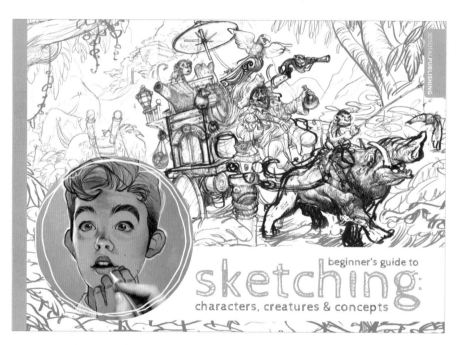

beginner's guide to
sketching:
characters, creatures & concepts

3dtotalpublishing.com | 3dtotal.com | shop.3dtotal.com

Sketching from the Imagination

In each book of the *Sketching from the Imagination* series, 50 talented traditional and digital artists are chosen to share their sketchbooks and reveal insights into their designs and creations. Visually stunning collections packed full of useful tips, these books offer inspiration for everyone.

3dtotalPublishing

• •

3dtotal Publishing is a leading independent publisher specializing in trailblazing, inspirational, and educational resources for artists.

Our titles feature top industry professionals from around the globe who share their experience in skillfully written step-by-step tutorials and fascinating, detailed guides. Illustrated throughout with stunning artwork, these best-selling publications offer creative insight, expert advice, and essential motivation.

Fans of digital art will find our comprehensive volumes covering Adobe Photoshop, Pixologic ZBrush, Autodesk Maya, and Autodesk 3ds Max must-have references to get the most from the software. This dedicated, high-quality blend of instruction and inspiration also extends to traditional art. Titles covering a range of techniques, genres, and abilities allow your creativity to flourish while building essential skills.

Well-established within the industry, we now offer over 50 titles and counting, many of which have been translated into multiple languages the world over. With something for every artist, we are proud to say that our books offer the 3dtotal package:

TECHNIQUE • CONFIDENCE • INSPIRATION

Visit us at 3dtotalpublishing.com

3dtotal Publishing is an offspring of 3dtotal.com, a leading website for CG artists founded by Tom Greenway in 1999